Praise

"A story of survival during wartime—not from ~~camera~~ ~~streets~~—but of life itself. When the men of the author's family, the Hamiltons, go to war, the women are left behind with barely adequate, if any, means of support, and must provide for themselves and their children the daily necessities of food and shelter. How they survive and impart their values is poignantly portrayed in this story of quiet heroism."
-Rich Rosenthal, President, North Jersey Civil War Round Table

"Joanne Rajoppi deftly tells the story of the women of one New Jersey family as they overcame personal tragedy and navigated the social, political, and economic complexities of post-Civil War America. Using the experiences of the women of the Hamilton family, she sheds light on the challenges and struggles that defined the roles of American women in the late nineteenth and early twentieth centuries. This is a fine work of local, family, and women's history."
-Phillip Papas, Senior Professor of History at Union County College, Cranford, New Jersey

"A story of women when they needed all their fortitude, craft, intelligence, and guile to survive, eat, and live. Ms. Rajoppi has provided us with new historical sources, a fresh story, and an account of a time when the widows of war were forgotten. An excellent read which I recommend."
-C. Brid Nicholson, Associate Professor of History, Kean University, New Jersey

"In this well-written and insightful work, Joanne Rajoppi does for Brunswick women what she had done so well for Brunswick boys. She restores these women to their place in history and reveals their hopes, desires, and dreams. This book is essential for understanding the lives of Northern women after the Civil War, a subject that has not received nearly enough attention."
-Louis P. Masur, Distinguished Professor of American Studies and History

"Women have played a vital and often times singularly unique role throughout American history. Yet early American history sometimes leaves little record of their inestimable achievements. With inventiveness and great originality Joanne Hamilton Rajoppi has done yeoman's work to recreate the antebellum lives of the Hamiliton woman. Manifesting the universality of the lives of many Northern women, Rajoppi's efforts may well become a tour-de-force in the recognition of the courageous role of the woman who sacrificed everything for their own families and a grateful nation."
-Paul F. Caranci, author and historian

Northern Women in the Aftermath of the Civil War

The Wives and Daughters of the Brunswick Boys

Joanne Hamilton Rajoppi

AMERICAN HISTORY PRESS
STAUNTON VIRGINIA

American History Press

Staunton, Virginia
(888) 521-1789
Visit us on the Internet at:
www.Americanhistorypress.com
Cover/interior design: David E. Kane

First Printing December 2016

To schedule an event with the author, or to inquire about bulk discount sales, please contact American History Press.

Library of Congress Cataloging-in-Publication Data
Names: Rajoppi, Joanne, author.
Title: Northern women in the aftermath of the Civil War : the wives and daughters of the Brunswick boys / Joanne Hamilton Rajoppi
Description: Staunton, Virginia : American History Press, 2016. | Includes bibliographical references and index.
Identifiers: LCCN 2016052703 | ISBN 9781939995186 (pbk. : alk. paper)
Subjects: LCSH: Hamilton, Mary Ann Ryan, approximately 1817---Family. | Hamilton family. | United States--History--Civil War, 1861-1865--Women. | United States--History--Civil War, 1861-1865--Influence. | Hamilton, Alexander, -1864--Family. | New Brunswick (N.J.)--Biography.
Classification: LCC CS71.H22 2016 | DDC 920.72--dc23

LC record available at https://lccn.loc.gov/2016052703

To the Hamilton Women: Past, Present and Future

TABLE OF CONTENTS

ACKNOWLEDGEMENTS

Women's history often remains unrecorded or shrouded in the stories of male family members. Digging into court records, discovering momentous life events and unearthing family secrets is a slippery slope. Often what is "found" is only a teaser for yet more undiscovered information, so a full-scale exploration becomes necessary, although there is never the promise of a strike.

Luckily for me, archivists, historians, curators, court officials, county clerks, lawyers, librarians, surrogates and law enforcement personnel in California, Massachusetts, Michigan, New Jersey and Washington states helped to navigate and steer me to maps, photographs and probate, birth, cemetery, hospital, military, veteran, newspaper and land records. Some things I happily stumbled across myself, like the Long Branch, New Jersey school report cards of my relatives from the 1880's and 1890's. Other "teasers" demanded exhaustive exploration.

Along the way I met some wonderful dedicated archivists and historians, among whom were Riley Kidd, M.D. of the Seattle Genealogical Society, who conducted a two year communication with me about the Hamilton children in Washington State, and Bette M. Epstein of the New Jersey State Archives, who was able to ascertain a time period for my great-great-grandmother's passing even though there was no paper documentation (as well as unearthing other information). A special salute to my New Jersey sisters and brothers—clerks and surrogates in Bergen, Burlington, Mercer, Middlesex, Monmouth and Union counties—who serve as Constitutional Officers. They are the record keepers who made my search smoother.

Many thanks to good friend and fellow writer Gary Szlec, who read this manuscript through many rewrites and offered valuable suggestions.

My gratitude is also extended to Dr. Samantha Pozner, who played medical detective to interpret the death certificates of several relatives. I am grateful too for the support of family and friends who encouraged me to tell the story of the Hamilton women. Any errors or omissions are mine alone.

FOREWORD

When my great-great grandmother Mary Ann Ryan Hamilton, a Civil War widow, petitioned the Federal Court in 1865 for a war pension, her request was based on her dead son's service, not her husband's—a seemingly odd appeal. But, like people, family stories are complex, and decisions and behaviors are often inexplicable unless we know their history. Sometimes answers are found in the unlikeliest of places, and often obstacles such as modern day "privacy laws"—as in the case of Mary Ann's daughter Susan, an epileptic, housed in an insane asylum—prevent us from learning as much as we want. Mary Ann's story and those of her daughters—Mary Jane, Susan and Alice—and daughters-in-law—Lizzie Gilliland Hamilton and Lida Howland Hamilton, grew out of my curiosity about the women of the Hamilton family after completing my great-grandfather's story in *New Brunswick in the Civil War: The Brunswick Boys and the Great Rebellion*. What happened to the wives and widows of the veterans? How did they care for their injured loved ones and sustain a household? How did those who had little or no marketable skills provide food and shelter?

The history of Northern women after the Civil War is not well researched in scholarly circles or in non-fiction works. Mid- and late-nineteenth century women's history is centered on the temperance and suffrage movements or on the issues Southern women faced during the Reconstruction Era. Except for what can be gleaned through painstaking research into personal diaries, letters and legal documents, there is a dearth of published information about the trials, difficulties and lives of Northern women in this period.

The story of the Hamilton women in this book reflects in part the story of Northern women. Like many of the estimated 200,000 Civil War

widows, Mary Ann Hamilton, the matriarch of the Hamilton family, faced the challenge of losing her sole support and raising two young daughters, one of who suffered from epilepsy (a third daughter was married). Her efforts to obtain a pension, and provide support and protection for her family while keeping the family together, echo the struggles which many Northern women experienced.

Mary Ann and thousands of other Northern war widows were also among the first beneficiaries of a revised federal veterans program. Beginning in 1862, the United States government addressed the needs of its soldiers and sailors or their dependents with legislation passed by Congress. The federal statutes that provided pensions—limited as they may have been—assisted countless widows and dependents like Mary Ann and made it possible for them to maintain a sustainable if poor home.

The Hamilton women's lives also mirror the growing pains of post-Civil War America: the westward migration and expanding frontier, the immigration influx and even the Wild West. Mary Ann's daughter Alice Hamilton Boudinot, and daughter-in-laws Lizzie Hamilton and Lida Hamilton uprooted their families in this period. They, their husbands and families bade farewell to their homes and relatives and all that they knew in order to travel first to Detroit, Michigan where the burgeoning furniture manufacturing industry beckoned and then, for the Alex Hamiltons, on to the territory and soon-to-be state of Washington. While Alex and his wife remained in the far west, the Boudinots and John Hamilton families returned to New Jersey and settled in the then world-renowned resort of Long Branch.

In an effort to organize the far-flung members of the family, each branch of the family has their own family chart. As was the tradition, children often were named for dead relatives and sons and daughters were named for their parents, a practice that can be confusing to decipher. I direct the reader to reference the family trees that can be found in the Appendix to better understand their genealogy.

The changing culture and work history of women in the last few decades of the nineteenth century and early twentieth century is also reflected in the Hamilton women's stories. Prior to the 1870's women were employed in a handful of low-paying industries like textiles. The only other "respectable" occupations for women after the Civil War were

teaching or nursing. Perhaps somewhat surprising to our modern eyes, in that era even the majority of secretaries were men. With the spurt in industrial growth and technology, and the invention of the typewriter and other office devices, women (especially single women like Lizzie and Alex Hamilton's daughters, Beth, Lizzie and Alice) found work and acceptance in the office place as clerks and stenographers.

Many, if not most, single women lived at home with their parents, as Beth, Lizzie and Alice did for a time. But an increase in pay provided the means to live independently and some, like Beth Hamilton, took the opportunity to do so. Clerical work allowed single women—for the first time in history—a new-found independence, which led in turn to an identity not defined by either parents or a husband. This meant that a woman like Beth could have a stand-alone listing in the 1891 Detroit City Directory as a stenographer. Marriage, of course, was still the ultimate "occupation" for women, but respectability for single working women before their marriage was starting to gain acceptance.

Unlike *The Brunswick Boys* I did not have the luxury of letters or family diaries for this book to learn about my great-grandmother's life or those of her children or daughters-in-law after the war. Letters may exist, perhaps wrapped in an old ribbon in a dust-covered trunk in an attic somewhere, but I have not been able to locate them. Instead, I embarked on a journey through the latter part of the nineteenth century—a trip both exhilarating and frustrating—a slowly unraveling detective story with elusive endings. The letters of the famous and celebrated persons of the era provided a wealth of information, but for the working class, like the Hamilton family, there were few documents to shed light on their existence.

As I put the finishing touches on this manuscript I received a response from a librarian who enclosed copies of obituaries of family members that I had requested. When I read one from 1985 for Myra C. Tunney, granddaughter of Alice Hamilton Boudinot Asay, I learned that she was survived by a son, Eugene Tunney. What were the chances I could locate Alice's great-great grandson? A little sleuthing and some luck led me to him. He had lived with his great-grandmother Cecelia for twenty years and was able to provide me with a treasure of remembrances, which shed even more light on a remarkable family and their survival.

Based on the information discovered I was able to patch and link the stories of the Hamilton women. Even with the hundreds of family related documents I was able to obtain and the scores of reference material I scrutinized, there are still blanks in the record, as well as frustrating obstacles. Thus, I made various deductions based on probabilities and possibilities and knitted the whole together into this narrative. In the end any errors or omissions are solely mine. The results of my efforts paint a picture of the heroism and perseverance of the Hamilton women. Like thousands of other Northern women, they recovered from the war while resolving to keep their families together, assist their children with the hope of a better life, and leave a legacy and model for future generations to follow.

Joanne Hamilton Rajoppi
December 2016

Northern Women in the Aftermath
of the Civil War

Chapter 1

A CIVIL WAR WIDOW'S
TRIBULATIONS

Don't fail to use my money to pay any expenses
there will be to bury Father in good shape.
- John P. Hamilton in a letter to his mother
dated January 29, 1864

When Alexander Hamilton, the patriarch of the family, died in January 1864 from the wounds he received at the Battle of Fair Oaks, his forty-seven-year-old widow Mary Ann Hamilton's hopes for a future free of economic worries suffered a devastating blow. Having barely gotten over grieving the loss of her eighteen-year-old and youngest son, James, at Chancellorsville in May 1863, her prospects seemed grim. With her oldest and middle sons also enlisted in the Union Army, Mary Ann's only source of economic support for the family in Alexander's three year absence from home during the war had been James, and now both were gone. Money would have been so tight that it is likely that she buried her husband in an unmarked grave (as there is, in fact, no record of a burial site that I could find despite an exhaustive search).

Before his enlistment in the army, James had supported his mother and sisters by working first in a grocery store and then in a New Brunswick, New Jersey rubber factory.[1] In a poor family like the Hamiltons, there was a need for everyone who could work to do so in order to help support themselves as well as contribute to

the family. This level of economic status and the need for everyone to work were relatively common for the times

Mary Ann and Alexander Hamilton were the parents of seven children: the oldest was Mary Jane; then came Alex Jr., John, James and the two younger daughters, Susan and Alice; a baby girl, Frances, died shortly after birth. The family had moved to New Brunswick, New Jersey from Lynn, Massachusetts where they had worked as shoemakers. In the late 1850s Lynn was the women's shoe capital of the world. Although it is not known why they left Massachusetts, the Panic of 1857, an economic depression when prices plummeted and businesses responded by slashing wages, may have led them to New Brunswick, at the time a robust manufacturing hub.[2]

Mary Ann Hamilton's relocation to New Jersey affirmed a common pattern for most women of the era who followed their husbands' work. Born in Halifax, Nova Scotia about 1817, Mary Ann Ryan traced the steps of many others who traveled to America for a better life. In 1832, at the age of fifteen, she braved the North Atlantic and a 600-mile-long voyage aboard the schooner *Rambler*, a packet ship that regularly ran between Halifax and Boston. She arrived in Boston with two siblings and a cousin, all under the age of twenty-five.[3] At the time the usual practice for unskilled young people entering America, especially girls and women, was to pursue domestic service. The other major option was in the growing manufacturing sector, so it is likely that Mary Ann found work in one of these employments until her marriage.

Although no marriage record could be located, Mary Ann Ryan met Alexander Hamilton sometime in the mid-1830s and they married shortly thereafter. Their daughter Mary Jane was born in 1838 in Massachusetts. Two years later the young family was living in New Hampshire where son Alex was born. Sometime in the next two years they relocated to Vermont where John, my great-grandfather, was born in Hartford, before the family once again returned to Massachusetts in 1849. It was there that their daughter Frances was born, but sadly died shortly after birth. The youngest girls, Susan and Alice also were born there in 1849 and 1852, respectively.

Mary Ann and the children accompanied Alexander

throughout New England as his shoe-making business dictated. It was disruptive then, as it is today, to uproot young children every few years, but Mary Ann persevered for the sake of her husband's work and the well being of the family. It was during their life in Massachusetts that Alexander's chronic drinking manifested itself, and eventually became an issue with the law and his family. In 1850, now a man with a wife and five small children, one of whom was an infant, he was convicted of "chronic drunkenness." The offense was considered so serious that he was sentenced to serve six months in the county workhouse located in Newburyport, Massachusetts (along with the indignity of paying court costs of $4.86).[4] The 1850 United States Federal Census, which listed his occupation as "shoemaker," also identified him as a "convict."[5] (In 1855 Alexander again was listed as a resident at the workhouse. However, the record does not state if he had been incarcerated for drunkenness or some other infraction.)[6] Alexander was prosecuted under colonial-era laws relating to public drunkenness. Massachusetts had a long history of statutes attempting to control the excessive consumption of alcohol as the "evils of intemperance" had had a long attraction with the ministry in New England since the mid-eighteenth century. New York and Massachusetts led the way, with the establishment of temperance associations in 1808 and 1818, respectively. The anti-alcohol movement gained momentum in the 1820s through the 1840s, and was part of a more massive humanitarian "reform" movement that sought to lobby government to enact strict alcohol laws and in some cases, complete prohibition.[7]

Three years prior to Alexander's first incarceration Maine had adopted a law prohibiting the sale of alcohol and became the first "dry" state. In 1852, two years after Alexander's jail stay, Susan B. Anthony and Elizabeth Cady Stanton, staunch abolitionists, suffragists, social activists and leading figures in the women's rights movement, founded the Women's New York State Temperance Society.[8] The ranks of the temperance movement were filled with women who knew first hand the effects of alcohol on their families and marriages.

For those with an alcoholic and perhaps non-working spouse, it is not surprising that they also joined the temperance

movement and espoused greater rights for themselves; many of them were active in the suffrage movement as well as abolition efforts. In fact, all three movements—suffrage, temperance, and abolition—intersected and crossed over in their membership, and sometimes their efforts, as part of the larger "reform movement." While there is no evidence that Mary Ann joined a temperance group in Massachusetts, there is every indication that she was well acquainted with them (by 1838 the American Temperance Society had more than 8,000 local chapters and 1.5 million members, no mean feat for a nation of about sixteen million people).[9] If not herself a member, she likely had friends and neighbors who were members, since there was a proliferation of such groups in most communities. We can only speculate how Mary Ann managed to live and feed the children who were aged twelve, eight, six, five and one in 1850. It had to be a difficult period. There was no government welfare, and "soup kitchens," as we know them, did not exist. Perhaps she found factory work, or neighbors may have helped with food and childcare. She was certainly not the first woman with an intemperate husband, though the ages of her children no doubt made her situation particularly challenging. Such hardships either hardened one or left one weaker, and in Mary Ann's case, as she kept her family together and fed, her resolve was strengthened—a resolve that would be tested again and again.

When she and the family moved to New Jersey a few years later it meant a new start. It was both exciting and relieving when Alexander found work almost immediately at the Novelty Rubber Company in New Brunswick. By 1860 father Alexander and fifteen-year-old son John worked for the rubber company making shoes, while eldest daughter Mary Jane worked in a nearby cotton mill. However, in the first of a series of family mysteries, oldest son Alex did not move to New Brunswick with the family. Instead, the then seventeen-year-old relocated to Eel, Indiana where he apprenticed himself to a master mill cabinetmaker, William Manley, while living with the latter's family.[10]

With the remainder of the family settled in one place and life now seemingly secure, there were times of happiness and celebration.

Oldest daughter Mary Jane, twenty-two-years-old, married James W. Fourcett, a cutter who worked with milling machines, in January 1861 at a small family wedding. The two met at the cotton mill where Mary Jane worked as a weaver. Alexander and Mary Ann were present when Rev. Charles Hill Whitecar, a prominent minister of the time, married the couple at the Methodist Episcopal Church on Liberty Street in New Brunswick.[11] How proud Mary Ann must have been to have her oldest daughter married and ready to start a household. On a pragmatic level, her wedding meant the loss of family income, but at the same time there was now one less person to feed and clothe. Shortly after the wedding, the young couple moved to Newark, New Jersey, some twenty-three miles to the northeast, where Fourcett's family lived. Soon their daughter, Mary Ida, was born, Mary Ann's first grandchild.

This was short-lived comfort. The joy of Mary Jane's marriage was tempered by the fact that the Civil War erupted three months later. The tensions, distrust and the rumblings of "secession," which were the hot topics of the day, along with Abraham Lincoln's election as president, finally ignited the conflagration. In April 1861 the firing on Fort Sumter initiated the "War Between the States" and disrupted nearly every northern and southern home, especially those with a man living in it. The Hamiltons were no exception. First Alex Jr. in Indiana joined Company K of the 19th Indiana Regiment in mid-April. Then in June John joined Company K of the 1st New Jersey Regiment. Their forty-eight-year-old father Alexander, finding the New Jersey Regiments filled, traveled to Pennsylvania to join Company D of the 57th Pennsylvania Volunteers in November 1861. Alexander's army service was short-lived. Six months after he enlisted he was seriously wounded by his own troops at the Battle of Fair Oaks, sent to a Convalescent Camp in Alexandria, Virginia and eventually discharged to return home. During Alexander's year-long absence Mary Ann was left alone at home with sixteen-year-old James, twelve-year-old Susan and nine-year-old Alice.

Mary Ann's sole support during the first year of the war was her youngest son, James, who worked for New Brunswick grocer

John Bromdey, who later testified at Mary Ann's pension hearing. Bromdey stated that during James' employment it was a common practice for the young man to furnish his mother with "...groceries, provision and other necessary articles for her support and comfort" and have them charged against his wages.[12]

When James left the grocer, he went to work for the Novelty Rubber Company, presumably for higher wages. It was the same company that his father and brother John had worked prior to enlisting in the army. James worked at the factory for about a year before joining the army in June 1862. According to a company superintendent, Lorin L. Platt, who also testified at the pension hearing, Mary Ann was dependent on James and he "...did habitually contribute toward her support."[13]

Yearning for adventure and despite the advice of his mother and his brother John, the now seventeen-year-old James quit the Novelty Rubber Company and joined Company F, 11th New Jersey Regiment in June 1862. From that date until her husband was sent home from the Convalescent Camp at the end of 1862 Mary Ann and her daughters remained alone, with no male presence and no dependable wages for the family. Even after her husband returned home, he was physically unable to work because of his war injuries. Since oldest daughter Mary Jane, now a new mother, had relocated to Newark with her husband, she was unable to help the family.

Although Alice, age ten, and Susan, age twelve, were still young, it was common practice at the time for many poor families to send their pre-teen daughters off to work. Although whatever they might have earned would have helped with expenses, Mary Ann instead kept them close and home-schooled the girls. In the 1860s free public education was not yet available in New Jersey, and the family could not afford the cost of private schooling. Perhaps due to her background, or perhaps due to personal conviction, it was obvious that education was something Mary Ann valued. As John wrote in his letters home during the war, he often mused over his sisters working on their lessons at the kitchen table. In a letter dated January 14, 1862, he asked his mother "... to tell Susie I

think she is improving in her writing and Alice must be a smart girl to write her name so well."[14] Mary Ann had another reason to keep the girls home: twelve-year-old Susan had "spells" (diagnosed as epilepsy, then considered a form of insanity) and was physically safer in her own home.

Like other women in similar predicaments, Mary Ann made do. In middle son John's letters home, published in *New Brunswick in the Civil War: The Brunswick Boys and the Great Rebellion*, he made numerous references stating that most of his army pay was sent home to his mother. There is no mention that his two brothers did the same, although it is likely that they did. There is also no reference to their father Alexander sending money home, although that is unlikely based on testimony taken at Mary Ann's pension hearing. Despite their good intentions, Mary Ann was unable to count on receiving money regularly from her sons, as mail and railroad theft were chronic problems during the war along with sporadic army pay. In order to compensate, she worked odd jobs at the Novelty Rubber Company, the same company where other family members had been employed before the war. Together, this maintained her until John and Alex were mustered out of the army and returned to civilian work.

Mary Ann experienced another harsh reality. Although her husband had returned home to convalesce, he had in effect abandoned the family years earlier, failing to support them in any manner after his enlistment in the army in 1861. My great-grandfather John wrote his mother that his father was anxious to purchase land in Pennsylvania. In fact, Alexander listed his occupation as "farmer" upon his enlistment in anticipation of purchasing land. While it may be true that Alexander was saving his army pay to buy land, he also had two small girls at home that needed food and support.

Shortly after his son James' death in May 1863, Alexander petitioned the Middlesex County, New Jersey Court as James' legal heir for his army back pay pursuant to "an act for the relief of such portion of the militia of this state as may be called into service" which had been approved on May 11, 1861. As a corporal James' pay scale was $14 per month, and on July 25, 1863 New Jersey issued a

voucher to his father for the pay in the amount of $48.26—a tidy sum.[15] One can't help to wonder if Alexander used this money to ease the financial burden on his family or "saved" it.

Sadly, Alexander's chronic alcoholism was a debilitating and deadly disease in the nineteenth century, as it can be today without treatment. The family doctor, Dr. Azariah Newell, testified at Mary Ann's pension hearing that he had treated Alexander for the "intemperate habit" of alcoholism as well as tended to his war wounds.[16] Mary Ann's lawyer stated it bluntly: "…for a period of nearly 4 years he (Alexander) had utterly abandoned the supporting of … his) wife and family … and was unable to provide support due to habitual intemperance during the last year of his life."[17] It is difficult to distinguish if Mary Ann's lawyer added some hyperbole regarding Alexander's condition for the benefit of the hearing. What is known is that Alexander had an alcohol problem that impacted his family, his work and ultimately, his own health.

Why would Mary Ann devote so much time and energy to someone who—as stated in the sworn testimony above—was a rascal at best? Was it her sense of wifely duties? Did she feel sorry for this now-wreck of a man she had once loved? Perhaps at the time she still thought she would make a claim on Alexander's pension? And in that case, if she threw him out of the house or divorced him, would she lose all rights to her war claim?

Her dilemma was not unusual for the time, as "Soldier's Disease," i.e., drug addiction and rampant alcoholism, was a widespread complaint after the war. Post-Traumatic Stress Syndrome (PTSS) as it is now known, and addiction to drugs weren't totally responsible for Alexander's problems. His alcoholism pre-dated his war service and his addiction to alcohol was one he battled throughout his adult life, as his 1850 conviction evidenced. Certainly, his war experiences exacerbated the problem. No doubt alcohol helped Alexander deal with pain issues from his wounds while satisfying his addiction. Today, we better understand the toll that alcoholism can inflict not only on the alcoholic but his family and the community.

When Alexander came home to convalesce and eventually die it could not have been easy on anyone. As a wife and mother Mary

Ann had a great many issues to juggle: the fatal injury caused by a minié ball slicing the legs off her youngest son at Chancellorsville in 1863, an alcoholic husband who abandoned the family only to return in need of constant care, an epileptic daughter, all combined with the stress and worry of trying to survive day to day and support herself and her youngest children.

Unfortunately, Mary Ann's situation was far from unique. Many men on both sides were severely injured or disabled during the Civil War. It is estimated that three-quarters of all surgeries or 60,000 amputations were performed due to minié ball injuries slicing and splintering arm and leg bones. Soldiers fighting on the ground were wounded in the buttocks, pelvis or genitals as evidenced by National Archive pension records filled with instances of "impotence and depression related to loss of sexual function."[18] Such problems darkened many veterans' marriages after the war.

Afflictions such as venereal disease contracted from prostitutes led to incontinence and impotence. Civil War medical historian Thomas Lowry speculated, "No one knows how many Union and Confederate wives and widows went to their graves, rotted and ravaged, by the pox that their men brought home, or how many veterans' children were blinded by gonorrhea or stunted by syphilis."[19] It was the soldiers wives who had to contend with these problems, care for their men, make accommodations and, in some cases, file for divorce if the situation became intolerable and they were unable to cope.

I have previously speculated that the court testimony for the pension hearing regarding Alexander and his alcoholism had been exaggerated, but with further research and a better history of his chronic problem, such as his previous conviction for chronic drunkenness, it has become clear that Alexander was a bit of scoundrel. Fortunately, this does not seem to have been hereditary.

In the context of the Civil War and other women's experiences, her husband's death at home was unique. Most soldiers died away from home, on the field of battle, in a hospital or from disease at a campsite. Instead, Mary Ann, having cared, supported and nursed him, now had to bury her errant husband. As her son John wrote

to her on January 29, 1864, "I am very sorry I could not have come home and seen him before he died …."And then advised her, "Don't fail to use my money to pay any expenses there will be to bury Father in good shape."[20]

Despite John's earnest request, it is doubtful that Alexander had any type of a formal funeral. Instead, as was typical for the era, the house drapes or shutters were drawn and Alexander's body was laid on display in the parlor or sitting room in an inexpensive (perhaps pine) coffin. Other than Mary Ann and her daughters, there were few mourners. Neither Alex nor John, the Hamilton sons, could obtain a furlough to come home for the funeral. Mary Ann's neighbor and friend, Mrs. Mary Hutchinson, and Lorin Platt, the rubber factory superintendent, surely made a condolence call and offered their sympathy. If any of John's or James' friends were in New Brunswick, either on furlough or having been mustered out, they would have paid their respects too, since they had a deep affection for Mary Ann, as John's letters testify.

Money was tight, very tight, and Mary Ann no doubt believed that her son John's army pay was better spent on food for her daughters or rent for their house rather than a fancy funeral and burial. There is no record of Alexander's last resting place despite a thorough record search of obituaries and death certificates, investigation of old cemeteries and research into cemeteries which have been moved due to urban renewal. It would not be surprising, however, if Mary Ann buried her husband in a pauper's grave. Money would better benefit the living, not the dead.

Indeed, there would be little or no money from her husband's estate either. Alexander died intestate, that is, without a will. While negligible in value, the estate still needed to be probated. It was usual for the person who was to administer the estate to post a cash bond with the county surrogate's office. The likeliest person to administer the estate was Mary Ann, but she was so poor that she was unable to post the $133.18 needed. Her employer, Lorin Platt, in a charitable act of kindness, posted the bond for her.[21] Mary Ann then was able to inventory her husband's goods for the court and pay off any creditors. One thing was certain, and Mary Ann held it

in common with other poor war widows: once their husbands were dead, they could not afford to mourn either in dress or everyday living. As Angela Esco Elder wrote in her article, *Civil War Widows,* "The inability to purchase proper mourning garb plagues women of lower classes. Especially during the economic hardships of the Civil War, mourning was a luxury that these women could not afford."[22]

Certainly, Mary Ann could not purchase the expensive silk black dresses or heavy veils, which the decorum of the day decreed. Perhaps, as Elder wrote, Mary Ann, like many widows who could not afford mourning attire, dyed their clothes black in order "to make them suitable. Though they were priced-out of respectable mourning rituals," women in Mary Ann's economic position "...often did the best they could to mimic these customs, even if it meant dying the only clothes they owned in a gloomy ink."[23]

Mourning etiquette also required a widow to mourn for a minimum of two and a half years, "...resign herself to God's will, focus on her children...devote herself to his (her husband's) memory."[24] In the end each widow navigated the system as best as she was able. We know that Mary Ann, while she entered a period of mourning, did not have the "luxury" to sit and do nothing for two and a half years.

Compounding the emotional losses of child and husband, the realities of life were now irrefutable. Although she did work intermittently at the Novelty Rubber Company, this did not provide enough income to support her and her daughters. Her sons' military pay certainly helped to make ends meet, but James' pay stopped with his death at Chancellorsville, and John's stopped when he mustered out of the army in June 1864. A few months later, in November, Alex also mustered out. Mary Ann was elated with the prospect of having her two beloved sons whole and on their way home, but alas, without any promise in hand of income or a paying job.

Chapter 2

A CLAIM FOR A PENSION

Mary A. Hamilton is a poor woman and not worth
more than a hundred dollars.- Lorin L. Platt,
Superintendant of the Novelty Rubber Company

Her husband's death was both a blessing and a curse for Mary Ann. On the one hand, she no longer had to nurse an invalid alcoholic husband; but on the other hand, she was totally without male support or presence—at least until her sons returned from the war. She was a woman without marketable skills alone with two small children. Her financial and emotional predicament, while not unusual, must have been difficult.

Although there are no accurate numbers, estimates calculated by historian Amy E. Holmes suggest that there may have been as many as 108,000 Northern women who had been widowed by the war.[25] Historian Angela Esco Elder ups the assessment to a more realistic 200,000 war widows.[26] The numbers are in flux due to new research conducted by demographic historian J. David Hacker who recalculated Civil War deaths for men based on a two-census method of mortality comparison, and increased the death rate by more than 20 percent to 750,000, which concurrently added another 37,000 widows to the count.[27]

What is known with certainty is that some three million husbands, fathers, sons, uncles and brothers on both sides went to war between 1861 and 1865 and almost one third, about 750,000, never

returned home. The plight of the women they left behind—women with little or no experience or skills for the marketplace—rendered them economically helpless. For many, too, their emotional support and strength died with the deaths of their husbands and sons. Like Mary Ann, many were also the mothers of minor children.

One practical solution for such women was to remarry, although there were numerous obstacles. While there were significantly fewer men in the North alive due to the tremendous loss of life of those in their teens to forties, there was also stiff competition for those men remaining from young women in their teens to late twenties who had never married, most in prime child-bearing age. Southern women, who lost an even higher percentage of men and were faced with the same dilemma, found interesting solutions. Some "cougars" delayed marriage and then married boys significantly younger then themselves, some by ten, fifteen or more years, so that they could have children and hopefully the economic support to rebuild their lives. Others relaxed their views on what constituted a "worthy" candidate for marriage.[28] In our case, there is no record of Mary Ann either having a suitor or considering re-marriage.

If not for the intervention of the federal government and the passage in July 1862 of *An Act to Grant Pensions*, many women would have been left destitute. Prior to the Civil War, veterans' benefits consisted of a changing basket of benefits. Beginning with the veterans of the Revolutionary War and continuing through the War of 1812, the Mexican War and the Indian Wars, the federal government provided warrants for free land on the frontier as a reward for service; disabled soldiers were granted half pay for life in 1776.

The first pension law based on service alone was passed in 1818; it was later modified to permit those soldiers unable to earn a living to be eligible for a service pension. By 1831 widows of veterans were added to be eligible to receive pension benefits. In total the number of those on pension rolls prior to the Civil War was small. The number ballooned dramatically after the Civil War which shifted the paradigm for veterans. Some two million Union soldiers returned home after the war to unemployment and

widespread homelessness. Many suffered from then undiagnosed Post-Traumatic Stress Syndrome, opium or morphine addictions (opiates were prescribed for diarrhea, a common ailment during the war; surprisingly, they are still the most effective treatment of diarrhea today). The large number of veterans made them a significant political force and power that was quickly recognized by the government and its leaders. Thus, even before they started returning home, the United States government dramatically added significant veteran benefits with the passage of a statute that remained the foundation of the federal pension system until the 1890s.

In addition to providing disabled soldiers with a monthly pension, the new act provided for widows and others, such as a mother losing a son, to receive a pension if those husbands or sons had died "… by reason of any wound received or disease contracted while in the service of the United States." A mother of a soldier had to prove that her son had not left a widow or legitimate child, but "… leave(s) a mother who was dependent upon him for support, in whole or in part."[29] The mother was entitled then to receive the same pension as such soldier or other person would have been entitled to had he been totally disabled. The act also specified that the pension given to a mother for her son could be the only one she received and allowed for a pension from $8 per month for a private up to $30 a month for a lieutenant-colonel.[30]

In 1860 the United States Pension Office had approximately 11,000 pensioners on the rolls and they received a total of just over $1 million a year in pensions. By 1885, pension payments had ballooned to $35 million (in today's dollars more than $908 million) for 325,000 pensioners and included not only veterans but their dependents, if they qualified. Along with the growth of pensioners, the pension office itself grew exponentially (from 72 employees in 1859 to 1,500 in 1885) trying desperately to keep current with the demand of processing applications.[31]

In late September 1864, just a few months after her son John's return to New Brunswick and probably at his insistence knowing the family's precarious financial situation, Mary Ann Hamilton hired

New Brunswick attorney Theodore B. Booraem, a well-connected Republican who had served as the tax collector for Middlesex County, to assist with obtaining veteran benefits. As a poor woman, it was a testimony to her resolve and strength (and perhaps want) that she was willing to petition the court for what might be a long, emotionally and financially draining experience. Booraem prepared a petition on her behalf for her son James' pension and presented it to the Court of Common Pleas in New Brunswick in September 1864. In it, Mary Ann signed an affidavit that declared James did not leave a widow or minor child and that she depended on him for her sole support, especially in the last two years.[32]

Why did Mary Ann seek her son's pension and not her husband's? As a widow of a disabled soldier she would have been entitled to receive her husband's pension. Alexander, too, died of wounds he received in service to his country. The simplest explanation is that since Alexander had not contributed to the household since his enlistment in 1861, it would be more practical to rely on the financial record of her son James who had, since 1861, donated regularly to the family. Besides, there were corroborating witnesses available who could testify to James' assistance to the family, as contrasted with Alexander's work records that only existed prior to the war.

According to court records, Azariah Newell, a physician and surgeon in New Brunswick, who treated Alexander for the five months prior to his death, stated that in addition to "… discharge of blood from bowels and bladder," his patient also suffered from an "intemperate habit" of drinking, which according to Newell "… rendered him entirely unfit for manual labor."[33] Alexander's physical injuries stemmed from the Battle of Fair Oaks on May 31, 1862. According to his pension records at the US National Archives, he had been wounded in the left thigh and sustained injuries to his spine and kidneys after being run over by his own troops. Eventually, he was discharged with a medical disability.[34]

Mary Ann's testimony included a statement that her husband abandoned her and the family and had refused to support them. The affidavit reads in part, "… Alexander Hamilton … died on or about

the 26 day of January AD 1864 and...for a period of about 4 years before his death, he had utterly abandoned the supporting of his said wife and family." In addition, Mary Ann testified that Alexander "...was unable, for said period, to provide any support, if he had been disposed to do so, in consequence of physical disability, of such degree as to incapacitate him for labour."[35] The latter comment referring to Alexander's war wounds and his inability to work due to the seriousness of his disability.

Taken at its most literal interpretation, it is accurate that Alexander left the family in New Brunswick in November 1861 and traveled to Pennsylvania to enlist in the army. Prior to signing up he worked in the New Brunswick rubber company, as did his son John. In his letters John wrote home to his mother it was his understanding from speaking with his father that Alexander hoped to purchase property in Pennsylvania to establish a farm. It is possible that Alexander had decided not to send money home knowing his sons James, John and Alex were already doing so. It is also possible that he may have sent some home, but there is no record of it or mention of it in John's letters.

If, in fact, Alexander did abandon his family according to his wife's statements, his son John maintained a cordial and loving relationship with him when the two met during the war. And Mary Ann certainly performed her wifely duties by caring and nursing him after he returned home. Nonetheless, there was testimony from others, including friends and neighbors, who corroborated Mary Ann's testimony as to her financial dependence on her son James. Such testimony gave her claim legitimacy and weight, although it can also be argued that the witnesses exaggerated the stories to impress the board and help advance Mary Ann's claim.

Among those who supported her claim was John Bromdey, a New Brunswick grocer. He testified that he knew the family well and that James had been employed as a clerk in his store for about two years before he enlisted. At James' request, Bromdey stated that he paid his wages directly to Mary Ann and also provided the family with flour, wood and groceries that were paid for by James. "This," Bromdey said in court, "was his [James'] constant practice while he worked for me."[36]

Mary Ann's next door neighbor, forty-nine-year-old widow

Mary Hutchinson, testified that she visited the family daily and that Mary Ann spoke on numerous occasions of her dependence on James and his assistance in her support. She stated that she "...often heard her [Mary Ann] say that without the assistance he gave her, she couldn't support herself and family."[37]

A third witness, Lorin L. Platt, one of the superintendents at the Novelty Rubber Company, testified that James had worked for him prior to his enlistment and before James worked for Mr. Bromdey at his store. He described a meeting with Mary Ann where she told him that James contributed regularly to her support. "Mary A. Hamilton is a poor woman," Platt stated, "and not worth one hundred dollars." Platt said he knew this from personal experience. Indeed, it was Platt who provided the cash bond so that Alexander's estate could be probated when Mary Ann fell short of funds. Mary Ann also worked at the Novelty Rubber Company where Platt was a superintendent so he was aware of her economic status. There is no formal record of Mary Ann's employment, but Platt's statement that she worked "more or less" verified the fact that her employment was borne of necessity and probably provided a small, part time income. Platt added that his "general impression and belief ...was then, and still is, that...Mary A. Hamilton was dependent on her...son James and that he did habitually contribute toward her support."[38]

Between Mary Ann's initial petition filed in late 1864 to November 1865, when the last testimony was collected, her claim was completed and presented for consideration. Attorney Booream was successful in proving her claim and the Pension Office admitted it on November 16, 1865, awarding her James' pension retroactive from his death on May 3, 1863. (Alexander had petitioned the court earlier for his son's back pay and had received it). The pension consisted of $8 per month with a retroactive amount of $140, a significant sum that would help with food and rent for the family.

By some estimates, the time frame for Mary Ann to obtain a pension was quick. At the start of the pension process some widows believed that there were "...serious obstacles, and the interposition of needless and burdensome formalities, in the prosecution of a just claim for a pension." The pension commissioner argued in

return that if claims were complete, they would not be delayed by more than two months. Claimants wanted swift action; in many cases, without a pension they faced the prospect of starvation for themselves and their children. As the war years progressed and claims increased, the federal pension office became swamped with requests and its staff grew proportionally.

Some of these claims lingered unresolved for years due to difficulties in obtaining evidence. From the documentary evidence needed to process a claim, it was a lengthy and sometimes arduous process of locating witnesses, deposing them and writing affidavits. Then the affidavits had to be signed, witnessed and presented to the court. Most women needed an attorney to navigate the legal maze and, Mary Ann, although poor and with very limited means to pay an attorney, was no different.

Perhaps this is where the funeral money went that John sent to bury his father. If so, it was a good use of money. Once Mary Ann received the pension, she had assurance that her children would eat. Coupled with John and Alex's contributions to the household on their return home and her part time employment, the family made ends meet. With the granting of a pension for Mary Ann, better times had finally arrived.

THE HAMILTON FAMILY GROWS

Mid pleasures and palaces though we may own,
Be it ever so humble, there's no place like home.
– "Home Sweet Home" by John Howard
Payne and Sir Henry Bishop (1823)

Though she was pained from the loss of her youngest son (and perhaps even by the death of her rascal of a husband), Mary Ann was relieved and overjoyed at the safe return of her two older sons, Alex and John, from the terrors of war.

John was mustered out in June 1864 and immediately returned to New Brunswick. Alex, who was mustered out in November of that year, made the decision to forsake his apprenticeship in Indiana, so he also returned to New Brunswick to help his family. It was undoubtedly a tearful yet joyous reunion for their mother, since she had not seen Alex for six years or John for three years. They had left home as boys and returned as men who had experienced and seen far more than they ever expected. More important, despite the far-reaching horrors of the war, they were not physically maimed nor disease ridden. Their homecoming was also an economic blessing: John returned with the $70.86 he received when he was discharged, a windfall in 1864, which would go a long way in paying the rent and food bills and perhaps even allowing a few small luxuries given the deprivations caused by the war.[39]

Now with two young men at home, Mary Ann had hope and a small respite from want, knowing her chances of a stable family income had been greatly increased. It seemed likely that both boys went to work at the Novelty Rubber Company where they

had ties—John as a former worker, and Mary Ann, who had been supported by the testimony of factory superintendent Lorin Platt.

The day-to-day horror of the war slowly receded as the returning soldiers acclimated to home life. They bore the scars of violence and the death of friends and family. Some carried the mark of war externally, others internally, while others suffered in both ways. Their chief desire was to reenter life after their long separation from family and friends, but like many soldiers it was difficult to tell stories to a civilian populace that could not relate to the horrors of the battlefield. Working with old friends at the rubber factory—some of whom were compatriots from the war—made reentry easier. Part of the healing, if it can be called that, was undoubtedly helped by the news of General Lee's surrender in April 1865, an event that essentially ended the war.

Although John and Alex's sister Mary Jane was married and living in Newark with her husband and young daughter, she stayed in touch with her brothers through letters they exchanged during the war. Unfortunately, those letters, if they still exist, have not been located. In the heat of battle, as John related in letters to his mother, knapsacks were lost or misappropriated by other soldiers who stumbled upon them, some of which were undoubtedly stuffed with letters from home.

When the brothers returned home there were many opportunities to visit their sister, since Newark was only twenty-three miles from New Brunswick. Traveling in 1865 was a somewhat challenging endeavor, dirty and often dusty, even if you had a horse. Although there were no paved roads, there was a developed train network in New Jersey, and Newark was a short train ride away. Hopefully there were many occasions for them to visit and for the brothers to get to know their young niece, Mary Ida. But tragedy suddenly struck when Mary Jane took ill with an infection, a common occurrence for the times. We do not know if the infection was precipitated by childbirth or something more mundane, such as appendicitis, but it progressed insidiously and rapidly. Despite medical intervention, there was nothing to be done for her, and tragically she died just a few days before Christmas in 1865 at the age of twenty-seven.

Her death certificate listed 'peritonitis,' an inflammation of the abdominal cavity membrane, as the cause of death.[40] Resulting from a rupture, such as appendicitis or a peptic ulcer, or as a by-product of childbirth, the massive infection almost always led to death. Without the intervention of antibiotics, which would not make an appearance for seventy more years with the discovery of sulfonamides, the first antibiotic used systematically—there was no hope. Peritonitis was a common cause of death in the nineteenth century.

Even in a world where death was commonplace, it can easily be imagined how overwrought Mary Ann became with her daughter's untimely demise. In just two short years she had lost her seventeen-year-old son, her oldest daughter and her husband. The heartbreak of knowing her beautiful four-year-old granddaughter was now motherless was excruciatingly painful as well. Mary Ann's son-in-law William Fourcett remained in Newark with her granddaughter for a few years. They lived with his extended family, but William soon remarried and moved his new family to New Haven, Connecticut.[41] It was another blow for Mary Ann, and she would not see her first grandchild again.

Perhaps it was the unpredictability of life and the experience of the war that led Alex and John to think about stability and starting families of their own. The young men were probably making a decent wage to consider marriage, as well as providing financial assistance to their mother. According to the New Brunswick City Directory of 1867 both men were working as carpenters. As mentioned in a study compiled by the conference on Research in Income and Wealth, an average daily wage for carpenters at the time was about $2.90 or $17.40 for a six-day week.[42]

Just three years after his homecoming, John married Lydia Jane Howland on August 27, 1867 at the First Presbyterian Church in Red Bank, New Jersey. The marriage certificate recorded that Reverend Charles E. Hill performed the ceremony and that Mary Ann was in attendance. Although we don't know how the couple met it was likely through mutual friends. Apparently they had a robust and passionate courtship, as Lydia, known as Lida, was seven

months pregnant when she was married—a bit of a scandal at the time. It appears that her parents did not approve or even know of the wedding. On their marriage certificate the couple listed their residence as Jersey City—a bold lie—and although Mary Ann's name is given as John's mother, two fictitious names were provided for the bride's parents.[43] Lida, a well brought-up young woman, was no doubt embarrassed by the circumstances. The couple's first child, Minnie, was born in October.[44] Despite the scandalous aspect of the marriage, the birth was an occasion of great joy for Mary Ann. She had a second grandchild, one she could visit anytime in New Brunswick since John was settled there.

Lida's parents, the Howlands, were a humble but well established family in Shrewsbury, Monmouth County and some twenty-four miles southeast of New Brunswick. Her father, Hartshorne "Harts" Howland was a fisherman who could trace his ancestry to Henry Howland of Plymouth, Massachusetts, brother to John Howland who had arrived on the *Mayflower* in 1620; Henry had arrived the following year.

The year after John married, Alex married Elizabeth "Lizzie" Gilliland, a Scots-Irish immigrant like Mary Ann, whose family had emigrated to the United States to pursue a better life.[45] Born in 1842 in Ireland, at the start of the Great Famine, Lizzie left the country with her father, mother and four siblings in 1851 at the age of nine. Her father, Samuel, was a weaver.

The Great Potato Famine, *An Gorta Mor* in Gaelic, was especially hard on the poor. Most of the Irish population subsisted only on potatoes, a single crop that nourished entire families. When the infestation blight occurred it destroyed more than 75 percent of the crop. More than 700,000 people died as a result of the famine (from disease, malnutrition and, of course, starvation) and more than half of Ireland's residents immigrated elsewhere, mostly to America, among them the Gillilands.

The family arrived in New York City—the major gateway for immigrants—on July 16, 1851 and Samuel quickly discovered that the slums of New York were swarming with prostitution, drunkenness and thievery. It was far from an ideal place to raise

a young family. Looking to the southwest, the family moved 52 miles to New Brunswick, a world of difference from overcrowded lower Manhattan. They settled in the manufacturing hub, where Irish and German immigrants before them had found decent pay working in one of the city's many thriving factories. By 1860 the Gilliland family was fully employed: father Samuel worked as a day laborer while his daughters, Mary J., Catherine and Lizzie worked at the rubber factory.[46] It was there that Lizzie met the Hamilton men: father Alexander, John, James, and later Alex when he settled in New Brunswick.

When John returned to the rubber factory with Alex after the war, John introduced his big brother to his factory friends. Alex, like the other Hamilton men, made an impression: he was lanky, and over 6'2" with dark hair and grey eyes. He was a war veteran who had fought valiantly and risen through the ranks of sergeant to become a provost marshal, a highly regarded post. Twenty-three-year old Lizzie was no doubt taken by his bearing and character. He met her parents, her brothers and sisters and eventually asked her father if he could court her. The twenty-eight-year-old carpenter proposed, Lizzie accepted, and the two were married on January 18, 1868 at the First Methodist Episcopal Church on Liberty Street in New Brunswick. The wedding was officiated by the pastor, Reverend A.V. Lawrence, and the young couple's parents and families were probably present for the happy occasion.

John and Lida were growing their small family in the meantime. A second child, Laura, was born in 1869 and the parents and children settled into a small home at the corner of John and New Streets.[47] While her boys were flourishing, Mary Ann had more challenges at home. Her now twenty-one-year-old epileptic daughter Susan was in a state of depression. She had episodes of violent crying and Mary Ann believed she also experienced instances of "self-abuse." In the nineteenth century the phrase "self-abuse" was a euphemism for masturbation, which was thought to lead to disability, insanity and even death. Reluctantly, Mary Ann decided to take Susan to the New Jersey State Hospital in Trenton,

a "modern" hospital advocated by reformer Dorothea Dix that practiced "compassionate care" for its patients.

For Dix compassionate care was a philosophy that freed the insane from chains and barbaric treatment. Based on a model of treatment developed by French psychiatrist Phillipe Pinel, "moral treatment" supported the idea that people should be treated as patients, rather than animals or criminals. During a stay in England years earlier, Dix also learned of York Retreat, a hospital for the insane founded by Quakers, a place that promoted kindness, patience, recreation and conversation as a means of humane and moral treatment for its patients. When Dix returned to America, she promoted and advocated these "new" hospitals for the insane, and the New Jersey State Hospital was founded as a result.[48]

Placing Susan in the hospital was a heart-wrenching decision that must have traumatized Mary Ann to a great degree. Epilepsy was not well understood in America, although advances in its neurology and treatment were starting to be made in Europe. For centuries those with epilepsy were treated with fear, and sufferers endured enormous social stigma, often being treated as outcasts or as insane. In fact, by 1880 the United States had created "official categories of insanity," one of which was epilepsy.[49]

George Man Burrows, an English general practitioner from the first part of the nineteenth century who devoted himself to the treatment of insanity, wrote about epilepsy in his treatise "An Inquiry into Certain Errors Relative to Insanity and Their Consequences." He stated, "...if an early death do not supervene, the malady induces demency (demented condition), idiotism and incurable insanity."[50] Information on Susan's condition and incarceration at the asylum was found in her medical records from the New Jersey State Hospital. Susan had suffered from epilepsy since childhood, although her mother told the medical staff at the hospital that she no longer experienced "fits." Her mother also reported that in 1867 her daughter had a "queer spell...and (had) not been entirely well since." According to the admission records of the hospital, Susan was depressed, cried, "....violently at times," was "inclined to be alone, said she had no friends" and "seldom speaks rationally."[51]

She was admitted to the hospital in November 1869 as an indigent, or non-paying, patient. From Mary Ann's perspective, bringing her to the hospital was an act of kindness and mercy. Many ill and depressed people simply were locked away in attics or basements, or warehoused in almshouses to waste away and die. Almshouses were houses for those who were indigent, who were without family or whose family could not care for them. Although founded with good intentions, they were houses of horror where little or no care was provided. The New Jersey State Hospital, on the other hand, was a "progressive" and humane hospital, a great improvement on the housing of the mentally ill in earlier decades.

In an 1843 report Dix stated that the status of insane persons was "in cages, closets, cellars, stalls, pens! Chained, naked, beaten with rods and locked into obedience." Dix knew what she was talking about since she had visited dozens and dozens of almshouses and prisons throughout New England documenting the status of the "insane."[52] By today's psychiatric standards, Susan might have been identified as severely depressed although there isn't enough data from the available records to give an adequate diagnosis. Yet because depression and epilepsy were so little understood in the mid-nineteenth century, Susan was judged to be "demented."

From a sampling of the literature it is evident that "madness" or mental disorders were vaguely and often arbitrarily defined in the nineteenth century, so it is not surprising that the basic civil rights of those deemed "insane" often were violated. In their article, "Lunacy in the 19th Century," authors Katherine Pouha and Ashley Tianin wrote, "The symptoms qualifying a woman's need for admittance during these times would be considered controversial in the present day. Symptoms such as depression after the death of a loved one, use of abusive language and suppressed menstruation meaning the end of a menstrual cycle, would not be acceptable reasons for admittance to a mental institution today," but they were in the nineteenth century. "Diagnosis such as epilepsy and nymphomania were not looked at as diseases but as bouts of insanity," the authors added.[53]

Certainly, the death of both her father and brother in the Civil War were cause enough for depression. There was no doubt that

Susan was ill, but we don't know if her illness stemmed from a physical, neurological or emotional cause or a combination therein. Once Susan was admitted into the hospital on November 12, 1869, Mary Ann likely helped her daughter settle into her new environment before returning home to New Brunswick. To some extent Mary Ann was satisfied that she was doing the best thing. Susan, she believed, would receive good care and was in the best hospital of its kind in the state. Hopefully, her daughter would return home someday soon. Perhaps that was all a mother in those days had—hope.

Chapter 4

DEATH VISITS AGAIN

If you get very sick, let me know at once...
- John Hamilton in a letter to his
mother dated April 1864

The new year of 1870 promised some happiness for Mary Ann. Susan was in a caring hospital and her youngest daughter, eighteen-year-old Alice, was about to be married. While there is no documented work history for Alice, she likely had a job, like her older sister Mary Jane, who had worked at the cotton mill since age sixteen. It was critical that everyone who could work in the family did, and Alice's salary, however small, would have helped with food and rent.

Perhaps it was on one of Alice's trips to purchase food for the family that she met her soon-to-be husband, twenty-one-year-old Meiller (also spelled Millar/Miller) Voorhees Boudinot, a New Brunswick butcher and the oldest son of a large family. A mutual friend may have introduced the two or they may have met at a church social—two practices which were a common and approved way for young people to meet in the day. However they met, the couple were a love match as evidenced by a note Miller wrote to Alice just before their wedding; it was also a relationship unknown to Mary Ann, at least initially.

Discovered in 2016 at the bottom of a box of old family photographs by my cousin Gene and his wife Cathy Tunney, the well-preserved note was probably written in December 1869 and it discussed the arrangements Miller made for the happy day. "Everything is ready," he wrote, "and I hope it wont [*sic*] be long before I can call you by the endearing name of wife." Miller also

urged Alice to procure the consent of her mother for the marriage because as he wrote, "It seems bad to deceive Mother [since] she soon will be my mother in law."[54] While we do not know if Alice asked and received her mother's consent and blessing, on January 4, 1870 she and Miller were married at the First Methodist Episcopal Church in New Brunswick on Liberty Street and neither her mother nor Miller's parents were in attendance, according to the marriage record.[55]

Any difficulty in the relationship between mother, daughter and son-in-law was mended because, according to the 1870 U.S. Census, the young couple lived with Mary Ann at George Street, north of Hamilton Street, in close vicinity to Rutgers College.[56] Young couples often lived with their in-laws and Mary Ann was pleased that her daughter was still in the house with her. As the months passed all seemed well, until Mary Ann became ill. It was a frightening prospect to a family when their foundation—such as a mother that held the family together, became ill. Mary Ann was only fifty-five years old, but weary and tired in spirit. Like many women of the time, she had endured much. We can speculate that perhaps her heart gave way or she developed cancer.

Unfortunately, records are scarce for this time period. Despite a thorough search, no death certificate, newspaper obituary or gravesite records for Mary Ann could be found. Yet, on September 16, 1870 her oldest son Alex filed a bond and letter of administration with the Middlesex County Surrogate on behalf of her estate.[57] Since such filings usually occurred shortly after death, and since Mary Ann was alive on August 8 when the United States Census was dated, we can be sure she died after August 8 and before September 16. It is most likely that she passed away sometime in the first two weeks of September 1870 as the family would have wanted to settle the estate as soon as possible.

In his affidavit, Alex swore that Mary Ann did not have more than $48 to her name, a statement bolstered by factory superintendent Lorin Platt's affidavit made for the pension hearing several years earlier.[58] For the Hamiltons it was a very sad time. Mary Ann was not only the matriarch of the family, she was the one who united

the family through their difficult transient years in New England as they moved from Massachusetts to Vermont to New Hampshire and then back to Massachusetts, subsisting on her husband's pay as a shoemaker.

She had cared for her babies and young children before they were old enough to go to work. She saw them through the lean war years, preparing "care packages" for her sons and writing weekly letters. She was there for each of her children: for Susan who she kept home and home-schooled and cared for during her young daughter's illness; for Alice, who she had also kept home and from work for as long as possible, and for Mary Jane and her granddaughter Mary Ida whom she adored. She encouraged her sons, too: for Alex who traveled to faraway Indiana to realize his dream of becoming a cabinet maker; for John who she worried about during his three year absence from home in the army and for her "baby," headstrong James who went to war against everyone's advice and paid the ultimate price. Her love and steadfastness bound the family together and her children loved her dearly.

Mary Ann was selfless and devoted to her family. We know from John's letters to his mother during the war that she spent any money he sent her—not on herself, but on necessities. "Dear Mother," he wrote to her in April 1864, "I want you to use the money I send home for you and girls. When I come home I don't want to find out that you could have used it for your comfort and had not done it. If you don't do anything less with it, buy good things to eat and buy the best of porter [a style of dark beer] for yourself to drink."[59]

Later, in the same letter, he urged his mother to tell him if she was ill: "Dear Mother, if you get very sick let me know at once and if there is any possible way for me to get home to see you without deserting, I will come."[60] There is nothing to tell us if Mary Ann had a short illness such as a stroke, or a lingering disease or a cancer, but it is likely she died at home, since hospitals were few and far between. Typically, there were many diseases which affected the American population in 1870, including infectious diseases such as typhoid, cholera and influenza; chronic diseases such an anemia; tuberculosis; cancers and many more. Any of these could

be fatal before the discovery of antibiotics, the implementation of hygienic water supplies and the construction of sanitary sewers and treatment systems.

Before the twentieth century care for the sick took place mainly at home. According to Linda Whitfield–Spenser in her 2011 dissertation on hospitals in Middlesex County, New Jersey, "The female in the household administered to the sick using remedies handed down through the generations. Only the rich and middle class," she added, "could afford doctors and there were few hospitals before the early 1900s."[61] There were no hospitals in New Brunswick to care for the sick in 1870, only the New Brunswick Almshouse and surely Mary Ann's family would not allow her to go there. Mary Ann had her married daughter Alice as well as two devoted daughters-in-law to nurse her at home. There was also the availability of a local doctor who made house calls, that is, the doctor went to visit his patients and not vice versa. His black bag carried available drugs and instruments to assist him in his attempt to aid those who were ill.

The almshouse, a local house where the sick, poor, unwanted and insane were warehoused, was the only source of government aid to the poor sick, like Mary Ann. Other residents in an almshouse typically provided medical care, or what passed for it. Sometimes the city contracted with a local physician to make visits. Unfortunately, most of these almshouses were filthy and unsafe and, in effect, death traps for the poor who lived there. During the late nineteenth century the inadequacy and high mortality rate of the almshouse led to the establishment of hospitals to care for the deprived sick.[62] It would take another fifteen years for the first hospital to be established in New Brunswick—New Brunswick City Hospital—but it would be too late for Mary Ann.

It is comforting to imagine that Mary Ann, at home in her own bed, had time for her family to gather round her, time to say good-bye to her family and they to her, a last time of embraces, well wishes and expressions of love for the family. With her death nothing would be the same; yet, it would be the women in the family who kept her spirit alive. Miller and Alice remained in the

house after Mary Ann's death and in November their daughter, named after Mary Ann, was born. That same year, Alex and Lizzie had a second daughter, Beth. The two brothers worked together, and their families lived together on Mine Street near College Avenue from 1870 to 1871. It was as much a marriage of trades as convenience. By 1870 the men had left the rubber factory and John was working full time with Alex, apparently having learned the carpentry trade from his older brother.[63]

In some respects it seemed to be a prescient move, at least temporarily. By 1873 the American economy had settled into a deep economic depression. Known as the Long Depression, or Panic of 1873, factories laid off workers, banks failed, railroads went bankrupt and businesses closed. At first, the carpentry trade was not impacted, but eventually it too was also hit since much building construction was halted. The downturn lasted for the next six years and changed the lives many Americans.

Like the Great Depression of the 1930s, the Panic affected each strata of society including hard-working families like the Hamiltons. The State Labor Department of Pennsylvania commented that "Never in the history of the country has there been a time when so many of the working classes, skilled and unskilled, have been moving from place to place seeking employment that was not to be had."[64] Many poor people were forced to rely on help from charities. The New York Society for Improving the Condition of the Poor, founded in 1842 with the aim of helping the "deserving" poor and providing "moral uplift," saw a dramatic and sharp increase "from 5,000 families on relief in 1873 to 24,000 in 1874 and an average of more than 20,000 during the later 1870's."[65]

In the midst of this economic uncertainty, the brothers' families were growing. John Jr. and Edna were born to John and Lida in 1872 and 1873; daughters Jennie, Lizzie and Alice were born to Alex and Lizzie in 1870, 1871 and 1872, respectively, and Alice and Miller had a son, William in 1871. Despite these joyous events, unemployment was growing and people were clinging to what little funds they might still possess. To economize on expenses,

Miller and Alice were living with his brother, William, a New Brunswick policeman, at 45 Shureman Avenue.[66]

There were more unsettling events to come for the family. Hospital records indicate that officials discharged Susan from the New Jersey State Hospital on December 1, 1873.[67] The hospital records gave no indication why she was removed nor are there any other records that could be located to explain the action. She was an indigent or non-paying patient in a state-run facility, so money could not have been the issue. One possibility is that her family decided to care for her at home, although Alex, John and Alice all had small children who might pose a concern. Another possibility is that the family had found another location for Susan, somewhere closer to New Brunswick, so they could visit her—possibly as a boarder in a home. There was still another alternative: perhaps her younger sister Alice wanted to spend some time with her before she and her husband moved.

Alice and Miller Boudinot were the first to be impacted by the Panic. It is likely that the butchery industry was hit hard by the depression; people had less money to buy meat when money was tight. Prior to 1856 the Boudinot family had lived in Michigan and Wisconsin, where two of Miller's siblings had been born (one in each state). Perhaps there was a desire to return to a place where his family had lived, and Detroit, then a fresh, exciting, "new" city renowned for its wide boulevards, beautiful trees and public parks, beckoned the young family. In late 1873 the Boudinots left New Brunswick for Detroit and Alice said good-bye to her beloved brothers, her sister Susan, and her sisters-in-law, along with nieces and nephews. Detroit was a young, upcoming city, despite its founding as a frontier outpost for the fur trade back in 1701. The city had grown quickly and become a center of commerce due to its location on the Canadian border and its proximity to the Great Lakes. It was a city of about 101,000 people in 1874.[68]

The family quickly settled in while Miller looked for work as a butcher, but work was hard to find. Having no friends or relatives in Detroit to help in introducing either of them to shopkeepers or business people, Miller had to search for work for months. It was

a stressful time for the family, and adding to this was the arrival of their second son, James, in March 1874. Sadly the infant died within four months.[69] Like many newborns of the era, the chance of early death was frequent. Alice, newly separated from her family and friends, with the additional anguish of losing her baby while her husband was still unemployed, undoubtedly felt crushed. There was no family, other than Miller, her very young son William and daughter Mary to comfort her.

Finally, hearing that the city was looking for police officers and knowing something of police work through his brother William in New Jersey (law enforcement requirements being somewhat lax in those days), Miller applied to the Detroit Police Department, which was expanding along with its city's population. He was hired and assigned to the 9th Street Station, a relatively new police location created to service the west side of the city.[70] Located on Trumbull Avenue near the intersection of Michigan Avenue and Church Street, the two-story brick 9th Street Station opened in 1873 to accommodate the ever-growing city. By 1877 the city had grown to 125,000 people, and Millar was one of about 150 police officers citywide. He cut a dapper figure—as noted by early Detroit photographs—dressed in his woolen uniform of a double-breasted long jacket with gold buttons, badge, and a high helmet with a circular brim.[71]

With Miller's secure job providing some relief, Alice and Miller now felt that they could write home extolling the virtues of Detroit. Alex would have been particularly interested to learn that furniture manufacturing was one of the fastest growing industries in the city, and Alice would have told him about the large quantities of mill cabinetry work being done in Detroit, Grand Lodge, Monroe and Holland. Neighboring Grand Rapids even earned the nickname of "The Furniture City."[72] With the expanding industry on the lookout for talented craftsmen, Alex, an accomplished carpenter, who was born with a streak of wanderlust, needed little more incentive to move his family to Detroit.

Within three years of Alice and Miller moving to Detroit, Miller left the police force after he found work as a butcher, his

true vocation, as opposed to the rough and tumble life of a street "cop."[73] The next year Miller and Alice moved to 90 Grand River Avenue, just off Woodward Avenue and two blocks from Grand Circus Park, where their daughter Cecelia was born in 1878.[74] That same year, Lizzie and Alex and their children joined them in Detroit. Undoubtedly, the couples were delighted to see each other after their long separation.

Life was good. Alex found work in the furniture trade almost immediately and the two families, reunited at last, enjoyed the beautiful new attractions the modern city movement was providing to its residents. There were magnificent free parks such as Recreation Park, which ran from Brady Street to Willis Avenue in the center of the city. It included a baseball field which was home to the National League's Detroit Wolverines from 1881 to 1888.[75] Water Works Park boasted a 185-foot minaret-like tower that helped to provide the city's drinking water supply as well as act as an observation tower that visitors could climb to view the park below and Windsor, Canada to the east, just across the Detroit River. Eventually Water Works Park encompassed one hundred acres with swimming and picnic areas, play equipment, baseball diamonds and a library. It was also a popular location with fishermen.[76]

Detroit offered many attractions to help occupy families' leisure time, if indeed they had that luxury. The Detroit Women's Club was organized in 1873, although it is doubtful that either Lizzie or Alice had time for such a pursuit with six small children between them. As the wives of a butcher and a carpenter, they also belonged to a far different social stratum from the members in the sophisticated and proper organization.

The following year Lizzie and Alex's daughter Annie was born. Although the house was ready to burst at the seams, it's easy to imagine that Alex and Alice missed John and his family, who remained in New Jersey. Alice most likely wrote to John to tell him of the beauty of the city; Alex most certainly told him jobs for carpenters were plentiful.

There was nothing to keep John in New Jersey. Their mother was gone and their sister Susan, who had been discharged three years

earlier from the State Hospital in Trenton, was apparently re-admitted in 1876.[77] A record for a Susan Hamilton was located for that year although there is no confirmation that it was actually John's sister since the registry book for that time period is lost. Perhaps Susan's condition grew worse or she could not be cared for outside the hospital so she returned. Unfortunately, despite a thorough search no records exist to her definite whereabouts. There is, however, evidence that Susan Hamilton did not die at the hospital, since she is not listed in the hospital burial records. Also, at the time it was a popular tradition to name children after deceased relatives. The fact that no Hamilton child was named Susan is evidence she likely was alive during the births of the children up until at least 1889 when the last Hamilton daughter was born.

An alternative possibility is that she may have been transferred years later, in 1898, to a new facility founded for epileptics called the New Jersey Village for Epileptics at Skillman in Montgomery Township, just eighteen miles from Trenton. By the late 1800s epilepsy was beginning to be recognized as a seizure disorder, and not insanity, and patients for the village were culled from asylums and prisons throughout the state.[78] There are limited records available for the village and New Jersey privacy restrictions did not permit me to investigate fully if Susan Hamilton was a patient there (even though I'm a relative over a hundred years later). Perhaps we will never know what happened to Susan, but her story and her institutionalization represent what occurred to many women who were categorized as insane until medical advancements caught up with their disorders.

With Alex in Detroit, John struggled to survive working as a sash and blind maker in New Brunswick.[79] Lida and John's third daughter, Ida, was born in 1877 and early the next year the family finally made the move to Detroit. Their oldest daughter, Minnie, who was twelve years old, did not make the trip with them. Instead, Minnie stayed in Long Branch with Lida's sister, Maggie Howland Asay, her husband, Walter Asay and their young son, Walter Jr. Maggie died in 1879 and Minnie almost certainly was a great help to Walter Sr., acting as an older sister to Walter Jr., and Laura

Howland, age sixteen, another relative who lived in the household. We have no record of why Minnie decided to stay other than she was at an age where independence and rebellion often appear. In August 1878 there was more news. Alice and Miller had another child, a son Frank, but unfortunately, the baby died at two months old. Happily, the John Hamiltons family increased later that year with a son, Sylvester, being born in November 1878.

John found work quickly with Alex's help and all seemed to go well. Another son, Walter was born to Lida and John in October 1881 as the family settled into their life in Detroit. Then, without warning, a family tragedy struck: in May 1881, little ten and one-half-year-old Mary Ann, namesake of her grandmother, became ill. She suffered from dropsy, an old term for the swelling of soft tissue due to an accumulation of excess water. The cause could have been congestive heart failure, systemic diseases, an insect bite or even dermatitis. There is no way to know what caused the serious symptoms in Mary Ann but she died on May 12, after lingering for several weeks.[80]

Although they lived in an age where death was always lurking, the depth of Miller and Alice's grief must have been excruciating. Mary Ann was their first born. A few short years before, her parents suffered the death of their infant son James. To bury Mary Ann too was beyond heartbreaking. The grieving was far from over when tragedy struck again—Miller died suddenly in June 1882. (Despite a thorough search, there is no death certificate or record of his death though years later his daughter Cecelia spoke of his death in Detroit). He was just thirty-three years old, in the prime of life and was about to become a father again. He may have had an accident, a heart attack or been taken by a fast-moving disease, all too common at the time. As his daughter Cecelia stated years later, his death was "untimely" and, of course, extremely life-altering to Alice and the children as well as to his brothers-in-law and extended family.[81]

Alice possibly felt as if a curse had been placed on her family. Her two children, one named for her youngest brother James, who had died at Chancellorsville in 1863, and one named for her beloved mother, were both dead. And now her husband was gone. Her mother,

too, had buried a husband and a son. In a manner of speaking her mother also lost a daughter when Susan entered the hospital. Now Alice was experiencing a similar trauma. Distraught, disheartened and nine months pregnant, Alice could not support herself and their children without Miller's income. Despite the growing numbers of women wage workers, "Women in the late 19th century," according to *Past and Promise: Lives of New Jersey Women,* "were expected to marry and devote their mature lives to the nurture and care of their families and homes."[82] Marriage meant economic security, too, and the death of a husband changed the paradigm. For Alice, who had no marketable skill or trade, Miller's death translated to poverty.

Her brothers Alex and John, although apparently gainfully employed, struggled to make ends meet with five children and seven children, respectfully. Alice made the only decision which made sense: she decided to return to New Jersey with children Cecelia, five and William, ten. As nice as Detroit was, she knew her home state better, felt comfortable there, and besides, Miller's family lived in New Jersey. Her brother John, however, was quite concerned for her, since she was a young widow with two small children who was about to have another child. He knew she was vulnerable and he wanted to be able to protect his youngest sister, so he decided to return to New Jersey with her as his wife's family still lived in Monmouth County, New Jersey, just south of New Brunswick. It was not a simple decision. Having uprooted his family to move to Detroit, a long, tiresome and costly journey, John now had to move the family back to New Jersey.

The prospect of seeing family again was a strong motivating influence. Despite the mysterious circumstances of John and Lida's marriage, Lida's mother, Deborah Howland Sutephin, would surely welcome her daughter and grandchildren, several of whom she never met. Her deceased husband's disapproval of the marriage was no longer an issue, and Lida could expect a warm welcome. And, of course, Lida and John would be reunited with their daughter Minnie in New Jersey. The two families, the Hamiltons and Boudinots, brother John and sister Alice, were changed by tragedy. They left Detroit with tearful farewells to Lizzie and Alex and their children. They did not know it at the time, but it was a fateful decision.

THE RICH AND THE WORKING POOR

"More money and more people than can be counted
spent summers here (in Long Branch)."
- Long Branch in the Golden Age: Tales of Fascinating
and Famous People by Sharon Hazard

In the last few decades of the 19th century, Long Branch, New Jersey evolved into a posh resort for the rich and famous. Wealthy patrons from New York and Philadelphia traveled on luxurious Pullman Palace Train Cars, which had dining and sleeping areas, or by steamer to Long Branch. The ocean community quickly became a fashionable watering hole where lavish hotels, racetracks, theatres and gambling casinos crowded the streets. Blessed with a temperate climate and wide, pristine beaches, the wooden Ocean Pier or boardwalk adjacent to the beach became a popular promenade "to be seen" and "to see."

Seven United States presidents lived and vacationed at Long Branch including James Garfield (who came to the city in hopes of recuperating after an assassin's bullet felled him in 1888), Chester A. Arthur, Ulysses S. Grant, Benjamin Harrison, Rutherford B. Hayes, William McKinley and Woodrow Wilson. Well-known actors and writers flocked to the seaside resort to entertain and work in what would be known in later years as the "Hollywood of the East." Lillian Russell, a famous actor of the day, joined the likes of Edwin Booth, the great Shakespearean actor and brother to the infamous John Wilkes Booth, assassin of Lincoln. Artist Winslow Homer, a frequent vacationer, portrayed Long Branch in many of his

paintings; writers Robert Lewis Stevenson and Bret Harte were also visitors. John Philip Sousa, world famous composer and conductor of the United States Marine Band, often played at Long Branch. Even Buffalo Bill Cody and his Wild West Show performed for the vacationing Astors, Drexels and Vanderbilts, scions of the Social Register, prominent American and upper class moneyed families.[83]

The old moneyed families of Philadelphia and New York met the new moneyed families in Long Branch. Flamboyant "Diamond" Jim Brady, who made his fortune in outfitting railroads, wore some of his assets in diamond jewelry and was often seen touring about town in one of his large automobiles with his girlfriend Lillian Russell. Diamond Jim, as his sobriquet suggested, sported diamonds wherever he went. "Jubliee" Jim Fisk, owner of the Erie Railroad, was also a nouveau-rich social climber. Fashioning himself as "Colonel" for being the nominal commander of the 9th New York National Guard Infantry Regiment, he had bought himself the military title to ease his way into the social hierarchy.[84]

There were scoundrels, too. A parade of con men frequented the area, where money was as common as saltwater. From the rascally local hack drivers who carried visitors who arrived by boat or train and overcharged their patrons, to an extravagant gold-digger named Josie Mansfield, money was the ingredient that fueled passions. In fact, there was so much money concentrated in Long Branch during the summer resort season that a branch of the New York Stock Exchange was located on the ground floor of the Rothenberg Hotel at the corner of West End Court and Ocean Avenue.[85]

Josie Mansfield played the femme fatale in a lover's triangle between Jim Fisk and Edward Stokes, friends and business partners in a refinery, as both men competed for her affections. After several years of fighting, Stokes finally shot Fisk dead. Three years earlier Fisk had attempted to corner the gold market with his friend Jay Gould. Their venture was a financial disaster and caused the Black Friday Panic of 1869.[86]

One of the chief recreations at Long Branch was gambling, either in the casinos or at the racetrack. The Monmouth Park Race Track opened on Sunday July 31, 1870. It could seat 6,000 and,

although ladies did not frequent gambling houses, their attendance at the racetrack was considered acceptable behavior.[87]

Long Branch was also home to a vast array of working people who maintained and serviced the dozens of mansions, ornate homes and hotels where visitors stayed. Lida Hamilton's parents, Hartshorne "Harts" Howland, a fisherman, and his wife Deborah lived in Ocean Township in Monmouth County, a neighboring town to Long Branch. After Harts died, Deborah married Joseph Sutphen, a widowed farmer, in 1875. By 1880 the Sutphens, Deborah, Joseph and Deborah's fourteen-year-old daughter, Laura Howland, lived with Deborah's son-in-law Walter M. Asay who had been married to Deborah's daughter and Lida's sister, Maggie. It was a close-knit family, and when Lida and John traveled to Detroit they left their oldest daughter, Minnie, with her grandmother Deborah and Uncle Walter.

John, his wife Lida, and Alice initially returned to New Brunswick from Detroit where Alice delivered her sixth child, Miller, in late June 1882. Sadly the father's namesake died within a month.[88] John and Lida returned to Long Branch with Alice and her children and they quickly set up housekeeping. The Hamiltons moved into a rental home near Broadway, the main thoroughfare in town. John opened a small carpentry shop at 504 Broadway at the corner of Morrell Street. In all probability Alice Boudinot and her children, William and Cecelia, stayed with her sister-in-law and brother until she could locate accommodations that she could afford.

In the months following the move, Alice Boudinot, a thirty-year-old widow, may have paid social calls on Lida's mother. Lida's widowed brother-in-law Walter (who was Alice's uncle by marriage) and his young son, Walter Jr., lived with the Sutphens. Eight years older than Alice, Walter worked as a telegraph wire-man. There were many occasions for Alice and Walter to converse, sip lemonade on the porch and even stroll in the nearby parks. Walter Jr. was six years old and Alice felt a motherly tenderness towards the boy. Her daughter Cecelia was five years old and the two children became friends. By the end of 1882 it seemed certain that Alice and Walter would marry and meld their two families into one.

But tragedy visited the Hamilton family again. Towards the end of the year, as the holidays neared, Lida and John's four-year-old son Sylvester became ill. He developed a high fever and sore throat, and had a bright red tongue with a strawberry appearance, all accompanied by a characteristic red rash—the symptoms of scarlet fever. An insidious infectious disease that commonly affected the young, scarlet fever was a major cause of death for children prior to the discovery of antibiotics. Lida's one-year-old son Walter likely was whisked to his grandmother's house so he would not contract the contagious disease. During the three days of Sylvester's illness, Lida was a constant presence, ministering to him with cold cloths for his forehead in hopes of bringing the raging fever under control. In the days when doctors routinely made house calls, it would not have been surprising if the doctor came and went every day and did what he could. Sadly, nothing helped, and Sylvester died on November 6, 1882.[89]

A medical doctor and prolific journal writer of the time, J. M. French of Massachusetts, wrote about childhood mortality in the December 1888 edition of *Popular Science Monthly*. "The younger the child," he stated, "the larger is the death rate." He added that out of every one hundred live births, a quarter died before the end of the first year and from forty to half die before the close of their fifth year.[90] It was a common practice for families at the time to have many children, about seven per woman, due to the high mortality rate for children, unfortunately a given in the nineteenth century.

There had been, according to the Annual School Report of Long Branch for 1881–1882, a scarlet fever scare in late 1881. It was so serious that the school enrollment for the year fell from 844 to 514. We do not know if that decrease represented deaths or severe illness because it is not noted in the report, but many more children died of the disease than survived.[91] There is no greater loss for a parent than the death of a child. Like any parents, Lida and John's grief must have been deep and despairing. Worse awaited. Their six-year-old daughter Ida caught the disease from her brother. Lida was determined to save the child. She lived in the sickroom with her child, periodically placing cool cloths on the girl's forehead,

giving her water and cool tea, fanning her fever-ravaged body and singing her favorite childhood lullabies. Supportive care was the only treatment available.

Among young children, according to Dr. French, five acute infectious diseases especially influenced the death rate. They were measles, scarlet fever, smallpox, diphtheria and whopping cough or pertussis. The "...most dreaded and at present the most fatal of these diseases," he wrote in 1888, "is scarlet fever." Collectively, these five diseases were responsible for 15 to 25 per cent of the deaths of children under the age of five years old.[92] While the death rate for children under five has decreased progressively in the United States through the years, the rate is still high for a developed nation, between six and seven deaths per 100,000 live births.

Ida lasted five days. She died on December 4, 1882, almost a month to the day after her brother.[93] The black wreath on the Hamilton door spoke volumes. Ida was interred next to her little brother Sylvester in Glenwood Cemetery in West Long Branch. The death of two children a month apart was extremely heart-wrenching. There was little consolation for their parents or siblings, and in those times there was also little time to mourn. The everyday routines of life continued as men worked at their jobs, women kept house and cared for children and children attended school for most of the year.

Beginning in 1875, in Long Branch as throughout New Jersey, there were "free public schools for the instruction of all children in the state between the ages of five and eighteen." In the 1880s Long Branch Public Schools District boasted a high school, located on Prospect Street between Morris and Willow Avenues, and several primary schools. By 1891 the district had seven schools, including a school in the neighboring town of Sea Bright, one in neighboring Branchport, and the Brook Street Primary, No. 6 where "colored" children attended.[94] The word "colored" was the common term for African-Americans at the time, and segregation, unfortunately, was also a routine practice.

Children attended four years of primary school, followed by four years of grammar school, capped by three years of high school.

Unfortunately because of the realities of being poor or, at best, middle class, many children dropped out before high school to work, and many did not complete the school year due to work commitments. As might be suspected, the Long Branch School District frowned on such behavior. "The evil results of absence cannot be measured," wrote Principal James M. Green in 1878, adding, "Some pupils will not be promoted because of the large amount of their absence. This non-promotion is not as a punishment. We feel greatly the evil influence of pupils going out to work in the latter part of summer term. I know that the earnings of those who go out are very acceptable in many cases, yet, should the financial gains be improved with the intellectual loss I fear the latter would have the balance."[95] A few years later, Long Branch Principal Christopher Gregory was more understanding. "I do not forget," he wrote in his annual report, "that school duties are not the only duties children have."[96] Both boys and girls often repeated classes because they left the school year before completing them; sometimes they even left in the middle of the year. An asterisk next to their name in the annual school report denoted that they left early, usually to start a summer job.

The Bureau of the Census first developed statistics on child labor in 1880. Labor participation rates of children, ten to fifteen years old, show that 32.5 percent of male children worked while 12.2 percent of girls in that age group worked in 1880. Data from a cost of living survey in 1889-1890 demonstrates the importance of child labor to urban households. Among families with working children it was discovered that children's earnings accounted for an average of 23 percent of total family income, a substantial portion in a family trying to meet its basic living needs.[97]

Some children of poor or struggling middle class families were employed as domestics in the wealthy households of vacationers or as servants or servers in the beautiful grand hotels lining Ocean Avenue. They could also work in the stables, with blacksmiths, or in various shops and restaurants throughout the town. An example of an advertisement that appeared in the March 18, 1885 edition of the *Red Bank Register*, a local newspaper, read "WANTED: A strong

boy about 16 years old for a mechanical position, who is not afraid of hard or dirty work, and writes a good hand. One living with his parents preferred. Address in applicant's own hand. A. Red Bank P.O."[98] Still other children worked with their fathers learning their craft, or with relatives and friends.

Lida's oldest daughters, Minnie, fifteen and Laura, thirteen, attended grammar school. The school year curriculum for Minnie and Laura in Grade F (grades were denoted by letters of the alphabet) consisted of reading, phonic exercise, vocal gymnastics and calisthenics, spelling, arithmetic, geography, recitation from charts and globe exercise, grammar, penmanship, drawing, vocal music, object lessons (names used in architecture, mechanics and agriculture), familiar animals, politeness, and laws of health.[99]

Minnie did not attend school after 1882, perhaps because she was approaching "working age" as well as "marriageable age," but her sister Laura and brother John Jr., ten years old, continued to attend. Laura was an excellent student, receiving yearly grades of 89, 92 and 83 throughout grammar school, but by the close of school in 1885 and in her second year of high school Laura stopped attending.[100] She was sixteen years old, two years beyond the minimum working age for girls. Just two years earlier, in 1883, the New Jersey Legislature had voted to set a fourteen-year-old minimum work age for girls and a twelve-year-old work age for boys. According to David Tyack and Elisabeth Hansot in *A History of Coeducation in American Public Schools: Learning Together*, girls outnumbered boys as both students and graduates of high school and represented 57 percent of the students and 65 percent of graduates in 1890. Girls also equaled and often surpassed boys in their studies. "Boys," they wrote, "often regarded secondary education as irrelevant to their futures, for they could obtain a variety of white-collar jobs without going to high school."[101] There was, of course, the practical reality of a family needing another paycheck. Contrary to these findings the Long Branch High School graduation classes from 1878 through 1888 list a preponderance of boys compared to girls, with the exception of three class years. Those who went on to college were few, but they

were all boys. Long Branch's statistics for these years did not follow the national norm.

If a girl, on the other hand, did continue her education, her only choice was to attend the New Jersey State Normal School in Trenton, a type of teachers college. Education for women was not highly valued in and of itself. Most girls were expected to marry soon after they completed grammar school or their first or second year of high school. Education was not deemed a priority for women at the time, and, in fact, many thought an educated woman was a detriment to her sex.

According to a register of graduates, out of the total number of young women who attended the Long Branch school system between 1878 to 1889, seven women became teachers; five women attended the State Normal School,; two worked as cashiers and one worked for a merchant. Nine of the women listed were married and the balance of thirty-four women, unmarried, were not working, presumably living at home, possibly keeping house. Of the men listed, there were doctors, druggists, lawyers, stenographers, photographers, clerks, professors and businessmen.[102] Despite the great expansion of the business work force that included women, education and working options for young women were very limited.

According to the authors of *Past and Promise: Lives of New Jersey Women*, many of the young, single women who were working in New Jersey in the late nineteenth century were usually immigrants or daughters of immigrants. "In addition to farm work and domestic service, which still continued to employ thousands of women, manufacturing provided an increasing proportion of women's employment. Many of the new goods and services enjoyed by New Jersey women were produced by women." These young women worked "in the garment and shirtwaist shops, in commercial laundries, in silk, cotton and woolen textile mills," while others worked in retail stores as saleswomen or staffing cashiers.[103] Their options for higher paying jobs were limited by their skill set, education and, of course, gender. "Despite the growing numbers of women wage workers," the authors of *Past and Promise* reiterate, "most women in the late 19th century, whether white or black,

native-born or immigrant, expected to marry and devote their mature lives to the nurture and care of their families and homes."[104] It would take another decade for the Hamilton women to move into business and offices.

Chapter 6

THE CULT OF TRUE WOMANHOOD

"A really good housekeeper is almost always unhappy."
- The Household (January 1884)

With death in the forefront of their thoughts amid the tragic losses in the Hamilton family in late 1882, there may have been a deep desire among some family members to live life to its fullest. After courting for nearly a year, an expectation in the late Victorian era (late Victorian standards required a courtship of at least six months followed with an engagement period of at least six additional months), widow Alice Hamilton Boudinot and widower Walter Asay were married on December 20, 1883 at the First Reformed Church of Long Branch.[105] Pastor Charles J. Young performed the marriage, one that was blessed a little over nine months later with the birth of a son.

The New Jersey birth index lists the event as occurring on September 15, 1884 although other records set the date as August 15.[106] George Jackson Asay was nonetheless welcomed into the world and both Walter and Alice were delighted by the event. Baby George joined Walter Jr., age eight; Cecelia, age seven; and William, twelve (Cecelia and William were the children from Alice's first marriage). It was undoubtedly a lively household with a baby and his three active and energetic siblings.

That same year Lida and John Hamilton had a daughter, Alice (named after John's sister). She was another beacon of hope in the Hamilton and Asay families, which had been torn asunder with the

deaths of Sylvester and Ida. There were six healthy children in the Hamilton home now, and Lida was kept busy attending to their needs. The children ranged in ages from one to seventeen. Life for Lida as wife and mother was a constant flux of varied functions. There were no servants in the Hamilton household, so caring and preserving the family fell to Lida while John worked long hours as a carpenter to pay the rent and bills.

A prevailing value system of the day was the "Cult of Domesticity" or the "Cult of True Womanhood" that emphasized ideas of femininity, women's role within the home, and the dynamics of work and family. "True women" were to possess the four cardinal virtues of "piety, purity, domesticity and submissiveness." This doctrine first developed in the early part of the nineteenth century and its values became an ideal for upper and middle class women. Although all women were supposed to emulate this ideal of femininity, social prejudice of the times eliminated black, working class and immigrant women from the ideal.[107]

The Cult of Domesticity was a pervasive value system described in religious sermons and texts, as well as presented in the two most widely circulated women's magazines of the day, *Peterson's Magazine* and *Godey's Lady's Book*. Catherine Beecher, an ardent and early advocate of the cult, glorified housekeeping and attempted to convince her readers that their daily work, however tedious or distressing, constituted important works assigned to them by Nature and God. With her well-known sister Harriet Beecher Stowe, who authored *Uncle Tom's Cabin*, Catherine Beecher wrote *The American Women's Home* in 1869, a repository of advice on childcare, health care, management of household finances and other domestic duties. An early proponent of "scientific housekeeping," Beecher believed that women must be acquainted with all "household sciences" and use them to run the household efficiently.[108]

Housework was hard, serious drudgery for women who did not have modern advanced housecleaning tools such as vacuum cleaners, dishwashers, washing machines, clothes dryers or dry cleaning establishments around the corner (early prototypes of vacuums and washing machines were not available until the early

1900s). The term "drudgery" appeared again and again in women's publications of the times. In the book, *So Sweet To Labor: Rural Women in America*, editor Norton Juster described a weekly schedule of "drudge" that might have included laundry on Monday, ironing and mending on Tuesday, baking on Wednesday and Saturday, daily tidying of kitchen and parlor, thorough cleaning on Thursday and again on Saturday. This was, in addition to childcare, cooking three meals a day, hauling water, keeping the fire burning in the stove and much more.[109]

Public utilities such as gas, water and sewer—which were a boon to women and helped to make their household chores more manageable—were slow to be introduced into the residential areas of the upper village (or the western section of Broadway-the main thoroughfare) in Long Branch where the Hamiltons and many of the year-round population lived. (The resort areas and large homes along Ocean Avenue were the first recipients of public utilities.)[110]

Although the Long Branch Electric Light Company was incorporated in 1885, it took several additional years for them to increase their service. In 1886 the Long Branch Sewer Company began operation, but included only three miles of sewer mains. In both cases the hotel areas were the first to be serviced.[111] Residents were so incensed at the apparent snub to modernization that *The New York Times* reported in April 3, 1886 that there was talk of secession for "perceived neglect." In response the town commissioners offered to spend revenue for improvements from taxes collected on the property where it was accessed, and a few years later residents began to receive services.[112] The main thoroughfare of Broadway—a virtual mud hole—was finally paved in 1891 (in 1892 they completed the paving all the way to the ocean) and sewer lines along with gas lines and electric continued to expand to more residents' homes.

The advent of public utilities may have made life more manageable for women, but there were still a multitude of household chores. If a home had a garden, the woman of the house tended to it, doing the planting, weeding, pruning and collecting. She preserved some of the fruit for making jellies and jams, and canned it for use

during the winter months. She scrubbed the house, made cleaning products, cared for the sick and prepared homemade remedies to aid their recovery. She also mended clothes, washed and ironed them by hand, and made clothing for herself and her children (either with a sewing machine or by hand stitching). In addition she knitted scarves, mittens and hats, some women worked crewel or needlepoint, and in between most of them raised and educated their children.

Writing in *The Household* in January 1884, a columnist stated, "A really good housekeeper is almost always unhappy. While she does so much for the comfort of others, she nearly ruins her own health and life. It is because she cannot be easy and comfortable when there is the least disorder or dirt to be to be seen."[113] Nineteenth century house cleaning, for the most part, was more than most women could handle alone. Surely Lida enlisted her children, and yes, particularly the girls, in housekeeping chores when they returned from school. Keeping six children and two adults clothed, fed and healthy was a daunting job. Many women of the era did not live to see middle age. Lida was thirty-four years old in 1884. According to life expectancy charts of the day, she potentially could live another thirty years, although for the poor and struggling middle class, hard work, childbearing and a lack of medical attention usually aged women prematurely or, in many cases, led to an early death. Certainly the tragedies of losing children at any early age exacerbated the stress and aging process.

Motherhood, along with being a wife, was viewed as the "perfection of womanhood." Motherhood, as described in *Godey's Lady's Book*, was a woman's most natural and most satisfying role. *Godey's* took a historical and patriotic stance, and considered mothers as crucial in preserving the memory of the American Revolution and in securing its legacy by educating the next generation of citizens.[114] Childbearing, and child mortality, were two of the most serious health issues for women and their families. Certainly Lida and Alice could testify to the difficulty of both.

Not all women professed or practiced the Cult of Domesticity. Indeed, a number of women advocated for women's rights. These

women were termed "New Women," and were often associated with the suffrage movement. They were accused of disrupting the "natural order" and were condemned as being "unfeminine." "They are only semi-women, mental hermaphrodites," stated American newspaper editor Henry F. Harrington in the *Ladies' Companion*.[115]

"The Declaration of Sentiments," written at the Seneca Falls Convention of 1848, the first women's rights convention, reiterated women's desire for political and civil equality and set the stage for a later generation to move forward. Despite the tireless work of suffragists Elizabeth Cady Stanton, Susan B. Anthony and Lucretia Mott and their fight for equality, most Americans remained tied to an idealized practice of domesticity and submission of women.

In late nineteenth century New Jersey there was a cadre of women, mostly single young women—both native born and new immigrants as well as a number of married women—working for wages who participated in the developing union movement. Like the "suffragists," these women worked for equality in the work place. Thousands of them joined trade unions and, in particular, local assemblies of the Knights of Labor, an early workers' rights association, in the 1880s. Hat trimmers, laundry workers, silk workers, and pottery decorators became "Lady Knights," supporting each other during strikes and pooling funds for sick benefits and funeral costs.[116] They represented an ideal of womanhood one hundred and eighty degrees from the values of the Cult of Domesticity. Conversely, the lives of the Hamiltons and Asays revolved around Lida and Alice, their homes and their children. A woman was queen in her own home although bereft of almost all civil rights outside of it.

Seeing to the children's education also came under the purview of domesticity. The Hamilton and Asay children were subsequently enrolled in the Long Branch Public School System. After Minnie, the oldest Hamilton daughter, left school in 1882 at age fifteen, Laura, the next oldest, continued through 1884 and 1885, completing her second year of high school. She regularly earned high grades as attested by her report cards. Just one year ahead of her was schoolmate Harry Woolley, the son of a widow. From 1880

through 1885, Harry and Laura attended the same school, although in different classes. John Jr. completed part of the 1885–1886 school year and then left to work with his father and learn the carpentry trade. He, too, performed well at school, earning an 87 percent average. Edna, twelve years old, began that same year and continued through the 1888–1889 school year until she too left school early at age sixteen. Alice's daughter Cecelia Boudinot, ten years old, started grammar school in 1887.[117]

Laura Hamilton and Harry Woolley, childhood school chums who became sweethearts, married as soon as Laura turned eighteen. On November 2, 1887 in the presence of her parents, family and friends, Laura married Harry at her parents' home on Jackson Street in Long Branch. Reverend Edward Cornet, pastor of the Beecher Memorial Parsonage, performed the ceremony.[118] More celebration occurred at the start of the year. On January 4, 1888, Lida and John's oldest daughter, Minnie, nineteen years old, married Douglas Riddle, age twenty-two, of nearby Oceanport. Riddle's family owned and operated Riddle Boat Works in Oceanport, where they designed and built racing sailboats and ice boats. The Riddle family was well known and had been residents of the area since the 1700s. Immediate friends and family attended the ceremony, which was also performed by the Reverend Edward Cornet at the Beecher Memorial Parsonage. The local newspaper reported that the young couple left by train on the afternoon of their wedding to New York City. They honeymooned for four days, and then returned to make their place of residence in Oceanport.[119]

The joy of seeing her two oldest daughters married was short-lived for Lida. Tragedy struck the Hamiltons once again when their youngest daughter, four-year-old Alice, nicknamed Allie, became ill in April and lay in a sickbed for three weeks suffering from a respiratory infection in her lungs. As her breathing became more labored, she developed fluid in her lungs and her heart, according to her obituary, which was published after her death on April 25. The cause of death was described as pneumonia on her death certificate.[120] One can only imagine my great-grandparents anguish at the loss of another child just six years after they had lost Sylvester

and Ida. "She [Allie] was thought," an area newspaper, *The Red Bank Register,* reported, "to be recovering, but paralysis of the heart set in and she 'Fell in her saint-like beauty Asleep by the Gates of Light.'" The poetic obituary reported that Allie had "won the hearts of all by her patience and sweetness."[121] Her parents buried her with her brother, Sylvester and her sister, Ida, at Glenwood Cemetery. In four months Lida gave her oldest daughter in marriage and lost her youngest to an early death—a deeply sad and unfortunate turn of events which was only too common for the era.

COMMUNITY-MINDED MEN AND WOMEN

"Music was rendered by the Long Branch Military Band." - The New York Times (December 1895)

Lida Hamilton was thirty eight years old in 1888, and although not past childbearing age, she was "old" to become a mother in an era of high mortality for both mothers and infants. Childbearing years included the years between fifteen and forty-nine but a woman over thirty-five in 1888 presented an extreme medical risk. A woman in this age group with a pre-existing condition, such as high blood pressure or diabetes, posed a threat to herself and her unborn child. There was also a greater chance for genetic disorders and a higher rate of miscarriage.

In 1890 the death rate from childbirth and puerperal disease (also known as childbed fever or postpartum sepsis, an infection usually contracted during childbirth) was 800 per 100,000 women between fifteen and fifty years of age, according to the 1890 Census Reports.[122] The infant mortality was even higher—some 165 deaths per 1,000 births based on 1900 figures.[123] Yet, in 1888 Lida became pregnant and in May of the following year gave birth to Jennie, a healthy girl and her last child.

At the time, life expectancy at birth for white women was about fifty years, and forty-eight years for men. The average expected "life length" though, at age sixty was seventy-four for men and seventy-five for women.[124] If you reached age sixty without dying from one of the top killers, including tuberculosis, pneumonia or childbirth

for women, your chances for a longer life were good. Seven months prior to Jennie's birth, in November 1888, Lida's newly married daughter, Minnie Riddle gave birth to her first child, a daughter named Elsie. Elsie was seven months older than her Aunt Jennie. Certainly the births of both children cheered Lida and John. They had a new baby daughter and a new granddaughter, and the girls would grow up together.

While Lida focused her life on home and children, John worked long days in the carpentry shop. There is no evidence that he worked for an employer, but instead was self-employed, working on building jobs in the town and vicinity. By 1882 he had a helper, his son John Jr., who left school early (based on the Long Branch school records that could be located). He was apprenticed to his father to learn the carpentry trade. John Jr. was fourteen, two years older than the minimum working age for boys. Many young boys left school early to work in the family business or work another job to contribute income to the family.

As early as 1883 John Sr. was listed in the Long Branch City Directory as working as a carpenter, and living at Jackson Street near the intersection of Broadway. Although the Hamiltons maintained a residence there, for a few years the carpentry shop was located at 504 Broadway at the corner of Morrell Street. John Jr. continued to work with his father until the time he was considered to have "learned the trade" and then he too was listed as a carpenter in the local city directory.

The Hamilton patriarch was also active in the community. He was a member of the James B. Morris Post of the Grand Army of the Republic, No. 46, an affiliate of the national organization for Civil War veterans. The group met at the GAR (Grand Army of the Republic) Hall at 497 Broadway in Long Branch. John's involvement was evident by the fact that he was elected post commander in 1892, 1893 and again in 1896.[125] The James B. Morris Post, named for a Long Branch native, a first lieutenant with the First New Jersey Artillery, was one of the more active posts in the state, with over fifty members. Composed of veterans of the Union Army, the GAR provided an opportunity for veterans to network and maintain

connections with each other. The GAR also became one of the first organized advocacy groups in America, supporting voting rights for black veterans in addition to lobbying Congress for expansion of veterans' pensions, and supporting Republican political candidates (the GAR operated as a *de facto* arm of the Republican Party during the Reconstruction Era). At one point, due to the party's decreased commitment to reform in the South, the GAR floundered, but the organization revived and grew to its peak membership of 490,000 in 1890.[126]

A Women's Relief Corps, an auxiliary of the GAR, was also part of many GAR Posts, and Long Branch was no exception. Each auxiliary, which was chartered by the GAR, opened its membership initially to relatives of veterans and later to any woman who made "a declaration of loyalty and allegiance to the stars and stripes." In addition to the loyalty stipulation, members were tasked with aiding and assisting the GAR with perpetuating the memory of the dead and assisting living veterans, or their widows and orphans. This latter objective included finding them homes and employment. A special concern of the corps was the maintenance of the graves of the Civil War fallen. Lastly, the corps dedicated themselves to the army nurses who served in the war, and lobbied the federal government to grant them pensions.[127]

There are no existent rosters that I could locate of the Long Branch Women's Relief Corps membership. However, since John was active in the GAR, it seems probable to assume that Lida had an interest (as the wife, daughter-in-law and sister-in-law of veterans) in the corps and participated in it. In 1891, the year prior to John assuming the Commandership of the Post, the women of the Long Branch Relief Corps directed, raised funds, and erected a large monument at Greenlawn Cemetery, West Long Branch, in memory of the deceased soldiers and the "unknown soldiers" from Long Branch (and vicinity) who had served in the war. The magnificent granite monument, which still stands, is a testament not only to the Civil War veterans but also to the women who conducted the fund raising.

Just a few years earlier, in 1887, the WRC, along with the GAR,

erected a white marble stone for a Long Branch Civil War nurse, Mary Dunbar, at the Old First Methodist Cemetery. Although the federal government did not keep official records of the women who served as nurses during the war, Dunbar was listed on the Monmouth County Veterans grave registry as a Civil War nurse. She died in 1887 "of neglect," according to her death record, and the women of the WRC honored her by providing a gravestone for her (recently Michelle Green and Arthur T. Green II of West Long Branch raised funds and erected a new footstone since the old gravestone had deteriorated). Dunbar's death lent credibility to the WRC's campaign for fair treatment of women veterans.[128]

The women also visited veterans at the New Jersey Home for Disabled Soldiers and Sailors in Kearny, New Jersey and in fact, by 1915, when John Hamilton was a resident there, the corps made a visit. According to the Superintendent's Report, "A delegation from James B. Morris Post, No. 46, Department of N.J., G.A.R. of Long Branch, N.J., visited and inspected the Home on October 25."[129] Undoubtedly it was a bittersweet experience for John who knew the visiting women, but alas, Lida, who had passed by that time, was not a part of the delegation.

John also was an accomplished musician and member in an 18-piece band, the Long Branch Military Band. Although there are no documented records of his area of expertise, from a close inspection of a photograph he appeared in with the band, the instrument he is holding seems to be either a tenor tuba or euphonium, a brass instrument commonly used in concert and marching bands. The band, housed at 563 Broadway, performed at all Long Branch City ceremonial events as well as many social functions.

Just as there were two distinct social classes living in Long Branch—the super rich in the summer and the local year-round working folks—so too there were distinct entertainments, although there was often some carryover in the realm of music. Musical diversion for the rich consisted of concerts, balls and "hops, all frequent events in Long Branch during the summer resort season. In addition to good food, the entertainment of guests at the largest grand hotels of the era was critical to their reputation. As George

H. Moss Jr. and Karen L. Schnitzspahn wrote in their book, *Victorian Summers at the Grand Hotels of Long Branch, New Jersey*, "From the largest to the smallest hotels, for entertainment of their guests, the quality of the orchestras and the frequent dances, the fashionable Hops, were equally important. The exceptional quality of music that was offered at various times throughout the day was considered a bonus."[130]

In an era when radio, CDs, DVDs, TV and computers did not exist, live music provided a welcome relief and entertainment to year-round Long Branch residents, as dancing to an orchestra in one of the grand oceanfront hotels did for the rich. Many of the hotels hired bands for the entire season. Beck's Philadelphia Band, for example, was engaged to play for the 1876 season at the Metropolitan Hotel, while the entire Ninth Regimental Band performed at the Grand Civic and Military Invitation Ball held at the Continental Hotel in August 1871. At the Ocean Hotel, according to one newspaper report, "The orchestra of William Keating discourses sweet music on the lawn and every evening after supper there is a concert and dancing."[131] Balls were a popular entertainment during the 'season.' "The ladies enjoy it, because they have an opportunity to show themselves 'at their prettiest' with their splendid dresses and costly diamonds. The gentlemen enjoy it in a lazy sort of way, especially if they are rich, or handsome, or can appear upon the committee list...many a dandy prides himself as much upon his spotless white vest or his graceful dancing," Moss and Schnitzspahn wrote in *Victorian Summers*.[132]

While music was an integral part of the entertainment of the wealthy, with bands and orchestras hired from New York and Philadelphia, the local year-round residents, most of whom were lower middle or struggling middle class, relied on either home-grown talent or visiting musicians who performed in outdoor concerts for their musical fare. It was the Long Branch Military Band that performed at city-sponsored events such as parades and official openings for the folks who lived in town as well as visitors during the high season.

In December 1895 the band played at a weeklong industrial exposition held at the YMCA Building—a new venture never held in the area before, according to a *New York Times* article. "In the way of entertaining amusement, nothing has been left undone. The Long Branch Military Band of eighteen pieces is in attendance every evening and furnishes excellent music. A concert commences every evening at 8 o'clock. The programme each night consists of ten well-selected numbers."[133] Sometimes, the band interacted to a greater degree with the summer visitors. In early September 1899 it celebrated the close of the resort season. Once again *The New York Times* reported that at an open-air event held at the country club grounds at the adjacent town of Monmouth Beach, summer "cottagers" from many of the surrounding shore towns were present. "The scene was a novel one," the newspaper reported. "Music was rendered by the Long Branch Military Band."[134] In August 1911 at the annual Doll Carnival, where a child was crowned queen, the band was also in prominent attendance. "The Queen and members of her court were driven in automobiles from her Majesty's home on Broadway to the park and were escorted through the park by the Long Branch Military Band to the throne," reported *The New York Times* on August 26.

John was not the only man in the family who was active in the community. Walter Asay, John's brother-in-law (husband to Alice Hamilton Boudinot Asay, John's sister), was a member of the Long Branch Atlantic Fire Engine and Truck Company, No. 2. In 1886 Walter was listed as one of the fifty-three members of the newly formed company.[135]

Created in November 1878, the Long Branch Fire Department, a volunteer organization, was divided into six fire districts with six fire companies. They were the Oceanic Fire Engine Co., No. 1; the Neptune Hose Co., No. 1; the Atlantic Fire Engine and Truck Company, No. 2; West End Engine Co., No 3; the Phil Daly Hose Co., No. 2 (named for the proprietor of the resorts' most successful gambling establishment and a large contributor to the fire department); the Oliver Byron Engine Co., No 5, (named for a popular actor who lived in North Long Branch) and eventually,

after the small town of Branchport was incorporated into greater Long Branch in 1904, the Branchport Hose Co., No. 3.[136]

The fire companies were much like popular men's clubs with active social programs, according to *Entertaining a Nation: The Career of Long Branch*. "There were long waiting lists for membership; initiations were conducted with elaborate horseplay; and the annual fireman's parade and the gala ball that followed were highlights of the social season."[137] There were also ladies' auxiliaries, one of which Alice, Walter's wife, no doubt joined to support her husband. The women helped to raise funds by hosting bazaars, May Day breakfasts and harvest suppers.

In 1892 the Atlantic Fire Engine and Truck Co., No. 2 had split their increased membership into two divisions: sixty engine members and twenty-nine truck members. Walter was an engine member.[138] The men in the fire companies forged a special bond and were as close as brothers. Walter made many friends there, including Thomas Bazley, co-owner of a plumbing, steam, gas fitting and hot water heating company in Long Branch. Bazley daughters, in fact, went to school with Cecelia, and the two families spent a lot of time together socializing.

Family life, with its concomitant ups and downs, went forward for the Hamiltons, Asays, Riddles and Wooleys. In September 1890 Alice and Walter Asay welcomed another son to their family, John H. Asay. While no birth record could be located for John, he was listed on the Monmouth County Surrogate files of 1893 as being Alice and Walter's three-year-old son.[139] The family now boasted four boys, baby John, George, Walter Jr., Walter's son from his first marriage and William Boudinot, from Alice's first marriage along with her daughter Cecelia, also a child of her first marriage.

Another happy occasion occurred when the two married Hamilton daughters, Minnie and Laura, joined their parents the following year, on September 6, 1891 in celebrating their sister Edna's marriage to Edward M. Haviland, a dealer in fish and oysters from the Monmouth County town of Red Bank. Edward's father, Captain J. Warren Haviland was an oysterman living in Shrewsbury Township who captained his own boat, and his son Edward worked with him.

Rev. Charles E. Hill of the Red Bank Methodist Church married the couple.[140] Edna was eighteen and Edward was twenty-three. The wedding itself appeared to be a small event, since the pastor's two children served as witnesses. Although there is no documentation on how the couple met, it is possible that Edna's married sister, Minnie Riddle, and her husband Douglas introduced her to Edward Haviland. Douglas Riddle's family were waterman so there is a strong possibility that the Riddles and Havilands knew each other since both derived their livelihoods from the sea, and both lived in the Red Bank/Shrewsbury area.

According to the standards of the era, a typical courtship began in church or at a family celebration. Couples had more freedom in the mid- and late-nineteenth century, another legacy of the social changes engendered by the Civil War. They attended dances, picnics and concerts and got to know one another well. Courtships and engagements were usually extended, since it was not considered proper for a couple to marry until the man could support his wife. For Edna and Edward that was not the case, since he had been working for years and had the income to support a wife.

Now three of the Hamilton girls were married. Lida's load appeared lighter with one less person at home (although one less person also meant one less body to help or provide an income). However, there were the demands of a new infant, not to mention the continuous household chores, her husband and the rest of her family. Like her sister-in-law, Alice Asay had a demanding role as mother to three young boys and a teenage girl. As Alice's daughter Cecelia would recall decades later, her mother's demanding role as a mother and wife wore her down, thereby making her susceptible to illness. Taking care of a home, small children and a husband was taxing work, and unfortunately the fate of many women was illness, and often death.

In the nineteenth century, the death of a parent—beyond the traumatic experience itself—could lead to much more than emotional distress and grief. If other family members were unwilling or unable to care for the young, parentless children, it meant poverty, dashed dreams, perhaps homeless wanderings, or worse—being sent

to an orphanage, which could be a small blessing or an unremitting horror. Cecelia's dream of completing high school, and those of her younger brothers, were about to be tempered by the specter of death visiting her family again and again.

BROKEN-HEARTED

"When I am dead, my dearest,
Sing no sad song for me;
Plant thou no roses at my head,
Nor shady cypress tree;
Be the green grass above me
With showers and dewdrops wet;
And if thou wilt, remember,
And if thou wilt, forget."
- "Song" (first stanza)
Christina Rossetti (1830-1894)

In 1893 as Cecelia Boudinot, Alice Asay's daughter, entered her senior year at Long Branch High School, the Hamilton family struck a milestone. Cecelia was the first person in the Boudinot, Hamilton and Asay families to complete three years of high school. Her pending graduation the following June certainly made her mother and stepfather proud of her accomplishment. Many young boys and girls still left school early to work and help out at home. Although the Asays were by no means wealthy, Alice's insistence that her daughter complete her education freed her from working or helping her mother so she could finish her schooling. As the only girl in the family, her attendance at school left the burden of housework, cooking and childcare entirely on her mother Alice.

Cecelia knew what it meant to be a woman and have the responsibilities of caring for others. As she frequently related to her great-grandson Gene Tunney, at the age of twelve she had an experience which stayed with her for the remainder of her life. It

was March 1888, and perhaps Cecelia was returning from visiting her father's family in New Brunswick or leaving Long Branch to travel there. Whatever the case, on March 12 she found herself on a stagecoach with several men. Suddenly the Great Blizzard struck, with ninety mile per hour winds and biting cold. The stagecoach was forced to stop, and become stranded like the more than fifty trains that were stuck between Albany and New York City, and also in Long Island, New Jersey and Connecticut. Over four hundred people died in the storm, which raged from March 12-14, many of whom died from exposure or were buried in drifts as they attempted to walk to nearby towns when their trains or other conveyances became stalled.[141]

After Cecelia's stagecoach became stranded, she related to her great-grandson, it was she—as the only female on the coach—who suddenly had to assume the responsibility for preparing the food and feeding the passengers. "It was a great annoyance to her," Gene related, "that because she was a girl the men believed that burden fell to her."[142] It was perhaps a valuable lesson in some regards because it reinforced society's views that women's roles were limited, and her reaction was to fight that mindset as a young woman. Marriage and motherhood were valuable roles for women, but they often led to a difficult life and took a toll on the health of women, as was the case with her mother.

Looking back decades later, Cecelia commented to a reporter that her mother's second marriage to Walter Asay and the subsequent births of the children from that marriage had "overtaxed" her. Alice had six children with Miller Boudinot, only two of whom survived, another two children with Walter Asay, and a stepson.[143] We don't know whether she had domestic help at home, but the family's economic circumstances seem to preclude it. Perhaps it was this "overtaxing" that led Alice to become ill in October 1893. She developed a bad cold that became progressively worse within a few days. Without the intervention of antibiotics, which were yet to be invented, Alice developed pneumonia. On October 7 at the young age of forty, Alice Hamilton Boudinot Asay died in bed at home surrounded by her brokenhearted family.[144]

Even in an age when death was fairly common, the death of a young mother with five children was still a tragedy. *The Red Bank Register* of October 18, 1893 posted a short but pithy obituary. It read, "Mrs. Alice Asay, wife of Walter M. Asay of Long Branch, died on Saturday, October 7th, aged 40 years. She leaves a husband and five children, the youngest of whom is three years old."[145] Both to Alice's immediate family and her brother John and his family, her death left a sorrowful vacuum. Perhaps the person who suffered the most was her husband, Walter. Lunacy records from 1895 attest to the fact that Walter, now the sole guardian of the children, soon entered a deep mourning period and was unable to work. We might imagine that it was left to Cecelia to pick up some of the care of the younger children after her mother's death. Cecelia's oldest brother, William, was twenty years old and working; likewise her stepbrother Walter Jr. was seventeen and also working, but the younger children, George, nine and John, three, needed a great deal of care.

There is no way to know if Cecelia alone took on the responsibility of the younger children after her mother's death. She herself was only a child of sixteen. It may be that Lida Hamilton, Alice's sister-in-law, and Lida's married daughters, Minnie, Laura and Edna, also helped with the children. We can only speculate that the two youngest Asay children were taken care of in some way—probably by close family relatives who lived in Long Branch. Since no city directories exist for that time period, it is not known if the Asays and Hamiltons lived close by, but Long Branch was a relatively small town and family help was nearby.

Despite her mother's death and the upset it caused, Cecelia managed to finish her senior high school year while averaging a "meritorious" grade (between 85 to 90). The senior course of study was rigorous and divided into two tracks: a "scientific course" and a "classical course," the latter as preparation for college. The scientific course that she took prescribed language courses in Latin or German; plane geometry and a review of arithmetic. There was chemistry with laboratory practice, English literature, composition, exercises in "elocution and expression" along with voice work and exercises in pantomime expression. Drawing included construction,

mechanical and elements of architectural drawing. Watercolors, still life, original sketching, and applied design were also part of the course work.[146]

Graduation from high school was a momentous occasion, and was treated as such by the school district. A "sermon" was usually delivered to the senior graduating class, and in 1894 Dr. Robert Stuart MacArthur, the longest-serving senior pastor at Calvary Baptist Church in New York City, delivered it at the graduation site. According to Long Branch Principal Christopher Gregory, "It was a matter of great satisfaction to be able to bring our graduates in contact with a man of Dr. MacArthur's strong personality."[147]

The graduation ceremony itself was held at St. Luke's Methodist Episcopal Church at the corner of Broadway and Washington Street in Long Branch on June 15, 1894. Originally dedicated in 1869 by President Ulysses S. Grant, the Romanesque Revival-style church, recently had been rebuilt at a cost of $50,000 having sustained a fire the prior year. The rough squared brownstone building was impressive, with a massive ninety-eight-foot tower that contained a Meneely bell weighing over a ton (two of the largest bell foundries and makers of chimes in America were operated by competing members of the Meneely families in Troy and West Troy, New York, respectively).[148]

Inside, a beautiful stained glass window called the "Peace Window" dominated the east wall. Designed in memory of President Grant, it showed him surrounded by the figures of Peace, Victory and Mourning. Its inscription, "Let us have peace," referred to the famed general's benediction at the surrender at Appomattox. The church was slated for dedication in July, but since it was the only available building large enough to hold the graduates, their families and friends, it was used for the ceremony a month before its formal opening. It was a dignified and stately venue, and the fact that it was a church lent solemnity to the event. "The spacious edifice was crowded with the friends of the graduates and of the school," Principal of Schools Gregory reported. "It was one of the most enjoyable commencements that we had had in a long time," he added.[149]

The twenty-one girls and twelve boys marched up the center church aisle past admiring family and friends. It was a bittersweet occasion for Cecelia. Her mother, the one person who encouraged her to stay in school, was not there to witness it. Perhaps Cecelia's good friend and fellow graduate, Mary Bazley, reached across the aisle to take her hand, to lend support. The Bazley girls, Mary, Lizzie, and Maime, attended school with Cecelia.

The girls, attired in their best white linen lawn dresses, and the boys in their heavy wool dark suits, took seats in the front rows. A reporter who attended a similar graduation about the same time for Red Bank High School wrote that the graduates "...made a beautiful picture of youth and loveliness and their bright young faces beamed with hope and courage."[150] Likewise, the graduates at Long Branch High School doubtless made a similar impression of energy and youth.

The commencement program consisted of an orchestra overture, chant of the Lord's Prayer, recitations of an essay and several poems by students. In addition, a chorus sang and in the second part of the ceremony there was another essay reading, a three-part chorus, a vocal duet, a valedictory speech and song. The program followed similar high school graduation customs of the era, ending with a presentation of flowers to each of the graduates.[151] Without a doubt the Asay and Hamilton families were in attendance to lend support to Cecelia and to show their pride in her accomplishment. Those dignitaries who were invited to participate in the ceremony attested to the importance of the occasion. In addition to Dr. MacArthur, Dr. James M. Green, Principal of the State Normal School and former principal of the Long Branch School District, presented the diplomas to each graduate.[152] Once each graduate had their diploma in hand the audience rose as one and gave a standing ovation to the new graduates. There was probably not a dry eye in the Hamilton, Asay or Boudinot families.

The new graduate lost no time in looking for a job. As she related to a reporter in 1976 at the age of one hundred, she had a "hard time getting a job, because at the time women were expected to marry young and have children."[153] Furthermore, family events

put the job search on hold: Cecelia's stepfather Walter, was still in a deep depression stemming from her mother's early death. A year-and-a-half after Alice's death Walter still suffered severe mournfulness to the extent that he could not work and was hospitalized for "lypemania," an affliction characterized by "deep sadness" and "melancholy." On March 4, 1895 Judge Charles Morris signed a commitment document based on an examination of Walter by Dr. James Chasey. The document stated that Walter could not support himself given his condition of severe depression. Walter was taken to the New Jersey State Hospital in Trenton for treatment, the same facility that Cecelia's Aunt Susan had gone to years before.[154]

Based on his doctor's diagnosis of lypemania, it is probable that Walter suffered from a major depressive disorder (MDD). It would not be unusual for someone who recently lost his wife to suffer from MDD. He may have refused to eat. People with MDD can become essentially catatonic. At the time, Walter's diagnosis of "lypemania" was considered a mental affliction. The illness was first defined by Etienne Esquirol, a French nineteenth century doctor, who reclassified the concept of melancholy replacing it with the new term to signify a type of depressive state. He defined it as a "disease of the brain characterized by delusions which are chronic and fixed on specific topics, absence of fever and sadness, a combination of which is often debilitating and overwhelming."[155]

It was this last symptom that most clearly defined Walter's illness. Walter's family recognized that his overwhelming grief over Alice's death so incapacitated him that he was unable to take care of himself or his children. His slide into deep depression proved fatal when he died in March 1895, just three weeks after his admission to New Jersey State Hospital. His family believed he died of a broken heart.[156] There is also the possibility that he committed suicide and that the authorities refused to note it from embarrassment.

There is no way to determine how the children were taken care of during Walter's fall into deep depression in the year-and-a-half between the deaths of their parents. Since Cecelia was the only female in the immediate family she would have taken on most of the responsibility, especially for now five-year-old John and eleven-

year-old George. Despite having family nearby, the laws of the time required that with the death of her stepfather, the children, including Cecelia, became wards of the Monmouth County Surrogate's Court, also known as the Orphan's Court. Cecelia, the new graduate, was not only saddened by the turn of events, but like any young girl frustrated that her dreams to work and become independent had become dashed.

According to a Monmouth County Surrogate Court letter filed in June 1896, Cecelia requested that her friend's father, Thomas Bazley, who also was her stepfather's colleague in the local engine company, be appointed to serve as her guardian, as well as for George and John.[157] At the age of fourteen a minor could choose their own guardian. Bazley was a successful businessman and partner in Bazley and Burns, a heating and plumbing firm on Broadway in Long Branch. The Lawyers Surety Company of New York and Monmouth County Surrogate David Sheraton signed off on the guardianship though it was relatively short-lived for Cecelia, since she would turn twenty-one in 1897 and thus be emancipated from the care of the court and the guardianship.

Cecelia was hit with another unexpected death in December 1896. Her stepbrother, Walter Jr., was rushed to Memorial Hospital in Long Branch with an abscess on the brain. Caused by an inflammation and collection of infected material, it could have been a result of an ear infection, dental abscess or other source. There was little anyone could do for the young man. At the age of twenty, Walter Jr. died, just twenty months after his father's early demise.[158]

Although science and technology were changing and advancing rapidly in the late nineteenth and early twentieth centuries, medical practice and knowledge was still relatively primitive by modern standards. Having broken away from folk remedies, but not yet "modern" in any sense of the word, the workings of the body and disease theory were poorly understood, and disease and death were constant companions for all classes. Death seemed to surround Cecelia: first her mother, taken so young; then her stepfather and now her stepbrother. We can only imagine Cecelia's trepidation about the vagaries of life. She was a young girl, full of life, who

probably felt very much alone, especially with her older brother William now living in New Brunswick.

Cecelia's brother, William Boudinot, was over twenty-one, and not considered a ward of the court. When his stepfather died he returned to his mother's hometown of New Brunswick to live with his Uncle William and his family. By the end of 1895 William was working for T. H. Riddle, a contractor at 102 Church Street in New Brunswick.

Cecelia's guardianship ended in 1897 when a final account by her guardian was filed in surrogate's court and was approved by the surrogate on December 12, 1897. The report showed payments for board, surrogate fees, and counsel costs. After all these costs were paid, Cecelia received a pay out of $191.67 from her father's estate. George and John, who were also under the guardianship of Thomas Bazley, inherited $207.55 each from their father. There is no explanation for the disparity in payments, although it is possible that the fees were less for the boys and therefore they received more money.[159] Apparently Cecelia took over the informal guardianship of the boys when she reached twenty-one. Protocol in the orphan's court was less formal and exacting in the late nineteenth century than it is today. Cecelia was the boys' sister and a suitable person to oversee John's development. George by this time was fourteen years old, and by law considered free to work. Although no work record could be located for George, John at age nine was apprenticed to Theodore Young Sr. and his son, Theodore Young Jr., electricians residing in neighboring Ocean Township, according to the 1900 United State Census. John lived with the Young family, learning his father Walter's occupation.[160]

In the late 1800s electricity was a marvel. Although people had known about it since Ben Franklin flew his kite, harnessing the electric force was the key. When Thomas A. Edison developed and built the first electric generating plan in lower Manhattan on Pearl Street in 1882, it was the start of a new way of life. By 1886 there were between forty and fifty water-powered electric plants on line or under construction in the United States and Canada. John was entering an industry in its infancy which was destined

to grow and change the social fabric and culture of the country.

Cecelia, who had been seeking a job, finally found one as a shirt operator at the Eagle Shirt Factory in Bordentown, New Jersey in 1899. We have no certain knowledge why Cecelia located to the Bordentown area, some sixty-two miles southwest of Long Branch, although there were Asay relatives living in the Burlington County area, and they may have helped her with job hunting. Cecelia is listed in the 1899 Burlington City directory as an independent woman: "Boudinot, Cecelia, shirt operator, h(ome) 15 West."

The following year, as she reminisced years later on her one-hundredth birthday interview, at the "old" age of twenty-three, she married Joseph H. Quigley, a wire mill gauger, similar work to what her stepfather used to do. The Quigley family was well established in Burlington County for many years and the young couple spent their early married years living with Joseph's parents. Recalling that time, Cecelia admitted to working hard in her job before she tied the knot, but after marriage, "I worked harder, yet," she said.[161]

The Quigley's, whose home was adjacent to Black's Creek which ran into the Delaware River in Bordentown, rented boats for duck hunting, made fishing nets and raised ducks. According to her great- grandson Gene Tunney, Cecelia was always busy: she raised ducks and chickens, kept house and looked after both immediate and extended family. "She loved her family," Gene recalled, "and did a lot for them."[162] She raised her granddaughter Myra and her great-grandson Gene, who lived with her for more than twenty years. She even sewed shirts after she was married. In a letter from her stepbrother John in 1910 we learn that he traveled to Bordentown to pick up his shirts from his sister. "Are the shirts done yet?" he wrote, "I will be over tomorrow night."[163] During the Great Depression she also took in extended family and cared for them. "I never saw her angry," her great-grandson recalled. "She was an even-keeled person who loved her family."[164]

Cecelia's stepbrother George, who turned seventeen in September 1901, left New Jersey for Los Angeles on the same day,

his aunt Jennie Hamilton noted in a family notebook, that President William McKinley was shot, September 6, 1901. Jennie, however, recorded the date in her notes as August 12 writing George "went to Los Angeles, Cal (stet) on the day that President McKinley was assassinated, August 12th."[165] The dictum "Go West, young man," first used in a 1851 *Terre Haute Express* editorial and later adopted by author Horace Greeley to foster westward expansion, proved to be an impetus for many adventurers, including George's Uncle Alex. Fifty years after it was first expressed, George found it too beguiling to ignore.

THE HAMILTON WITH WANDERLUST

"Go West, young man, and grow up with the country."
- John Babsone Lane Soule (1851)

Lizzie Gilliland was married to the adventurer in the Hamilton family. Her husband Alex, Mary Ann Hamilton's oldest son, seemed to have fancied himself as a bit of a pioneer and risk taker. Like tens of thousands of Americans and recent immigrants, he participated in the great western migration that took place in the nineteenth century. In 1858, at the age of sixteen, he moved to Eel, Indiana, a sleepy village of four hundred people situated between the Eel and Wabash Rivers, 714 miles due west of New Brunswick, New Jersey, where the rest of his family lived. Young Alex—perhaps fueled by the confidence of youth or a determination fostered by the American spirit—made the journey by himself, by train and stagecoach, perhaps part by boat and undoubtedly a lot by walking. He instinctively heeded the words of John Babsone Lane Soule, who in an 1851 *Terre Haute Express* editorial, wrote, "Go west young man, and grow up with the country." In Eel he became an apprentice to local cabinetmaker William Manley, and lived with the Manley family with two other young trainees.[166]

Alex was also a young man who took responsibility seriously. When the nineteen-year-old joined the Army immediately after the start of the Civil War, his apparent maturity granted him a lieutenancy and later, a spot on General George McClellan's elite

Provost Guard, the precursor of the military police, where integrity and character counted.

When Alex and John's mother died in September 1870, it was Alex who acted as her executor, paid her outstanding bills and settled the small estate's inventory.[167] With his mother's death and the institutionalization of his sister Susan, Alex probably felt less burdened with responsibilities than he had in years. He still had obligations, but they were the duties of a loving husband to Lizzie and father to Jennie and Lizzie, born in 1870 and 1871, respectively.

There were many pitfalls and pressures bedeviling nineteenth century families. In September 1873 the banking firm of Jay Cooke and Company, which was heavily invested in railroad bonds, closed its doors, precipitating a major economic panic across the country. Mirroring Cooke's collapse, other banking firms and industries soon followed suit. In the end, a total of 18,000 businesses failed within two years, and by 1876 unemployment had hit a record high of 14 percent.[168]

Work soon became scarce for Alex and John, so they had to be resourceful. Their sister, Alice, and her husband, Miller Boudinot were also hit hard by the depression and, as discussed, the couple relocated to Detroit, Michigan in late 1873. Once Miller was employed after the couple settled, they wrote home about the city and the booming furniture manufacturing industry in Michigan at a time when the rest of the country was suffering high unemployment. It didn't take much for Alex to decide to join his sister and her family.

Moving in 1870s America was not an easy task. Detroit was 870 miles west of New Brunswick, New Jersey and most roads were rutted and uneven, which made passage difficult. As with advancements in medicine, the modern paved highway system was decades in the future. In all probability, if they had the money, the family took the train, also an arduous and sometimes dangerous journey. Train derailments, boiler explosions, head on collisions and bridge collapses were common occurrences in the era. By 1861 the Erie Railroad, the first long railroad in the country, had laid track from New York City to the Lake Erie town of Dunkirk, New

York. Reorganized after a bankruptcy as the New York, Lake Erie and Western Railroad Company, this company provided the most direct route for the family. After boarding in Jersey City, New Jersey (a short train ride from New Brunswick), they might have traveled to Dunkirk or Buffalo, New York—both on the shore of Lake Erie. Once there they had a choice either to embark on a steamboat to continue across Lake Erie to Detroit, or make an additional rail connection to continue west.[169] It was certainly a long and tiring journey for a family with young children. That same year Lizzie had their fifth child, Annie, so it's possible that Lizzie was already pregnant when the family started the trip, an even greater hardship for her. Household goods were expensive to ship by train, so in all likelihood the families sold what they could before leaving New Jersey. One can imagine that they did retain some small heirlooms—a gift that a parent had given them, a vase lovingly wrapped and packed, or a few pieces of family china.

The late nineteenth century in America ushered the start of the great "progressive" movement in which municipalities recognized their responsibility to provide infrastructure and certain basic services to their constituents. In the past decade Detroit had organized its first police department, opened a public library, started a state university and admitted African-American children to the public school system. The University of Michigan began to accept women in 1870, and in 1871 Nanette Gardner petitioned Detroit's Board of Representatives for the right to vote—which was granted—and then became the first woman to cast a vote in the state. That same year the state passed its first compulsory school attendance law, requiring all children between eight and fourteen to attend school for at least twelve weeks a year.[170]

Lizzie and Alex's children, Jennie, Lizzie, Alice and Alex Jr., were eight, seven, five and four, respectively, when their parents settled in Detroit in 1877. When John and Lida joined them in Detroit a year later, the two brothers set up housekeeping within shouting distance of each other on Brigham Street. Perforce by necessity, by 1880 Alex and his family had moved in with Alice and Millar at 90 Grand River Street. Alice's and Alex's children would have been

enrolled in public school. John and Lida's children, Laura, John Jr. and Edna, were nine, six, and five, respectively, (Ida and Sylvester were just one). Combined with the mandatory enrollment of children in Detroit, there was also their parents desire to see them educated. The closest primary school to the cousins was the Miami School, located about seven blocks from their home.[171] Meanwhile, Millar and Alice's children, Mary, nine, and William, six, probably showed their cousins the ropes at their new school, since they had arrived in Detroit a few years earlier.

The Detroit schools the children attended had recently been revamped in 1872 into "Union" schools (schools "unified" various classes under one roof). Students in a Union School were located in the same building, but were separated by classrooms into three or four grades or departments. The Primary Department, for example, comprised the first four grades; the fifth, sixth, seventh and eighth grades constituted the Grammar Department, and the High School Department included the ninth, tenth, eleventh and twelfth.[172]

In addition, in the Primary and Grammar Departments, each grade or year's work was divided into two parts or classes, A and B, the A class being the more advanced. In grades one and two the course of study included language, numbers and music; at third and fourth grades, geography and drawing were added, and language, number and music lessons became more advanced. At seventh and eighth grade, history and government were included.[173]

By 1881 the Hamiltons had moved near the western outskirts of the city to 140 24th Street. Alex Jr. would have joined his sisters in attending primary school at Webster School on 21st Street between Fort and Baker Streets, about a five-block walk from their home.[174]

While the children were occupied with attending school, their fathers were concerned with starting and growing a business. Even before they moved to Detroit, the brothers knew of Michigan's growing reputation as the furniture manufacturing mecca of the country, where large quantities of mass-produced furnishings were being assembled. The production of furniture evolved into two separate industries in Michigan: residential furniture and the

manufacture of business and institutional furniture. As a trained cabinetmaker, Alex was in the right place at the right time.

The Hamilton brothers assessed their prospects in their new urban home. It was a beautiful city in its design. After a devastating fire in the city in 1805, Judge Augustus Woodward, the first chief justice of the Michigan Territory, had envisioned a first class city rising from the ashes. In a style somewhat reminiscent of the layout of eighteenth century Savannah, he designed a geometric footprint consisting of parks and baroque styled radial avenues emanating from Grand Circus Park. The streets were broad thoroughfares, and Detroit soon became known as the "Paris of the West." On Woodward Avenue, the main boulevard, businessman Frederick Sanders, the inventor of the ice cream soda, situated his popular store where a growing number of customers could delight in the craze for his new drink. The Detroit Opera House opened in 1876 and J. L. Hudson opened his first store on the ground floor of the opera house. A retail department chain, it became the second largest of its kind in the country next to Macy's. The family also founded Hudson Motor Car Company, which merged with Nash-Kelvinator Corporation, eventually becoming American Motors Corporation. In 1987, AMC was acquired by the Chrysler Corporation.[175]

Grand Rapids, Michigan's second largest city, became the best-known place in the nation for the manufacture of furniture, but other Michigan cities, including Detroit, Grand Ledge, Monroe and Holland, also produced large quantities of furnishings. By 1890 Michigan employed more than 7,000 people in 178 furniture factories across the state. Today, Michigan is still home to five of the world's leading office furniture companies.[176]

In an age of grand excess, Victorians loved to fill their homes with tables, chairs, knickknack shelves, bookcases, coat racks and much more. Bare rooms were thought to be in bad taste, so every surface was filled with objects. Wallpaper was readily available because it was now mass-produced, and elaborate floral patterns, especially those in the primary colors of red, blue and yellow with a background overprinted with cream and tan colors, were popular.

In an era when more furniture was considered a sign of prosperity, many homes became crowded with large, heavy pieces. Furniture competed with paintings, sculpture and vases overstuffed with flowers. Instead of individual examples, matching furniture for a particular room became the "in" thing. The Grand Rapids Chair Company pioneered the creation of whole suites for bedrooms and dining rooms in the 1880s.

Like many other post-Civil War industries, new processes, inventions and machines drastically changed manufacturing. Machine production of furniture reduced costs substantially by diminishing the amount of hand labor. Specialized machinery was developed to carve multiple copies of a single part. The King Spindle Carving Machine, for example, created four identical panel pieces at one time. Planers, saws, joiners and dovetailing machines comprised just a portion of the furniture manufacturer's required equipment.[177]

Sears, Roebuck and Company, the Chicago retailer, was a prime provider of mass produced furniture through extensive advertising and marketing. The company produced its first catalog in 1891 and increased its merchandise and advertising pages each year of publication growing to over 1,000 pages by 1908. To the growing middle class it was one-stop shopping in a book—the equivalent of today's internet shopping—where everything from sewing machines, to watches, to baby carriages and stoves were sold. It was also the place to go for affordable furnishings. A four-piece mahogany bedroom suite consisting of a bed, a chiffonier (a high, narrow chest similar to a highboy), commode, and dresser cost just $39.25. Another massive "high grade" bedroom suite including a dresser, washstand and bed was reduced from $44.95 to $43.95.[178]

Specialized machines, efficient as they seemed, were not able to do all the work. Carving, painting and inlay work remained the task of skilled craftsmen like Alex. Many upper class customers who could afford to pay more also favored handmade pieces of furniture. According to the Michigan Historical Museum, an unskilled laborer in the great furniture factories in the 1880s might have earned as little as $1.50 a day, but an extremely skilled craftsman, such as

Alex Hamilton, may have earned up to $7.00 a day even though both worked about sixty to seventy hours per week.[179] According to the Census of Manufacturers, workers involved in hand trades—painters, paperhangers, carpenters, blacksmiths and wheelwrights—were skilled craftsmen and often had relatively high earnings. (The average annual earnings of hand trades craftspeople in 1880 was $339.)[180]

Alex, however, was a man who valued his independence and, if given a choice, would not work for someone else. He and John opened their own carpentry shop in 1878. Prior to opening it Alex, who had been living in Detroit for a year, may have worked for someone else, but no records have been found to confirm this. Alex and John's shop was located at 61 Beaubien Street, and the business was listed as "Hamilton Brothers" in the Detroit City Directory.[181] Beaubien Street ran from the Detroit River, where some of the larger Victorian homes were located, to intersect with Gratiot Street, one of the main thoroughfares, where shops and warehouses were situated. It was a clever place to locate a carpentry shop, since homeowners of large homes were always in need of skilled craftsmen to renovate, repair and build.

Hamilton Brothers prospered until 1880, when John decided to return to New Jersey. Alice's husband Miller had died suddenly in 1882 and she decided to return to New Jersey, where Miller's family still lived. John, her favorite brother, along with his family, accompanied her. We know that John and Alice were especially close as evidenced by John's heartfelt letters sent home during the Civil War.

By 1881 Alex was listed solely in the Detroit City Directory as having his business at 21 Cass Street. For the next seven years Lizzie and Alex would live at 140 24th Street. Unfortunately, tragedy was also in store for the couple. In 1884, six-year-old Annie, their youngest daughter, contracted diphtheria. Called the "plague among children," the infection was a major cause of illness and death among the young. An upper respiratory tract illness characterized by sore throat, low fever, chills, difficulty swallowing, rapid breathing and bluish skin coloration, it was highly infectious. As the disease

progressed, a tracheotomy or surgical opening of the trachea was often performed to improve breathing. There was little anyone could do for Annie and she died a painful death on November 29, 1884, breaking the hearts of her parents and siblings.[182]

Perhaps it was Annie's sudden death or the growing population of Detroit, which by 1885 had reached 170,000, that propelled Alex to move further west. Detroit may have become too citified for his tastes, with the installation of electric lighting in 1883 or the construction of the city's first skyscraper, the ten story Hammond Building, in the late 1880s. Since his teenage years, Alex had shown an inclination to shy away from gentrified geographic areas. He liked to wander and wander he did.

In 1889, having spent eleven years in the future Motor City, Alex and Lizzie moved to Seattle in what was then Washington Territory. The move would have been exciting. The Northern Pacific Railway, the newest transcontinental railroad with 6,800 miles of track, was completed in 1883, connecting the Great Lakes with the Washington Territory. The railway advertised for people to move to the Pacific Northwest and provided "immigration agents" to assist with the move. There were even special excursion trains for people to visit the fertile valleys and to locate land. Perhaps Alex and Lizzie took advantage of one of these excursions to travel to the territory (Washington became the forty-second state in November 1889).

Seattle certainly had an impressive location, lying on a narrow strip of land between Puget Sound and Lake Washington. Beyond the surrounding waters were two majestic mountain ranges, the Olympics to the west and the Cascades to the east. It was a town built on hills, with a mild climate and lush vegetation. There were abundant natural resources nearby, including virgin forests and coal. There was also a protected deep-water harbor, Elliott Bay, which fostered the fishing industry, shipbuilding and trade. Those industries, in turn, would lead to the city becoming a major shipping and trade center.

According to the Seattle City Directory, Alex and Lizzie lived on Lake Avenue at the corner of Rainier, a neighborhood located at

the far southeastern corner of Seattle near Lake Washington. Alex's occupation again was listed as carpenter. Interestingly, there is no evidence of their son Alex Jr. accompanying them to Seattle, nor is there proof of his remaining in Detroit, but we do know that Lizzie and Alex's three daughters initially stayed in Detroit. The west was too uncivilized for attractive, single young women who were now nineteen, eighteen and seventeen years old, respectively.

The three Hamilton teenagers were on their own in Detroit, trusted by their parents to behave within society's strictures. In reality, they were about to embark on a defining moment for women in America. Through education and the advancements and inventions of the times, new opportunities never experienced before were about to revolutionize the workplace for women. The Hamilton girls were on the front lines.

THE NEW WOMAN

"She (the emancipated woman) dresses likes a man,
as far as possible, thereby making herself hideous...
the next stop will be to wear her hair short and
adopt a mustache." - Letter to the Editor, *The New
York Times*, April 8, 1896

The Seattle that Alex brought Lizzie to was—just a few years earlier—a wide-open town of flowing liquor, easy women and serious high stakes gambling. Its inhabitants were mostly loggers and sailors, and other rough and tumble types, many of whom worked hard in the timber and shipping industries and played even harder. It was a lawless town where lynching was often the only substitute for "justice" (in 1886 rioters had forced 350 Chinese workers to the docks for "deportation"). Schools barely operated and indoor plumbing was unknown.[183] However, by 1890, just six years after the Great Northern Railroad made its way to Seattle, the population had climbed to 42,837 from 3,533 in 1880. Among this throng of people was an influx of women who, it was hoped, would help to "civilize" the town.[184]

If she didn't know before she arrived, Lizzie would have discerned immediately that Seattle was no place for young, unmarried women. Alex must certainly have had more than an inkling of Seattle's rough character. There may have been other reasons for Lizzie and Alex to leave the girls in Detroit. The couple would have wanted to find a suitable home and employment before sending for their children. Also, if one or more of the girls was still in school, it would have been disruptive to their education to take

them, and the uncertainly of the state of the schools in Seattle (the first high school graduation did not take place until 1886) may have been yet another factor.[185] Another more practical reason for leaving them behind was the cost of traveling with five or six people, as compared to two.

The three girls, having attended primary and grammar school in Detroit, as mandated by law, would have entered high school next. Jennie, as the oldest, would have been the first to attend, beginning when she was thirteen or fourteen in 1884. Despite its growing population, Detroit had only one public high school, Union Capital (it was housed in the old state capital building), located near Grand Circus Park. Students had a choice of course curriculums including the "English Course," the "Classical Course" and the "Latin Scientific Course." (The previous year, in 1883, the Detroit Board of Education had added a new course called "Commercial" to its curriculum.)[186]

Commercial education was a kind of vocational education for white collar occupations; it appealed to both sexes and their families. Initially, boys were the first to take commercial and business courses, but they were soon outnumbered by girls, especially as more and more clerical positions became available to women.[187] Office jobs, once the purview of men only, gradually were transformed with the expansion of government bureaucracies and growth in business, especially large corporations. Men who worked as clerks and secretaries saw such positions as a foundation to higher level positions, while women who took work as a clerk, typist or bookkeeper would often remain in those positions, finding advancement to positions of responsibility few and far between. Nonetheless, commercial education offered a positive forward step and it presented greater opportunities for young women to earn more pay (other than factory work) and to expand their horizons. Clerical work also became an acceptable way station before marriage and was an alternative to teaching.[188]

In Detroit, both young women and men could enroll in the commercial tract at school. If Jennie did enroll—and it would seem likely she did—she would have been one of the first to

enter the program after its introduction. The commercial tract began in the tenth grade and included arithmetic and practice in rapid computation; bookkeeping; penmanship; correspondence; commercial and physical geography; medieval and modern history or a language, either French or German. In Grade eleven, geometry, French or German were offered, along with bookkeeping, penmanship, correspondence, American history, commercial law and business ethics. In twelfth grade, natural philosophy, English literature or French or German were offered.[189]

Lizzie, a year younger than Jennie, and Alice three years younger, likely would have followed Jennie into high school and taken the commercial course, in preparation for finding work after graduation. The Detroit Board of Education annually published a report of the school year where they published the names of the graduates. The oldest Hamilton daughter Jennie would have graduated in about 1888. Unfortunately, the Board of Education eliminated its practice of publishing the graduates' names after 1886, so there is no hard evidence that Jennie and her sisters attended high school or graduated. There is, however, circumstantial proof that they did attend—at least for some time—since each worked in offices for a year or two around the time of their expected graduations.

As early as 1886 Jennie is listed in the Detroit City Directory as a clerk. By 1889 Alice is listed in the same directory as a bookkeeper for a firm of patent attorneys, Thomas S. Sprague and Son at 37 Congress West. By 1890 Lizzie and Alice were working as stenographers for Wood and Fales, a Detroit law firm located in the Moffat Building on the southwest corner of Fort and Griswold Streets in the financial district. Jennie is listed for the same year as a clerk. Their employment provided credibility that they had academic training for their positions, which included typing, bookkeeping, stenography and business practice skills.

Although the Detroit commercial high school tract did not offer stenography, the girls may have supplemented their education by taking a course either at one of the many private business schools or from an independent teacher in Detroit. According to David Tyack and Elisabeth Hansot, in *Learning Together: A History of Coeducation in*

American Public Schools, private commercial school enrollments were "...more than a quarter of the total number in all public and private secondary schools" by 1890.[190]

One such school, the Detroit Business University, founded in 1850 and located at 19 Wilcox Avenue in downtown Detroit, was a school of shorthand and typewriting and other "work skills." The school's broad mission was "to educate young men and women for usefulness." The school included a College of Business, School of Shorthand, School of Penmanship, School of Language and Elocution, School of Mechanical and Architectural Drawing and English Training School. Despite calling itself a "university," ads for the school made it clear that neither age nor prior education were requirements for admission.[191]

Promoted in the 1891 Detroit City Directory, the school advertised its shorthand and "Type-writing" curriculum as "easy to learn...and can be acquired by any person who has a fair idea of the correct pronunciation and spelling of words, no matter how young. "This school," the ad advised, "prepares young men and women for amanuensis (secretarial), office and reportorial work, including shorthand, type-writing, correspondence, spelling, grammar, business writing, etc."[192] Susan B. Carter and Mark Prus, in their article, "The Labor Market and the American School Girl, 1890–1928," offered another important reason girls might have chosen the commercial tract. With the idea that women would not remain long in a business position (the assumption being that they would leave to marry) employers might not be willing to invest time and money on training, preferring instead to hire women who already had the skills they sought.[193]

Once their parents headed west to Seattle, the girls boarded together in rooms at 282 Third Street, sharing expenses and providing support for one another. They were now independent women, with each receiving their own recognition and listing in the Detroit City Directory as Miss Alice Hamilton, Miss Lizzie Hamilton and Miss Jennie Hamilton, respectively, alongside with their positions. Although they earned a respectable salary, somewhat higher than female teachers (who averaged $350 annually),[194] they

also had to save for their eventual trip west to join their parents. This would be a difficult task—after they paid for rent, food and clothing, there were few discretionary funds left. In Pittsburgh— just 280 miles distant from Detroit with a similar size population— in the same year, the weekly salary for a stenographer ranged from $5 to $18 with an average of $9.55. A bookkeeper averaged a bit less, about $9.08. A female clerical worker averaged about $433.12/ year; her male counterpart received $925.70, more than twice the amount women were paid. Each worked 54 to 57 hours a week or an average of 9.25 hours a day, six days a week. [195] By scrimping and saving and probably not eating as well as they could have, the girls managed to get by and still put some money aside for their trip.

Perhaps unbeknownst to them, the Hamilton girls were on the forefront of the boom of women in the workplace as "typewriters," stenographers and clerks. They represented a new type of American woman, a "New Woman" who pushed the limits of society and its vision of women whose sole domain in the past had been the home. In 1870, less than 2,000 women were employed in business offices within the entire United States. By the 1880s the creation of a clerical workforce exponentially increased women's participation in the labor force by tens of thousands. [196]

For urban, middle class single women, options were extremely limited as there were only two major occupations outside of the home for them in the late nineteenth century: low paying factory work or clerical work in offices. (For educated women, teaching was a respectable option.) In the first half of the nineteenth century, with the creation of mill towns, industrialization opened the labor market to young, single women. Girls, some as young as eight or nine, left their families to work in factories and live in dormitories with other young women, making meager wages for long hours. [197] It wasn't until the 1880s that women had the alternative of working in an office.

It was the proliferation of railroads and the multimillion-dollar corporations that they eventually became that spurred the beginnings of the modern business office. They had hundreds of employees—conductors, ticket sellers, engineers, construction

workers, accountants, clerks, payroll officers and many others. All of them were distributed across the entire country, and they had to be trained, directed and supervised. Unlike the sole proprietor or a city-based company, administering this behemoth required a new system of organization and a vast communication system. Such an organization demanded more professional management than a group of stockholders and bankers could provide.[198]

The railroad needed managers to coordinate the movements of people and goods, operate roundhouses, maintain rail lines and other pieces of infrastructure, staff stations, and oversee all other aspects of railroad services. As demand for rail services grew, more employees were hired to coordinate the overlarge workforce and in due time a "hierarchy of staff" eventually took shape. By the mid-1800s management was now an integral part of the railroads' organization, as mid-level managers oversaw central offices and supervised bookkeepers and clerks and other service and support staff. By 1880 this business model was so successful that it was copied by Western Union (one of the world's largest telegraph providers at the time), the banking industry, and insurance companies.[199]

Once this "modern office" had emerged, there were job opportunities for a different type of work, one that was less arduous than factory drudgery. (Ironically, clerical work was originally a managerial level of work for men with opportunities for advancement in the small business model prior to 1870). Although the hierarchical modern office structure was an impetus for women who were seeking entry, the positions they were hired for were repetitive in nature and offered few opportunities for promotion. However, an office job—even one with routine tasks—offered more money than most, and included a certain level of respect. It became acceptable for single middle-class women to be employed as bookkeepers, clerks, typists, stenographers and secretaries. And with the great business expansion both domestically and internationally, there was a greater demand for more and more office workers in such positions.

Combined with this demand, new technologies—among them the telephone, typewriter, calculating machine, elevator and electric

light—were proliferating. These changes, in turn, had a tremendous effect on society and communication. Instead of writing and sending of letters by mail, which could take days to months, words could now be transmitted over telegraph lines in a matter of hours, or by phone in a matter of minutes. One has to wonder if people in late 1800s felt the same wonder that occurred in the 1990s with the introduction of cell phones and the internet.

There was additional innovation to be found in the design of office furniture. Gone was the ubiquitous fancy roll top desk for clerks, since it did not support good placement for a typewriter. Charles Sholes, Carlos Glidden and Samuel Soule had introduced the most notable technological advancement in the office, the first practical mechanical typewriter, in 1868. They sold their patent to E. Remington and Sons, manufacturers of sewing machines, for $12,000 in 1873 and the rest is history. By the time typewriters made their way into offices in the 1880s there was an even greater demand for clerical labor. Typewriters also changed the way work was performed to increase the demand for a different kind of labor than had previously been hired.[200] Innovations such as these spurred on even more diverse jobs, and while men were generally hired over women, gradually, because of the sheer volume of openings, women began to make significant inroads into professional employment.

As Elyce J. Rotella wrote in *Women's Labor Force Participation and the Growth of Clerical Employment in the United States*, "Prior to the development of the modern, mechanized office, the skills required of clerical workers had been specific to the individual firm and many clerical jobs were entry points to job ladders...."—jobs men vied for. "With increased mechanization and routinization [*sic*] of clerical tasks, the skills required of clerical workers became much more firm and general. This allowed employers to hire young, educated women. Together with the growth in commercial education, there was a rapid change in gender composition of the clerical work force."[201]

Today, it might seem remarkable that the girls' parents left them unchaperoned in Detroit in 1889, but this was a time when young people had more responsibilities, and they matured earlier.

The Hamilton girls situation might also be viewed as part of a new social movement of the "New Woman," one who asked for equal opportunities in the workplace, the right to vote and sexual freedom.

It was not surprising that the "New Woman" challenged the traditional roles of womanhood, and in doing so provoked a reaction to this perceived threat to society. Besides all-out criticism, it generated numerous satires in fiction, plays, political cartoons and newspaper editorials of the "emancipated woman." In a *New York Times* letter to the editor on April 8, 1896 such women were denigrated and vilified. "She (the emancipated woman)," the writer stated, "dresses like a man, as far as possible, thereby making herself hideous...the next step will be to wear her hair short and adopt a mustache." She wants, the writer, added, "...to work by man's side and on his level and still be treated with chivalry due her in her own kingdom—home and society—and abatement of this treatment produced a storm of indignation and wrath quite beyond the sex she is endeavoring to emulate."[202]

Equality and political rights for women were hot topics of the day. Ever since the first women's rights convention at Seneca Falls, New York in 1848, where Elizabeth Cady Stanton and Lucretia Mott offered a "Declaration of Sentiments," a manifesto of greater civil, social and political rights for women, the suffrage movement gained momentum and support among many women and even some men. It likewise engendered its own opposition group, simply called the anti-suffrage movement.

The attack against the New Woman became intertwined with the anti-suffrage movement, a group that pitted not only man against woman, but woman against woman. Founded in 1871, the Anti-Suffrage Party supporters tended to see women's role as concentrating on what they perceived as "feminine" duties, a maternal role and the exertion of influence and reform through example. Despite a reluctance to become involved in politics, the anti-suffragists ironically became organized, and founded the National Anti-Suffrage League. In 1910 they launched the *Anti-Suffrage Review*, a publication which denounced the behavior of the

suffragettes as "violent, sexually deviant, unnatural, unfeminine and a threat to other women."[203]

There is no evidence that the Hamilton girls in Detroit were either suffragettes or anti-suffragettes, but they did represent a new behavior for American women, not only in the workplace but also as living independently from parents and spouse. Like their cousin Cecelia Boudinot in New Jersey, they were living and working and socializing as single, financially independent woman in what was, in 1890, despite progress for women in the workplace, still a man's world.

While it was now permissible for women to work outside the home, society considered the ultimate occupations for women that of wife and mother. Seattle was a city where men outnumbered women and at their arrival the girls were presented with a pool of marriageable-age men from which to choose. Maturity, good judgment and parental consent often weeded the acceptable from the non-acceptable marriage candidates, that is if a girl conferred with her parents. For one Hamilton daughter, her choice would set in motion an unfortunate series of events. For another, life would take a cruel and tragic turn.

IMAGE GALLERY

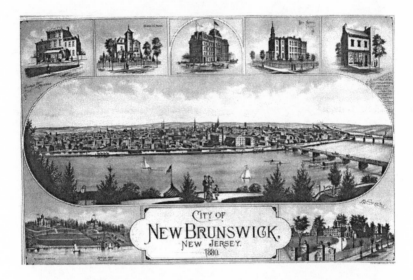

A city view of New Brunswick, N.J. dated 1880 highlights the city's location on the Raritan River, a major transport hub for commerce. (Library of Congress)

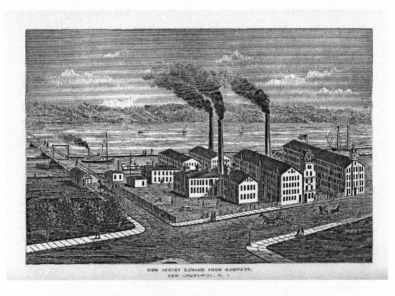

The New Brunswick Rubber Shoe Company (shown above) and the Novelty Hard Rubber Company where the Hamilton men worked were both owned by German immigrant Christopher Meyer. (History of Union and Middlesex Counties, New Jersey)

The Hamilton family lived near busy George Street in New Brunswick. (New Brunswick Free Public Library Postcard Collection)

Mary Ann's sole support for several years was her youngest son James. When he enlisted in the Army she worked part time at the rubber factory to supplement the money her sons sent during their military service. (Library of Congress)

......140, U. S. Pension Bureau Building and Grounds.

The United States Bureau of Pensions was located in the Patent Office in Washington, D.C. until 1887 when a new building was constructed to serve the needs of thousands of Union veterans after the war. Mary Ann Hamilton's pension application was received by the Monmouth County Courts and then reviewed by the D.C. pension office. (Library of Congress)

Puck., Dec.20, 1882, Vol.XII·No.302

Widows of Union soldiers line up to receive their pensions at the United States Sub-Treasury in New York City. (The Sub-Treasury was the precursor of the Federal Reserve Bank). (Puck Magazine)

Mary Ann was overjoyed when her sons, first John and then Alex, returned home from the war unharmed. More than 750,000 husbands, brothers and sons were killed in the war. Welcoming a surviving veteran home was an occasion to celebrate. (Library of Congress)

The First Methodist Episcopal Church on Liberty Street in New Brunswick was the site of Alex Hamilton and Lizzie Gilliland's marriage on January 18, 1868. (New Brunswick Free Public Library Postcard Collection)

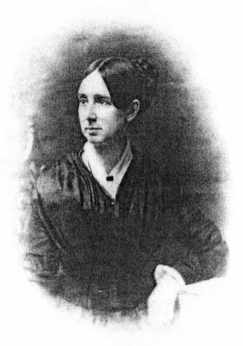

Reformer Dorothea Lynde Dix was the driving force advocating for "compassionate care" for the mentally ill. Dix founded New Jersey State Hospital in Trenton in 1848 based on her precepts for care of the "insane." (Library of Congress)

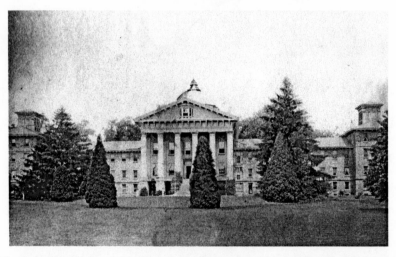

New Jersey State Hospital, now Trenton Psychiatric Hospital, was Susan Hamilton's home for many years. Many people, especially women such as Susan who was an epileptic, were incorrectly termed "insane" and hospitalized for mental illness. (Trentonian, Local History and Genealogy Collection, Trenton Public Library)

John Hamilton Jr., my grandfather and John and Lida's son, was born in 1872 in New Brunswick shortly before the family moved to Detroit. (Author's Collection)

The Detroit Metropolitan Police Department, Trumbull Avenue Station was Miller Boudinot's precinct house while he worked as a policeman. (Detroit Historical Society)

Detroit policeman of the era stand outside their precinct house. Their distinctive wool coats, high helmets and badges identified them to residents as law enforcement. (Detroit Historical Society)

The Boudinot children—baby Cecelia, William and Mary Ann—posed for a family photograph in 1879, two years before Mary Ann's tragic death. (Tunney Family Collection)

JUDGING CLASS 5, LONG BRANCH 4288 -15

Horse shows were a popular past time in Long Branch, a resort frequented by the wealthy in the summer. Here spectators watch the judging on Championship Day. (Library of Congress)

John Philip Sousa, world famous conductor of the United State Marine Band, was a frequent visitor to Long Branch where he entertained the elite and working class with his patriotic marches. (Library of Congress)

BROADWAY SCHOOL

The Hamilton children attended the Broadway Primary School located in the Upper Village of Long Branch near their home on Jackson Street. (Annual Report of the Long Branch Board of Education and the Principal of Public Schools for the Academic Year 1893-1894)

The Cult of Domesticity fostered a life centered on family, motherhood and patriotism. Girls could choose another path to follow but, as depicted on this illustration, it led to dissipation and being an outcast. (Library of Congress)

The popular New Housekeepers Manual espoused advice on managing a home, childcare, health care and other domestic duties. (Library of Congress)

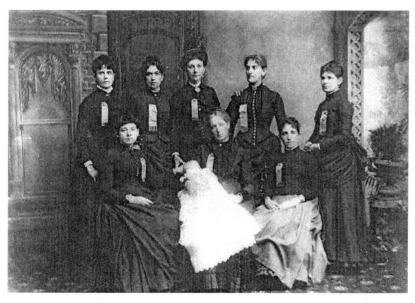

Lady Knights of Labor, a workers' rights association, lent support to each other during strikes and pooled funds for sick benefits and funeral costs. (Library of Congress)

The Women's Relief Corps of the Long Branch Grand Army of the Republic helped to raise funds to erect this monument at Greenlawn Cemetery in West Long Branch in memory and honor of the city's men who served in the Civil War. (Long Branch Free Public Library)

Great-grandfather John Hamilton, second row, third from the right, was a respected member of the Long Branch Military Band. The Band held concerts and entertained at local events. (Author's Collection)

Walter Asay served as a member of the Long Branch Atlantic Fire Engine and Truck Company, No. 2. Walter was an engine member. (Long Branch Free Public Library)

Alice Hamilton Boudinot Asay posed for a photographer about 1882. She was thirty years old but appeared to be much older. (Tunney Family Collection)

Cecelia Boudinot's high school graduation took place at St. Luke's Methodist Episcopal Church in Long Branch, the only available building large enough to accommodate the graduates, their families and friends. (Long Branch Free Public Library)

Cecelia Boudinot worked at the Eagle Shirt Factory, located at the corner of Spring and Ann Streets in Bordentown. (Mission First Housing Group)

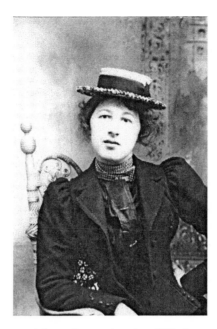

Cecelia Boudinot posed for a photographer circa 1899, the year she started her employment at the Eagle Shirt Factory. The following year she married Joseph Quigley, whose family were longtime Bordentown residents. (Tunney Family Collection)

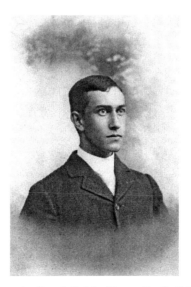

Studio portrait of Joseph Quigley (Tunney Family Collection)

The fountain at Grand Circus Park, Detroit's signature public space in downtown that connects the theatre district with the financial district, was one of the attractions of the beautiful progressive city known as the "Paris of the West."(Library of Congress)

Michigan boasted dozens of furniture factories and became famous as the Furniture Capital of the World. Here a man works by hand on a furniture factory floor after a machine operator has shaped the pieces of wood. (Grand Rapids Public Museum)

GET A HOME IN THE FERTILE NORTHWEST. WE WILL GLADLY HELP YOU TO INVESTIGATE. NO OBLIGATION INVOLDED. A. M. CLELAND, Gen. Pass. Agt. Northern Pacific Railway, St. Paul, Minn. L. J. BRICKER. Gen. Immigration Agt.

The Northern Pacific Railroad advertised "homeseeker excursions" to the Pacific Northwest to entice settlers there. Alex and Lizzie may have taken such a train to the Washington Territory. (Wikimedia Commons)

Alice and Lizzie (Beth) Hamilton worked as stenographers for two lawyers. This photograph illustrates a stenographers room at a Detroit manufacturing company about the turn of the twentieth century. (Library of Congress)

The Hamilton girls worked in offices where typewriters were common and used predominantly by women. Here a young woman uses a typewriter with apparent ease. (Library of Congress)

Geronimo, on horseback at left, the feared Chiricahua Apache chief and defender of his people, surrendered to the U.S. Army in 1886 after keeping a quarter of the Army (about 5,000 men) at bay for months with a band of thirty-six warriors. Known for "guerilla" warfare, Geronimo and his small band terrified settlers. (Library of Congress)

A map of 1891 Seattle eighteen months after the great fire shows a bustling port and growing city. The Hamilton girls arrived to a "new" city that was quickly becoming civilized. (Library of Congress)

The death certificate for Alice and Platt Elderkin's premature baby girl listed her death on December 12, 1891. The couple left Seattle for Snohomish shortly afterwards where they hoped to discover their "fortune." (Seattle Death Registry, Volume 1)

The grand and elegant court of the Palace Hotel in San Francisco was home to Alice and Platt while they house hunted. At the time, the Palace was the largest, most modern and "elite" hotel of its kind in the west. (Library of Congress)

The *City of Kingston* passenger steamer ran from Seattle to Vancouver and made numerous stops along Puget Sound. It may have been the steamer that Jennie and David Millar took on their honeymoon. (Puget Sound Maritime Historical Society)

Dr. Washington E. Fischel, a well-known and respected St. Louis doctor, was Jennie's attending physician during her hospitalization at St. Luke's Hospital. (Becker Medical Library, Washington University School of Medicine)

Jennie's burial certificate listed "ovarian tumor" as her cause of death. Just 22 years old, she died on January 12, 1893 and is buried at Bellefontaine Cemetery in St. Louis. (Missouri Death Records)

Arthur A. Denny, one of the founders of Seattle, was the city's wealthiest citizen. Edwin Griswold, Beth's husband, worked for him in various capacities for many years. (Seattle Public Library)

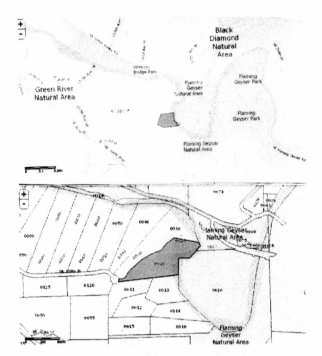

Two maps of the Green River Valley show the Griswold property adjacent to what is now Flaming Geyser Natural Park. (Google Maps)

The Borden Condensed Milk Company plant was located in Auburn about twelve miles from the Griswold farm. Local dairies sold their milk to the plant. (White River Valley Museum)

An unidentified dairy farm, circa 1910, was one of many in the Auburn vicinity and bore a resemblance to the type of farm the Griswolds managed. (White River Valley Museum)

The Ethelton Hotel at 1317 3rd Avenue in Seattle was the site of Beth's last days. The office of her good friend Dr. Wyllis Silliman was in the Arcade Building, one block away on 2nd Avenue. (Seattle Municipal Archives)

Wyllis Silliman's 1922 passport photograph shows an alert, attractive man in the prime of life. (U.S. Passport Applications, Ancestry.com)

This typical YMCA hut in Flanders was one of hundreds of clubs which provided rest and relaxation to servicemen in World War I. (Library of Congress)

Temporary field hospitals were set up near battlegrounds to help the wounded in World War I. Here injured soldiers in Meuse, France are being treated in a bombed church, a stark contrast to the hospitals and clinics that provided more comprehensive medical care to the troops. (Library of Congress)

The YMCA provided physicians and staff for hospitals and clinics to serve the wounded during World War I. Wyllis' skills as a doctor were especially needed due to the shortage of trained medical personnel. (Library of Congress)

IMAGE GALLERY

Young Alex Hamilton worked as a "cash boy" for Lowman and Hanford Stationery and Printing Company located in the 10-story Lowman Building, the tallest building in downtown Seattle. (Seattle Public Library)

The gold rush of 1898 created a mad rush and mass exodus of adventurers who traveled by ship from Seattle to Alaska to "discover gold." Most were unsuccessful and ill-prepared for the difficulty of reaching the gold fields. (Seattle Public Library)

Four men using rocker to mine for gold on Nome beach, Alaska, ca. 1900.
(University of Washington Libraries, Special Collections, Hegg 1355)

The shingle-style chapel at the Soldiers Home served both Catholics and Protestants and was
designed by world-renowned architect Stanford White. Landscape architect Frederick Law Olmstead
designed many of the park-like environments at the homes. (Library of Congress)

Promotional Map of Sawtelle Soldier's Home
Artist: Karen Kelley, 1898

An 1898 promotional map of the Pacific Branch of the National Home for Disabled Volunteer Soldiers in Sawtelle details more than 900 acres of the campus. The Home was a city unto itself with a hospital, dining hall, chapel, library, barracks, parade grounds, staff residences and administrative facilities. (Map of Sawtelle Soldier's Home, Karen Kelley, 1898)

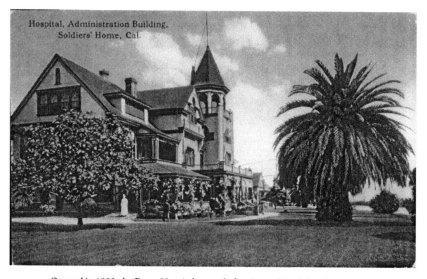

Opened in 1900, the Barry Hospital, named after General Patrick A. Barry, served the men at the home. It was replaced in 1927 with the James W. Wadsworth Hospital. (Santa Monica Public Library Image Archives)

Alex Hamilton's headstone sits among his brother veterans' graves at the 20-acre Los Angeles National Cemetery (*aka* Sawtelle Veterans Cemetery). (Author's Collection)

The veterans at the Soldiers Home received a respectful and ceremonial funeral
including a band which preceded the hearse to the adjacent cemetery.
(Santa Monica Public Library Image Archives)

Lizzie Hamilton hired Milo B. Stevens & Company, a well-known firm of
war claim attorneys to file her pension application based on her husband's
service during the Civil War. (Los Angeles City Directory)

Edna and John Hamilton Jr. attended Ladies Night on May 11, 1915 at John's Long Branch
Lodge No.78 of the Free and Accepted Masons. John marched in the Decoration Day parade
at the end of the month, caught pneumonia and died a few weeks later. (Author's Collection)

Edna owned her own home at 63 Jackson Street, an uncommon occurrence for women at the time, but suffered financially when her husband died suddenly. (Author's Collection)

Mildred and J. Herbert, Edna and John's children, were orphaned when their mother died in 1922. (Author's Collection)

A skilled seamstress, Edna may have earned a living as a tailor after her husband's death. A detail from a nightdress she made illustrates her sewing abilities. (Author's Collection)

IMAGE GALLERY

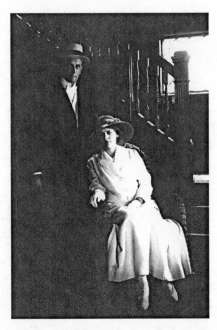

George Asay, son of Alice Hamilton Boudinot Asay and Walter Asay, stands by his wife Ada in an undated photograph circa 1917. The couple relocated to California several years later and settled in Beverly Hills. (Tunney Family Collection)

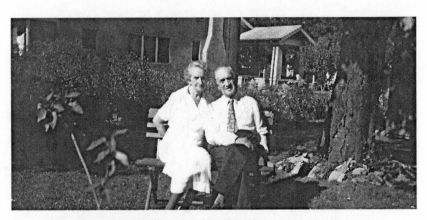

Laura Hamilton, great-grandfather John's second oldest daughter, married Harry Woolley and lived in Long Branch for the remainder of her life. The couple lived at 44 Norwood Avenue. (Author's Collection)

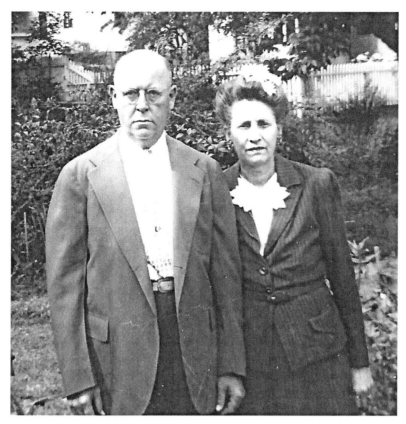

Jennie Hamilton Bolshaw, great-grandfather John's youngest daughter, was the family historian. She and her husband Harry Bolshaw lived for many years in Bergen County. (Taormina Family Collection)

TWO BRIDES

"The traditional Victorian wedding was usually held
in church or in the bride's house. Depending on how
wealthy they were, the place would be decorated with
extravagant bouquets and potted palms."
- Sarah Vu in *Victorian Nuptial*

When Lizzie and Alex eventually sent for the girls in 1891,
Jennie, Alice and Lizzie certainly were excited and thrilled
by the prospect of traveling across the vast open space that comprised
America's still-untamed wild west. Just a few years earlier, in 1888,
the Northern Pacific Railroad had completed its tunnel under the
Washington Cascades at Stampede Pass, giving Tacoma and Seattle
a direct link to the east for the first time. The railroad operated
through the northwestern states from Minnesota to the Pacific
Coast, making the trip more convenient and direct for the girls.[204]

The Northern Pacific Railroad offered its customers first
class and second class accommodations, each with substantial fare
differences. Those traveling first class were offered "elegant dining
cars, being marvels of luxury and of the most elegant design."[205]
They were also provided with Pullman Tourist Sleepers, each with
upper and lower double berths, furnished with mattresses, pillows
and blankets. Each Pullman car had a "uniformed colored porter
charged with the sole duty of looking after the comfort of our
patrons."[206] The railroad also offered special accommodations for
the "intended settler" with Free Colonist Sleepers for second-class
passengers traveling from St. Paul and Minneapolis to the Pacific
Coast. Although the sleeper itself was free, passengers had to provide

their own bedding or purchase a $3.00 package comprised of a mattress, blankets, pillows and curtains. Second class passengers, like the Hamilton sisters, were not permitted to use the "elegant dining cars," but instead procured their meals at regular "eating stations along the route or could carry cooked provisions with them."[207]

The cost of the two thousand mile trip from St. Paul to Seattle was four cents per mile, or approximately $80 per person.[208] The average rank and file female worker in an office received anywhere from $5 to $18 per week in large cities such as New York City.[209] Estimating that the girls made somewhere around $10 per week at their jobs as stenographers in Detroit, it would have taken them two months of full salary to afford the one-way $80 ticket to Seattle. In reality it had to have taken them longer to save this amount, since they had rent, food and clothing costs to budget. There was also the additional cost of traveling from Detroit, where they were living, to St. Paul, the terminus of the Northern Pacific, a distance of approximately seven hundred miles.

Although the thought of living in Seattle was tremendously exciting, it must have been somewhat frightening at the same time. The Washington Territory had only entered the Union recently, and a long distance train trip, onerous as if might be, would be the adventure of a lifetime. If the newspapers and pulp fiction of the day were any indication, the west was a wild and rough place. Stories abounded with a sensationalism that would challenge modern day concepts of civilized behavior.

Asa Shinn Mercer, who had been the University of Washington Territory's first teacher in 1861, traveled across the continent to New England twice, once in 1864 and again in 1865, to solicit wives for the men in the territory. Women were scarce, and his admirable intention was to return with hundreds of young marriageable women. He did return—first via the Isthmus of Panama while battling disease and dampness and then by way of Cape Horn, a particularly dangerous route due to strong winds, large waves and treacherous currents—but with far fewer women than he had hoped for (he had promised five hundred but returned with less than one hundred). They would forever be known as the

Mercer Girls or Mercer Maids, and since they had a large pool to select from, most quickly found husbands.[210]

By 1891 the major Indian wars were over, but the American West was still a most unruly place. There were still roaming bands of Indians, too: violent, wild "red men," in the parlance of the day, who might scalp you, and if rumors were true, inflict unmentionable atrocities on you if you were a woman. The most feared Apache leader, Geronimo, and his small band of warriors, evaded capture from United States and Mexican forces for more than a year just five years earlier in 1886. It was estimated that in the last five months of Geronimo's career, he and 16 of his warriors killed 500 to 600 Mexicans. (Although Geronimo also attacked American settlements, he had a special hatred for the Mexicans who had killed his mother, wife and three small children in 1861, in addition to dozens of others in their band).[211]

The girls may have also read about range wars between cattlemen and sheep men and the often violent outcomes of such disputes. The invention of barbed wire had also spurred controversy: the farmers used it to corral livestock and deter trespassers, but it also put a stop to open grazing, allowing smaller farms to sprout. Grizzly bears and roaming packs of wolves added a bit of additional danger. "Wolfers"—those who killed wolves for money—had exterminated hundreds of thousands of the animals. There was also the cowboy—a symbol of the American frontier—who had become a figure of legend with stories of rugged self-dependence and chivalry, if the newspaper accounts of the day could be believed. The west was an exciting and often dangerous place, full of surprises, but it also had the potential for great adventure.

When the three Hamilton sisters arrived in Seattle in 1891, they found a new and surprisingly calm city in the making. Two years earlier, on June 6, 1889, a devastating, fast-moving fire leveled most of the wooden buildings in town, leveling 116 acres in the city's business district. As a result twenty-five blocks of downtown were left in smoldering ruins. Property damage ran into the millions of dollars, but the fire also had the positive affect of promoting municipal improvements, among which were widening and resurfacing of the

streets, the start of a professional fire department, reconstructed wharves and a municipal water works. New construction rules stipulated that all new buildings were to be made of brick or steel, replacing the previous flimsy wooden structures.[212]

It had taken a short time for the city to become relatively civilized. By the late 1880s the first bathroom with indoor plumbing had been installed, sewer lines for new residences were mandated, a YMCA gym was constructed, and the first street car, cable car, and ferry service had been initiated. In 1890 the city's premier department store, Frederick and Nelson, was opened, and it would continue to operate for 101 years.[213] The "wild" town had become gentrified just in time for the arrival of the Hamilton girls—and possibly to their dismay, after all of the stories they had undoubtedly heard and read. However, it was a heart-warming reunion for the girls and their parents, since they had not seen each other for two long years. We can imagine that they spent days, if not weeks, trading stories with their parents, recounting their train ride and expounding on news about friends in Detroit—information they had probably included in their letters to their parents but which didn't capture the full flavor of their activities.

The sisters wasted no time in becoming "Seattleites." Lizzie, who now called herself Beth, took a job as a stenographer for two attorneys, John H. Allen and Jay C. Powell, who had offices at 31-35 Union Building at 713 Front Street. According to the 1891 Seattle City Directory, the attorneys also had a new fangled contraption—a telephone (with a three-digit number no less). Beth boarded with her parents at South Clarence Avenue, two houses north of Milwaukee Avenue.[214] Of the three sisters, Beth continued her career beyond her first year in Seattle. She is listed in the directory as a stenographer from 1891 through 1896. She boarded with her parents during those years although she was listed separately in the city directory—another testament to her independence.[215]

Within a year of arriving in Seattle, Alice and Jennie relinquished their careers for marriage. Alice, eighteen years old, married Platt B. Elderkin, age twenty-one, on April 18, 1891, a short time after arriving in Seattle, after a whirlwind courtship.[216] Although she

is not listed in the directory for 1891, Alice may have worked as a stenographer, as she had in Detroit, and so it is probable that she met her husband at her workplace since he was employed as a stenographer for the U.S. Land Office in Seattle.

The United States Land Office was part of the General Land Office (GLO), an independent agency of the United States government responsible for public domain lands. Platt Elderkin's field office had been established in June 1887, and it oversaw the surveying, platting and sale of public lands in the Western United States. It also administered the Preemption Act of 1841 and the Federal Homestead Act of 1862, both passed in order to assist in the disposal of public lands. Both laws gave applicants (or squatters in the case of the Preemption Act), the ability to purchase land at little or no cost. Other functions of the office included the entry of mineral rights, as Washington State was rich in a number of mineral resources. Platt may have used the information he gained in the office as an opportunity, since he became a miner himself shortly after his marriage.

According to their marriage license Alice and Platt were married in the home of Reverend and Mrs. John F. Damon at 910 5th Street in Seattle. Reverend Damon was one of the first Congregationalist ministers in the Washington Territory. Ill health had forced him into semi-retirement in the 1880s. As a result, although he was not assigned to a specific church, he married hundreds of couples, usually at his home. Reverend Damon's wife served as a witness to Alice and Platt's marriage, as did Pearl M. Cary, who may have worked as a domestic in the Damon household.

A young woman of this era was often married at either a church or at her parent's home. While it is impossible to know if Alex and Lizzie disapproved of the match, it was unusual that Alice was not married at home given the fact that her sister's wedding the following year took place there. It was also odd that Alice did not ask one of her sisters to serve as maid of honor. It seems that the young couple married quietly, quickly and perhaps secretly to deflect any criticism from the Hamilton family because the couple could not have known each other for very long. The sisters had

arrived in Seattle in early 1891 and Alice was married only one or two months later in April.

Alice's Aunt Jennie Hamilton, who lived in Long Branch, New Jersey, was the family record-keeper, maintaining newspaper announcements and clippings of important events in the Hamilton family both in New Jersey and for Alex's family in Detroit and Seattle. Significantly, there is no record of Alice's marriage in Jennie's papers. Perhaps, as soon was proven, the marriage was not something to celebrate. Surprisingly, after the wedding, the young couple had moved into Alice's parents' Clarence Street home. If there was disapproval of Alice's choice of a marriage partner, Lizzie and Alex might have offered an invitation to live with them as a peace offering. Such an arrangement may also have afforded the parents an opportunity to learn more about Platt. Both Lizzie and Alex wanted the best for their daughter, including a good, reliable husband. Living as a group would tell them a lot, and allow them to assist the couple, especially since they were about to become parents. Sadly, in December, Alice gave birth to a stillborn girl, who at seven months was unable to survive. The unnamed child was buried at Lakeview Cemetery in Seattle.[217]

After the death of their baby the next record of the Elderkins appeared in the 1892 Seattle City Directory which listed Platt Elderkin as having "removed from Seattle to Snohomish" Washington. [218] Alice would have accompanied him. Snohomish was a very small rural community 48 miles northwest of Seattle. There is no conclusive evidence of Platt's reason for relocating to Snohomish, and it makes little sense since there were few occupational options for him in that rural, sparsely populated area.

In 1884 Snohomish had seven hundred residents, a two-story courthouse, a sawmill, a school, six saloons and a church. Since the discovery of gold in 1859 in Rock Creek, Klickitat County, Washington, there was a migration of miners to the area. In 1889 more gold was discovered at Monte Cristo in eastern Snohomish County, drawing large numbers of prospectors to the area.[219] Perhaps gold was the impetus for Platt's relocation, since his employment at the Land Office gave him firsthand knowledge of strikes. He may

have even struck gold himself. According to an October 15, 1895 article in the San Francisco newspaper, the Elderkins "came into a legacy of $25,000" while living in Washington State.[220] There is no explanation of what the legacy was (from bequests in a relative's will, for example) and there are no records that could be located to explain it. Could it have been a gold or other mineral bonanza? Possibly.

Three years later, in the spring of 1895, Platt and Alice had relocated again, first to Los Angeles, and then a few months later to San Francisco. As befitting well-heeled visitors, the couple stayed at the Palace Hotel, the grandest and most elegant hotel in the western part of the United States at the time.[221] All 755 rooms boasted a private bathroom, and each room was equipped with an intercom or call button to summon hotel staff when needed. The "modern" hotel also was equipped with "elevators" or "rising rooms" which delivered guests to each of seven floors. The Palace was the epitome of elegance and the Elderkins were guests at the hotel for several weeks.[222]

In October of that year Alice made the news when she sued one William Wallace for embezzlement in the courts. As reported in the *Los Angeles Herald* newspaper, Wallace knew Alice and Platt when they lived in Seattle. He followed the couple to California and, according to the newspaper article, the couple helped him "in many ways" (Wallace told his wife that the Elderkins were going to set him up in business). The dispute occurred when Alice asked Wallace to sell a rig and horse for her. He sold it for $150 and pocketed the money himself. At that point, Alice brought suit against the wily Wallace, who was no stranger to the other side of the law having sold cash registers for his employer and also keeping the money. The disposition of Alice's case is not known although it would have been apparent that with a prior criminal record Wallace would have spent some time in jail. [223]

Alice and Platt decided to stay in San Francisco, purchasing a real estate lot perhaps intending to build a home. They changed their minds and sold the property in June 1896 for $10.[224] That same year, Platt is listed in the San Francisco City Directory as an

attorney residing at 1513 Grove Street.[225] In the late eighteen and nineteenth centuries aspiring attorneys were required only to take an oral test before a judge to be admitted to the bar. As a former stenographer in various government offices who would have been familiar with laws and government regulations, it would have been relatively easy for Platt to pass the test. It was not until 1919 that the oral test gave way to a written examination. (The first state to introduce a Board of Law Examiners was California, by order of the State Supreme Court).

By 1896 Platt's marriage to Alice wasn't faring as well as his career. In February 1899 he sued Alice for divorce on the grounds of desertion, as reported in the *San Francisco Call*.[226] In August, he was granted a divorce.[227] He wasted no time, and was remarried in Nevada a few days later to Mary or Marie A. Bidewell, who had an eleven-year-old daughter named Elba.[228] The fact that Platt remarried immediately upon being granted a divorce suggested that he and Mrs. Bidewell had been an item for some time, and that Alice had been out of the picture for an equal amount of time. Unfortunately, there is no surviving record of the divorce because all civil records, which were housed in the Hall of Records, were destroyed in the fires following the Great San Francisco Earthquake of 1906. Did Alice leave Platt and if so, why? Or was "desertion"—one of the criteria for a divorce—just a convenient ploy for Platt, the attorney?

We do know that Alice did not return to Seattle. And we know that in 1910 she was still alive because her mother's census data indicated three living children, Alice being one of them. Did she remarry? Have children? Return to work? Did she keep her married name or revert to her maiden name? There is simply no way to answer these questions with certitude. While several Alice Hamilton's were found in the San Francisco City Directory, none matched Alice's age or profession. (The detective in me will continue to search old records in the hopes that the rest of Alice's story can be told). There is a clearer record trail for Platt, who was listed alternatively as an attorney-at-law in the city directory in 1897, 1899 and 1900. His career as a lawyer may have stalled at some

point. Beginning in 1904 he was again listed as a photographic reporter and subsequently in 1910 as a shorthand reporter. In later years, according to the 1920 and 1930 census, he was listed as a lawyer. Platt Elderkin died in 1932.[229]

The year following Alice and Platt's wedding, Jennie, who was now known as Jean (perhaps so she would not be confused with her Aunt Jennie in New Jersey) married David Millar on July 7, 1892 in Seattle.[230] The groom was the owner and manager of the Silver Creek Ranch in nearby Kitsap County. While there are no land records that could be located for the Silver Creek Ranch, a proliferation of small ranches existed in the region. Kitsap County, with a population of 4,600 in 1890, was completely rural. Large-scale berry (strawberry, cranberry and cane berry) farms and dairies were located in the Poulsbo and Bainbridge Island areas of North Kitsap.[231] There were also apple, pear, peach, plum and pear orchards. The soil was rich in glacial till, ideal for growing, and the county had an agricultural history dating back to the early 1880s. There were hundreds of small farm and ranch parcels throughout the county and David Millar owned and managed one of these.

Jean's namesake, her aunt Jennie Hamilton of New Jersey, clipped the newspaper article of the wedding as a keepsake. The article was titled *An Elegant Little Wedding Party at the Lake* and read,

> There was a quiet little wedding out on the shores of Lake Washington last evening in the picturesque home of the bride's parents. The contracting parties were David Millar and Miss Jean McIntyre Hamilton. Outside of the immediate members of the family only Mr. Millar's boon (good) companion, R. B. Leithead, was present. It was an elegant affair, however, and Rev. John F. Damon officiated. Following the ceremony came a wedding feast, and under a shower of rice the newly wedded couple drove away in a carriage and took the steamer for Victoria, whence they will visit all points of interest along the Canadian Pacific line this side of Calgary.

> The wedding presents were numerous and elegant. Mr.
> Millar is the owner and manager of the Silver Creek
> Ranch in Kitsap County.[232]

Jean's wedding was in stark contrast to Alice's wedding. The only similarity between the two was that Reverend Damon officiated at both. Beth served as Jean's maid of honor and Robert Leithead Jr., the groom's best friend, a druggist, served as best man.

Following the traditions of the day, the Hamilton home was decorated with a profusion of white adorning doorways, windows and fireplaces. After the ceremony, the couple received the congratulations and best wishes of the family at an elaborately decorated corner of the bride's home (one contemporary etiquette book cautioned guests never to congratulate brides, only grooms). Since it was a summer evening, tables might have been set up outside where the party could eat after the ceremony.

The bride and groom cut the cakes, a light white bride's cake and a darker groom's cake. As soon as the cakes were cut, the couple changed into their traveling "costumes" and prepared to depart on their honeymoon. As they set off in the carriage, well-wishers threw satin slippers and rice after them—if a slipper landed in the carriage, it was considered good luck.

By all accounts it was a lovely wedding and yet one can't help thinking that throughout the joyful day, thoughts of Alice, her lost baby, and the Elderkins move to Snohomish might have been on the minds of Lizzie and Alex as they considered their two daughters and their different fates. It was a blessing to them that they could not see ahead to a still more tragic turn of events that would soon unfold.

Chapter 12

A SWEET AND BITTER LOVE

"And thou art dead, as young and fair
As aught of mortal birth
And form so soft, and charms so rare,
Too soon return'd to Earth!"
- George Gordon "Lord" Byron
1788-1824

In early days men "captured" their brides and carried them off to a secret place where they could not be found by relatives. While the moon advanced through its phases—about thirty days—the couple drank a brew made of honey and mead, thought to have aphrodisiac powers. So came into being the word "honeymoon."[233]

In Victorian times, a honeymoon was both a time to become intimately acquainted and a time to relax. Immediately after their wedding, David Millar's best man would have preceded the couple to the steamer to look after their luggage. Traditionally no one would ask where the couple was going because it was considered bad taste. Only the best man knew, and he was strictly bound to secrecy. As indicated in their wedding announcement the couple planned to embark on a cruise along the Canadian Pacific coast. There were many steamers that plied Puget Sound between Seattle and British Columbia in Canada. Although there is no way to know which steamboat they took, possible ships were the *George E. Starr*, a side-wheeler that ran between Tacoma, Seattle, Port Townsend and Vancouver, or perhaps the *North Pacific* which ran from Olympia to Vancouver. *The City of Kingston*, a steel-hulled propeller boat, also served the international run between Tacoma and Vancouver (until

she was unfortunately rammed in a heavy fog and sank in 1899).[234]

Many of these steamboats had dining rooms with white linen tablecloths and flower bouquets, and were considered an elegant means of travel. As one advertisement for the *City of Kingston* and *City of Seattle* steamships stated, they offered "palatial steamers and the largest and finest steamer on Puget Sound." The company also advertised "Only first-class accommodations and the cuisine of the very best."[235] It was a luxurious means of travel, especially for a honeymoon, so one can assume that Millar was sufficiently prosperous to afford this luxury.

By the 1880s and 1890s steamboat technology had improved considerably and since rail lines were limited and roads were still poor and there were few, if any, automobiles, the water route was the most accessible method of travel between cities on Puget Sound. Its "Mosquito Fleet"—so called because steamers were so numerous that the locals said they resembled a "swarm of mosquitoes"— included a large number of private transportation companies running passengers and freight. Seattle's central location on Puget Sound quickly helped the city develop its status as a major maritime transportation center. Steamers moved settlers, farm produce and livestock, machinery, timber, mail and anything else needed to build and serve the settlements along the coast.[236]

Navigational skills were critical on these ships, especially since fog was a common occurrence on Puget Sound. Captains had no radar, GPS or depth sounders and often their experience at reading echoes from boat whistles bouncing off the coastline were the only indicators at their disposal to navigate in poor visibility.[237] During her honeymoon and subsequent journeys in the months immediately following her marriage, Jean wrote several letters home describing her travels. Her letters were published in the *Home News* newspaper. Although no known copies of her letters exist nor archives of the *Home News* for that time period, we know she wrote them as her Aunt Jennie in New Jersey commented on them. Keeping journals and writing letters was a common activity in Victorian times, whether one was an explorer, tourist or honeymooner, and many travelers to British Columbia recorded their experiences. "Some

were local residents and journalists…many more were visitors from afar keen to detail their experiences," according to an article entitled *Boosterism and Early Tourist Promotion in British Columbia*.[238]

The Millars traveled to British Columbia on their honeymoon to relax and escape the hectic pace of the city. In 1908 P. A. O'Farrell of New York City wrote in the *Saturday Night* magazine that British Columbia's Arrow Lake Country provided the opportunity to trade the hustle and bustle of the "Big Apple" for the "relaxing sight of orchards, gardens and lawns." Poet and travel writer Ernest McGaffey, in a 1913 article for *Sunset* magazine, hailed Vancouver Island as a place where a "Modern metropolis touches the margin of a pristine wilderness.[239] O'Farrell and McGaffey together hailed the province's restorative powers and their observations were echoed many times by other tourists, and most certainly by Jean.

In 1920, Irene Todd, who wrote an accompanying article for *Saturday Night* magazine, journeyed, like Jean, along the Pacific Coast. She chronicled the natural beauty of British Columbia including "the softly breathing sea" and the "shaggy islands over which a few stars kept watch." She praised the way in which the sunrise "broke over the snowy summits of the mountains of British Columbia, tingeing them with crimson and gold."[240] These highlights of her travels are no doubt similar to what Jean experienced and perhaps also wrote about.

For someone like Jean, who had grown up in Detroit and then traveled to another, albeit less congested city like Seattle, the grandeur of British Columbia's natural attractions would certainly be a subject to write about. With the exception of traveling by train through the Northern Rocky Mountains en route to Seattle, she had never traveled through such wilderness or viewed such natural beauty before. The steamer traveled northward towards Vancouver and the coastal landscape was highlighted by the Coast Mountains, high snow-covered mountain peaks rising majestically above narrow fjords and inlets.

When the Millar's steamer stopped at Vancouver, the couple saw a "small" city of about 14,000, but also one that was advanced technologically for the time, boasting an electric streetcar system

that ran from the Granville Street Bridge to Union and Westminster Streets. The city also possessed beautiful beaches, adding to Vancouver's reputation as "one of the healthiest cities on the North American Continent. Its climate, the geographical situations, its modernity all help to make it so, but there is added to those factors the magnificent sea bathing."[241] Since the couple was traveling in July they surely took advantage of these waiting opportunities.

In addition to visiting Vancouver, the steamer stopped at Vancouver Island and Victoria, British Columbia's capital, known as the "Garden City" for its lush foliage and flowers. Jean and David would have visited the nearby attractions, including the Fisgard Lighthouse, the first of its kind on Canada's west coast. They may have taken a buggy ride to admire the recently completed Craigdarroch Castle, the baronial mansion on a hill built by coal magnate Robert Dunsmuir and his wife, Joan. Unfortunately, Dunsmuir died before the castle's completion, but his two sons finished the thirty-nine-room, 25,000 square foot residence just prior to the Millar's visit. The house, set on twenty-eight acres of formal gardens, cost $500,000 to build (about $14.3 million in today's currency).[242]

All this and more was likely memorialized by Jean in her letters home. While we don't know the extent of their trip, it certainly would have taken several weeks for them to travel north from Puget Sound into the Salish Sea and its network of coastal waterways which separate the British Columbia mainland from Vancouver Island. They would have stopped at major port cities along the way, including Tacoma, Victoria, Vancouver, and Port Angeles, taking time to explore each of them. At the conclusion of their honeymoon, the couple returned to Seattle and traveled to Millars' ranch in Kitsap County to set up housekeeping. Unfortunately, a quiet happy life did not ensue.

Just a few months later, in January 1893, Jean and David were in St. Louis, Missouri, where Jean was admitted as a patient to St. Luke's Hospital, an Episcopalian facility. We don't know why the couple traveled to St. Louis, a distance two thousand miles from Seattle, but there are several possibilities. Perhaps the newly married

couple went to visit family, since there were Millars in St. Louis, although there is no way to know if they were relatives (Millars also are buried in Bellefontaine Cemetery—the same cemetery where Jean was laid to rest). Or perhaps St. Louis was a stopover on a longer trip. They may have been traveling cross-country on pleasure or even to New Jersey to visit the Hamilton family and in particular, Jean's namesake, her Aunt Jennie. It's also possible that St. Louis was the destination for a business trip for David and that Jean accompanied him. Whatever the reason for their stop in St. Louis, Jean was hospitalized, and her attending physician was Washington E. Fischel, one of the city's most respected and well-educated physicians.

Fischel had graduated from St. Louis Medical College in 1871 just before his twenty-first birthday. After interning at St. Louis City Hospital, he traveled and did post-graduate studies for three years at the universities of Prague, Berlin and Vienna. returning to St. Louis to set up practice in 1874.[243] He served as a member of the medical staff and Board of General Direction of St. Luke's Hospital. He also served as a lecturer on therapeutics, professor of hygiene and forensic medicine and lastly as professor of clinical medicine at the St. Louis Medical College and the Washington University Medical School. He was instrumental in developing a department of pathology at the latter school, its object being the study of the cause and cure for cancer.[244]

He was a doctor's doctor. As one of his contemporaries recalled, Dr. Fischel was "always informed as to the newest in medical research," and "was ready to abandon the old and adopt the new whenever his judgment and experience confirmed the new as better."[245] Rather surprisingly, his written scholarship was not preserved, but from secondary sources its apparent that he was a prolific contributor to medical literature in the form of papers and reports to various medical societies. As another colleague commented, "He was an eager student of medical literature and was broadened by frequent intimate personal contact with the great clinicians of this and other countries."[246] David and Jean could not have hoped for a more informed doctor to deal with her illness. Dr.

Fischel's pleasant demeanor and kindness were also well known. Still another colleague noted, "His [Dr. Fischel's] presence in the sick-room seemed to radiate cheer and courage; his confidence and strength brought renewed hope.[247] Another stated, "Only by meeting him face to face and receiving his hearty handclasp and his genial, courteous greeting...by observing the gentle thoroughness of his examination of his patients...and by feeling the atmosphere of strength and cheer he brought with him...is it possible to have known Dr. Fischel as he was."[248]

Jean Hamilton Millar was just twenty-two years old and she was probably in severe pain. When Jean arrived at the hospital and was examined, her condition was diagnosed as an ovarian tumor (as cited in a certificate), possibly ovarian cancer, which one American gynecologist of the era, Harry Sturgeon Crossen, called a form of "creeping death that defies early discovery."[249]

If she was what might be considered a "typical Victorian" she probably voiced few complaints until her discomfort made silence impossible. The Victorian era was a modest time when women did not readily speak of female complaints. Fear of stigmatization prompted people to conceal their symptoms, yet when Jean's symptoms progressed to a point of great physical unease she could no longer ignore the fact that something was terribly wrong. Her husband was probably as frightened and concerned as Jean and sought out the best medical opinion he could find with no expense spared.

While Jean's young age would normally make ovarian cancer a dubious diagnosis, there is a remote possibility that she did suffer from it. There are, however, other medical possibilities that may have led her doctor to diagnose a tumor. One suggestion is that she suffered from an ectopic pregnancy, a situation where the fertilized egg implants itself outside the uterus in the fallopian tube near the ovary, causing abdominal pain and absence of a menstrual cycle. The most feared complication of an ectopic pregnancy and usual outcome is a subsequent rupture of the tube, leading to internal bleeding, intense abdominal pain, shock and even death. It would not be unusual for a young married woman such as Jennie to suffer from this condition.

Another possibility, one perhaps more probable due to its

progression, is ovarian torsion. In this disease the ovary, often including the fallopian tube, becomes twisted around the vascular pedicle, the tissue containing arteries and veins. Twisting obstructs venous flow, thus causing engorgement and edema. Engorgement can progress until arterial flow is compromised leading to ischemia (restriction in blood supply to tissue) and infarction (tissue death). An ovary with a mass or cyst is more liable to twist. This disease most commonly occurs in women during their early reproductive years and 20 percent of torsion occurs during pregnancy. Further complicating matters is that a twisted ovary can also untwist, causing intermittent symptoms. Ovarian torsion was cited in the medical literature as early as 1890 and would have certainly been known to Dr. Fischel.

There were no advanced diagnostic tools available in the late nineteenth century that could confirm a diagnosis. Abdominal Ultrasounds, Computed Tomography (CT) and Magnetic Resonance Imaging (MRI), would not be invented for another eighty years. In fact, diagnosis of ovarian torsion is still challenging today because it is non-specific with no absolute clinical profile. A clinician must differentiate between ovarian torsion and other possibilities such as an ectopic pregnancy and even appendicitis or ovarian cysts, among others. Surgery to remove the ovary (to keep it from twisting again) is critical, otherwise an array of complications, including peritonitis and sepsis, and eventual death could follow. By the mid-nineteenth century physicians were able to perform a limited range of surgeries on the ovaries and uterus. Interestingly, there were strong prejudices against doctors performing examinations of females and their sexual organs. The introduction of anesthesia and antiseptic methods helped to make gynecological surgery more available and practical and eventually overcome opposition. By 1880 the separate specialty of gynecology—the practice of dealing with the health of the female reproductive systems and breasts—had become well established.

A third possible diagnosis would have been endometriosis, a painful disorder in which tissue that normally lines the inside of the uterus grows outside the uterus. When the displaced tissue has

no way to exit the body, a large endometrioma, or cyst (growth of blood vessels on the ovaries), can occur. If this were the case, the cyst eventually would hemorrhage internally and, in turn, cause death. Dr. Fischel was a general practitioner, not a gynecologist, but he was well informed, and he would have called in a specialist to exam Jean. "Whenever he required specialized skill," his colleague Dr. Abraham Jacobi, stated, "he knew where to find it and when to advise it."[250]

We have no knowledge of whether a surgeon attempted to correct the possible torsion (if such a procedure was even known in 1890s). Whether Jean underwent surgery or not, she was undoubtedly in great pain, and opium and morphine would have been prescribed to alleviate it (both were legal and readily available in those days). Her husband of six months was at her side constantly—perhaps taking a moment to rush to the telegraph office to send a message to Lizzie and Alex in Seattle informing that it looked as though the end was near. Sadly, on Friday, January 12, 1893 Jean (Jennie) Hamilton Millar died at St. Luke's Hospital, leaving a stricken, shell-shocked husband and distraught family in Seattle.[251]

There was nothing her doctor could have done to help her. Yet, he would remember Jean and all other patients he treated in the future, and would use that knowledge and concern to establish the Barnard Free Skin and Cancer Hospital in later years. He would also impart his passion to his son, Dr. Ellis Fischel, who would help found the Fischel Cancer Hospital in Columbia, Missouri in 1940, the second cancer hospital in the country and the first hospital west of the Mississippi, to devote itself to the treatment of cancer patients.[252]

David buried Jean in Bellefontaine Cemetery in St. Louis. There is no way to know why he did not have her body sent back to Seattle. Her obituary appeared in the *Home News* and cited the cause of her death as typhoid fever.[253] Her death certificate, signed by Dr. Fischel, noted the cause as being an ovarian tumor. The prejudice against articulating women's diseases in the late Victorian era obviously lent itself to prudery even in death. The death of

women like Jean from a reproductive disease and the actions of many forward-thinking physicians like Dr. Fischel were catalysts which eventually brought better medical treatment to all women.

Chapter 13

THE GREEN RIVER VALLEY

"By 1880, Washington's cowherd had grown to
more than 27,600 cows fostering a growing dairy
farming tradition that continues today."
– *Dairy Farmers of Washington*, 2014

The "career" woman of the Hamilton family was undoubtedly oldest daughter Lizzie. She had changed her name to Beth, possibly to avoid confusion with her mother who shared the same given name. While the family still lived in Detroit, Beth's first entry in the Detroit City Directory was in 1890 along with her sister, Alice. Although there is no documentation to support whether Beth or Alice attended and graduated high school or took the "Commercial Tract" offered by the school, by 1890 the girls had acquired the needed skills to work as stenographers for Emery T. Wood and Bingley R. Fales, whose offices were in Detroit's financial district.[254]

When the sisters moved to Seattle in 1891 to join their parents and brother Alex, Beth sought office work and was hired immediately as a stenographer for Jay C. Allen and John H. Powell, a law firm located at the Union Building in downtown Seattle.[255] She appeared to be a model employee, punctual and responsible, because she worked for the firm for seven years until her marriage in 1897. Beth was twenty-five years old in 1897, well past the median marriage age of twenty-one for women (as documented in the 1900 US Census). Young by today's standards, she was, in fact, what the Victorians referred to as a spinster, an unmarried women. While society was very slowly changing its concept of women and

their role in society, Victorian culture believed the proper function of women was to marry and bear children. The idea of a working "bachelor" woman was starting to take hold, but a vast majority believed a "working woman" was a temporary phenomenon until she got a "real" job taking care of her husband and children.

We cannot specifically say how or when Beth met Edwin Coman Griswold, but he was ten years her senior and had worked for many years for Arthur A. Denny, one of the founders of Seattle and the city's wealthiest citizen. Denny held multiple interests, including the Denny Clay Company, Denny Hotel Company, and the Dexter Horton and Company Bank (the precursor of the Seattle National Bank). He was also the founder of the University of Washington and president of the Seattle and Walla Walla Railroad Company. The Denny patriarch died in 1899, and his four sons inherited his various businesses.[256] Edwin Griswold worked for the company in various capacities, beginning in 1889. He served as a coachman, gardener, collector and by 1900 as an agent. He boarded for those years at 1328 Front Street in Seattle.

Originally from Madison County in New York State, Edwin also had been married previously, as stated on his and Beth's marriage license.[257] Apparently he was a widower although no documentation could be located on his first marriage. It is perhaps not all that surprising that Beth was his second wife, since most of the men close to her age were already married. Edwin was thirty-five years old when he and Beth married. In general, men who married for the first time were about twenty-six, or five years older than their brides. (And, as has been described previously, in the years before antibiotics and other benefits of modern medicine, the chances of one partner or the other dying while still young were proportionally high).

The couple wed on August 18, 1897 at Lizzie and Alex's home. The ceremony was officiated by Reverend John F. Damon, the same minister who conducted the weddings of Beth's sisters. Immediate family and friends were present and Miss Bertha Leighton and her brother Charles, friends of the couple, served as witnesses. Alex and Lizzie were probably thrilled that Beth had achieved "Victorian

success," and was now settled with a husband. She was the last of their daughters to marry, and while her parents might have also felt sad at losing their daughter, it was not so much a loss as the gain of a son-in-law, since Beth and Edwin did not go far.

The new couple lived with Lizzie and Alex at their home at 423 First Avenue West, presumably so that they could save money to buy a farm.[258] Edwin, brought up on a dairy farm in rural New York, aspired to own one. Although he spent years working in an office he enjoyed the outdoors, as demonstrated by his work as a coachman and gardener for Denny and Company. According to the 1900 census, he was working as an agent for the Denny estate shortly after his marriage to Beth and continued working for the estate until 1904.

Unfortunately, it seems that my families' days of happiness were more than balanced by sadness—Alex Sr.'s health was now deteriorating. He was fifty-eight years old in 1900 and was continuing to work as a carpenter. When he became ill, doctors confirmed the anticipated and feared diagnosis: tuberculosis, a potentially fatal and contagious disease of the lungs. Prior to the introduction of antibiotics, treatment for tuberculosis was mainly supportive, consisting of encouragement to rest, eat well, and maintain isolation. At one time it was thought that climate affected TB. Alex's doctor may have suggested that the disease could be exacerbated by the damp, rainy climate of Seattle as opposed to a sunny, warm, dry climate that was believed would help slow its progress. Today, we know that there is no correlation between climate and TB. Alex and Lizzie certainly did not want to move away from their three remaining children, Alice, Beth and Alex Jr., but they must have gotten some consolation from the fact that they were grown and settled. The doctor probably insisted that Alex's illness demanded a more benign climate, so in 1904 the couple left Seattle and settled in Los Angeles, California. It had to have been heart-wrenching to leave their children, and yet Los Angeles was not too far away—a few days train ride. Their children could visit them whenever they wanted to do so.

The Hamiltons had a choice of transportation to California. The Great Northern Pacific Steamship Company had both a train

and steamship available to make the journey from Portland, Oregon to San Francisco and the San Francisco and Portland Steamship Company had a direct steamer run along the coast. Although train travel continued to improve, it was still a long, dirty, dusty and tiresome ride between twenty-nine and thirty-six hours from Portland to San Francisco. By steamer, on the other hand, it was twenty-nine hours from a Puget Sound port to the Port of Los Angeles and a steamship was a more leisurely and less stressful way to travel. The cost for either was about $17.50, although for the train a berth and meals were included.[259] Since the cost was the same it would seem that the Hamiltons chose the steamship, a selection which would have been less taxing on Alex's health.

Once they arrived in Los Angeles, in December 1904, Alex was admitted to the United States Home for Disabled Volunteer Soldiers in neighboring Sawtelle.[260] Since wives could not stay with their husbands at the hospital, Lizzie rented a place in Los Angeles to be near him. By the time the Hamiltons arrived, the Los Angeles population had quadrupled from 50,000 in 1890 to nearly 200,000 in 1904. Rudimentary roads were improving, but Los Angeles County was still mainly farmland where cattle grazed in pastures adjacent to vegetable and fruit orchards.[261]

Around the same time, Edwin and Beth Griswold had saved some money and had located a promising property in the Green River Valley, about nine miles east of the larger town of Auburn and less than three miles south-southwest of the small rural community of Black Diamond. The land had been settled originally by homesteaders and owned by three different families over the years. The Homestead Act, passed in 1862 and frequently amended thereafter, allowed any citizen over twenty-one to apply for a quarter section (160 acres of land). The tract had to have been surveyed and located in one of the thirty "public domain states" (all states were public domain states except for the thirteen original colonies). The prospective homesteader paid a filing fee of ten dollars to temporarily claim the land, and then made a small payment thereafter to the land office representative.[262]

The homesteader had six months to begin living on the property. He or she could commute the claim before the end of

five years to a cash entry ($1.25 per acre) as long as the claimant had lived on the property for at least six months. After five years of continuous residence a patent or deed would be issued to the homesteader. During the five year period the homesteader had to build a dwelling and cultivate some portion of the land. After publishing his intent to close on the property and paying a six dollar fee, the homesteader received the deed for the property.[263]

Auburn, Washington had been settled in 1893 by a large group of settlers who had moved there from Auburn, New York, (coincidentally Cayuga County, where Auburn is located, is near to Madison County, where Edwin was born). The settlers moved into the fertile river valley and quickly established a farming community. The Auburn area was a center for hop farming until 1890, when crops were destroyed by aphids or plant lice.[264] (Hops are used primarily as a flavoring and stability agent in beer to which they impart a bitter, tangy flavor.)

In an effort to recover from their losses, many of the new settlers converted the hop fields to dairy or berry farms. At the time, just over a century ago, the United States was primarily an agrarian society. In 1910 there were 6.4 million farms in the United States of which 57,500 were located in the State of Washington—many of them dairy farms.[265] Today, there are still 37,000 farms in Washington and, according to the Washington State Dairy Federation, 426 of them are dairy farms.[266] Although the proportion of dairy farms seems low, Washington currently ranks fourth in milk production per cow in the United States.

In March 1904, Edwin, along with Wyllis A. Silliman, a Seattle physician, purchased property jointly from Eleazer and Mary Whitney.[267] Dr. Silliman had moved to Seattle, Washington in 1903 with his wife Minnie, son W. Benjamin, and daughter Laura from Monroe County in New York State. He established an office in downtown Seattle's Arcade Building and became Edwin and Beth's doctor and eventually, a very good and close friend, especially to Beth.

Edwin and the doctor shared a common heritage. They were both from New York State and both had grown up in and around

dairy farms (like Madison County, Monroe County also had a large number of dairy farms). Silliman's father Charles was, in fact, a farmer in Clarkson, New York and had a parcel worth $19,000 in 1870, according the United States Census for that year (approximately $350,500 in today's dollars).[268] One can imagine that having made the doctor's acquaintance, Edwin and Wyllis shared their common background and Edwin confided his dream of starting a dairy farm. After perhaps many conversations about dairy farming, the three, Edwin, Beth and Silliman, bonded. Silliman surely considered that buying land with Edwin was a good investment for someone so knowledgeable about dairies. Perhaps the doctor wanted to help a fellow New Yorker and his young wife.

On March 1, 1904 Wyllis Silliman and Edwin Griswold bought "309 acres more or less," according to the deed from Eleazer P. and Mary E. Whitney in Black Diamond, Washington for a sum of $6,000, about $154,000 in today's dollars. The available records do not make clear the amount of money each contributed to the purchase, but since it was a joint venture, it would be logical to assume that each brought $3,000 to the settlement. Neither Beth's nor Minnie's names were on the deed, however, Washington State is a community property state, and property acquired during the marriage (with the exception of gifts or inheritance) is owned jointly by both spouses.

The Griswold-Silliman property, according to the deed, consisted of four lots and "the Southwest Quarter of Section 28, Township 21, North, Range Six East of the Willamette Meriden." The description of the property adheres to the Public Land Survey System, a rectangular system of surveys regulated by the US Department of Interior, Bureau of Land Management. A section is an area nominally one square mile, containing 36 sections of 640 acres each making up one township on a rectangular grid. Customarily, sections are surveyed into smaller squares by repeated halving and quartering, with a quarter section being 160 acres.[269] The Griswold-Silliman property was of a suitable size to farm.

The property abutted the Green River, then a 65 mile long river arising on the western slopes of the Cascade Mountains and,

until 1906, flowing into the White River in downtown Auburn. (In 1906 the White River changed course above Auburn following a major flood, and it now empties into the Puyallup River.) Flooding was of major concern to the farmers in the valley in the first half of the twentieth century. In 1962, the Howard Hanson Dam was built, thus providing water management for the river and putting a stop to large scale flooding.[270] The Griswold property lay west of what is today Flaming Geyser State Park, a 480-acre park with river access, hiking trails and two geysers. It is part of the Green River Valley, a spectacularly beautiful green and lush region. Majestic Mt. Rainier, the highest mountain in the continental northwest, is visible in the distance.

Beth and Edwin's move was auspicious for them and the area. A subsidiary of the Northern Pacific Railroad, the Northern Pacific and Puget Sound Shore Railroad, opened a line from Puyallup, just eleven miles from Auburn, to Seattle in 1882. In 1902 the Seattle-Tacoma Interurban Line provided easy access to both cities. The railroad and improved roads were an impetus for new companies to set up businesses in the area. Among the newcomers were the Borden Condensery, which made Borden's Condensed Milk, and the Northern Clay Company.[271]

Earlier, in 1898, the Carnation Company began to condense milk at a factory located in Kent, five miles from Auburn. Although the company went bankrupt about a year-and-a-half later, its plant and equipment were acquired by the Pacific Coast Condensed Milk Company, which would later become the Carnation Milk Company, known for condensing milk from its famous "contented cows."[272] Condensed products were based on a somewhat new process of controlled evaporation (of beverages amenable to the process). The milk is heated for several seconds, destroying some of the microorganisms and evaporating some of its water. Condensed milk had great sanitary value when fresh milk was not universally available or drinkable. Raw milk, without refrigeration and often days old by the time it reached market in urban areas, was recognized eventually as a source of disease (the standards for the pasteurization of milk were not established until

1912). Condensed milk was viewed as a safer beverage especially for babies, young children and pregnant women, since it could be stored for years without refrigeration if unopened and thus remain safe for consumption.

Carnation, to ensure healthy cows and high quality milk, distributed pure-bred bulls to the farmers supplying the factory. Eventually, Carnation established its own breeding farm, where the latest techniques in animal husbandry were practiced and the multi-million dollar idea for the advertising slogan, "Our milk comes from contented cows," was born.[273] Unfortunately, no records could be located to confirm that the Griswolds' farm provided milk for the company, but their ranch was of such a size that they probably sold their milk to a large dairy in the area.

In 1907 two dramatic events occurred which affected Beth and her husband. First, the Sillimans were getting a divorce and Dr. Silliman and his wife divested themselves of their interest in the farm before the divorce. On February 23, 1907 Wyllis Silliman and Minnie Silliman deeded to Edwin Griswold, "a married man," the balance of the property for $1 consideration.[274] Deeding property for such a nominal consideration almost always occurs between relatives: parents to child or perhaps sibling to sibling. It is rare indeed for someone outside the family to deed property for one dollar. It is obvious that the reason was the Silliman pending divorce, which was finalized later that year. Minnie, of course, owned one-half of her husband's interest whether her name appeared on the deed or not since the property was acquired during their marriage.

Unfortunately, we are not privy to what were undoubtedly interesting and perhaps dramatic negotiations between Wyllis and Minnie. We do know from Minnie's divorce filing, which was filled with negative aspersions and complaints, that she was anxious for the divorce to proceed and may indeed have initiated the proceedings. It would not be surprising if Minnie arranged for a "settlement" with Wyllis—under the table, so to speak—for a financial payment in lieu of her share of the property. After a review of the financial "demands" of the divorce, it seems that an understanding on the property was reached between the couple

since there is no mention of the property or payment for such in the divorce decree. In any event, the Griswolds now owned the property completely.

Chapter 14

FARMING AND THE NEW WOMAN

"There is no gilding of setting sun or glamour of poetry to light up the ferocious and endless toil of the farmers wives."
- Hamlin Garland, American writer (1860-1940)

By 1905, Beth, the former stenographer and office worker, was establishing and expanding a dairy farm with her husband. She never would have guessed working on a farm could be so tiresome. Farm life was even more physically challenging at the turn of the previous century before the widespread use of mechanized equipment. Every member of the family was expected to contribute to the farm's success. Beth seemed to be an improbable farmer's wife. To this point, she had worked indoors in offices, and as far as we can tell she had no experience in outdoor work nor any experience with farms or farm animals. Edwin, the son of a farmer, would have had to play the part of farmer and teacher to Beth, showing her a variety of skills to help her to cope with the new experiences that presented themselves in the country.

Beth, the "career" woman, was now a farmer's wife. Had she given up city life readily? Was the allure of owning property and being one's own boss an overriding factor in moving to the country? Were the stories of her grandfather's dreams (Alex's father, Alexander) of owning a farm a factor in her willingness to move to the country? We will never know for sure, but such speculation is interesting. She was now a partner with her husband, co-owning the

property and joining him in his efforts to make the farm a success. A fair assumption is that my great-grandaunt was the plucky type with a "can-do" attitude and the motivation to do whatever it took to succeed.

As Grey Osterud wrote in his book, *Putting the Barn Before the House: Women and Family Farming in Early Twentieth Century New York*, a woman, like Beth, who founded a farm with her husband "... espoused an ethic that I call mutuality and they called 'togetherness,' making decisions jointly and sharing labor in a flexible manner. These women articulated a view of family farming as an equal partner-ship."[275]

Many women, according to Osterud, subsidized the down payment for the farm after having saved money from their earnings prior to their marriage. Certainly this would have been a similar situation for Beth, who worked seven years as a stenographer while living at home with her parents. This presented an opportunity for her to save, and once married to Edwin she would have been able to contribute to the purchase of the farm. Their partnership was not only one of marriage, but, thanks to the enlightened laws of Washington, also one of property ownership. Joint ownership in marriage was a new experience for many married women— especially those who came from non-community property states like Beth. By sharing possession they now also had a strong, financial reason to help make the farm successful.

This could also be a venture fraught with additional difficulties, especially for women. As Caroline Harris Bevier Stevens related to Osterud, on her parent's farm, "Women's proper place was wherever she was needed to be, and that was twenty-four hours a day. It didn't make any difference," she added, "if you were a girl." Similar to the Griswold farm, in all probability, the Stevens family had no electricity, no inside plumbing, no running water and no telephone like most farms in the early 1900s. Water was carried into the house from an outside pump.[276] This was in stark contrast to the home Beth had lived in Seattle, which very likely had running water and indoor plumbing. We can only imagine Beth's response to farm life as someone coming from a city used to the conveniences of city life.

Was she angry? Frustrated? Overwhelmed? Or perhaps challenged? It might have taken years to make such a cultural adjustment from career woman to farmer's wife. Or she may have been fine with this lifestyle; we just don't know.

Edwin, in all probability, taught Beth the rudiments of farm duties—how to milk cows, feed and water chickens, gather eggs, and plant seed. "Dairy cows had to be milked, fed and watered twice a day, creating a kind of chronic emergency that took precedence over everything else," Osterud wrote. This shared labor between men and women extended to all areas of the farm—from cutting firewood to churning butter to pulling weeds in the garden—with one exception, housekeeping, which was entirely a woman's concern. Osterud related that on dairy farms in particular all hands had to work together not just to milk the cows, but to harvest hay in the summer. "All labor was valuable," he wrote, citing that families with more daughters than sons or with older daughters and younger sons often treated one girl "as if she were a boy; size and strength mattered more than sex."[277]

Every day a farmer's wife would be up at 4:00 a.m. After having dressed, she would start a fire in the kitchen stove and prepare breakfast. Then she might turn the stock into the pastures, put out feed and water for the chickens, feed the stock hogs and then return to the house to make the beds and straighten up. Perhaps she would then hoe the garden or pull weeds, sweep the floors, sow a flower bed or repair a fence. Along with cooking all the meals, she baked once a week, kept a vegetable garden, washed dishes, scrubbed all the laundry by hand, hung it and if needed, ironed and folded it. It was laborious, tiring work. There were no sick days, no paid holidays. Sunday was perhaps the only day of rest for the observant.[278]

Children, too, were an integral part of farm life, but instead of taking a factory job or working as a domestic, they helped with chores, learned how to farm, how to care for animals, all of which provided relief to overworked parents.[279] Sadly, Beth and Edwin did not have children, but they did have other help. The 1910 United States Census listed a boarder, fourteen-year-old Dorothy Niel, who probably assisted Beth with household chores and farm work.

Households also took in children whose own families could not support them. They were kept "bound out" until they came of age and afterwards were free to move on if they chose. The Griswolds also had a farmhand, twenty-eight-year-old John Goodhead, who worked on the farm with Edwin and also lived with the family.[280]

There were neighbors and friends who helped out, too. George Krouse and his wife, Pearl, lived in Auburn and were good friends. Krouse was a dealer in livestock and probably sold the Griswolds their cows, chickens and pigs. Edwin considered George a "dear friend receiving numerous kindnesses from him over the years."[281] There was also Wyllis Silliman, who maintained a very close relationship, especially with Beth, both before and after his divorce in 1907. As reflected in his United States Passport photograph Silliman was a tall, handsome man sixteen years Beth's senior. He was sophisticated and well educated, a graduate of Yale Medical School who also studied for four years in Europe as a young man. When he met the Griswolds in 1904 he was unhappily married, as testified to by his wife who reported in the divorce complaint that the two lived separately for several years prior to 1907. In fact, Mrs. Silliman testified that her husband was not "fit" or "competent" to have custody of their minor child, a son, (the couple also had a daughter, Laura, who was married by then) and added in her divorce complaint that he was living "on a farm where he has resided for the past two years."[282] Could this be the Griswold farm, in which he had a one-half interest? What made Silliman unfit for custody? Was Minnie suggesting that Wyllis was a homosexual? Or was she implying he was a deviant by living with another woman and her husband? If he did, in fact, live with the Griswolds, why? Was he invited to? What was the relationship among the three? Was his attachment as Beth's doctor and friend so strong that he could not leave her?

The rift between Silliman and his wife was deep. According to Mrs. Silliman she was forced to work for the two years prior to the divorce because Silliman refused to provide for her or their minor son, and she accused him of desertion and abandonment. In the end, she was granted custody of their son, as well as alimony and court costs, by the court.[283]

One of the things that drew Beth and Wyllis together was her illness. First and foremost, Silliman was a physician and Beth's doctor. There is no record when she first developed chest discomfort, a sensation of pressure and squeezing in her chest. Perhaps she was nauseous, fatigued, dizzy or had been experiencing shortness of breath. She might even have experienced stomach pain, or because she was a woman her illness may have presented itself differently with discomfort in the neck, jaw or back or stabbing pain instead of more typical chest pressure.

Perhaps Beth thought her symptoms were due to the hard manual labor on the farm, or she might have been suffering from anemia. Initially, she may have believed it was nothing serious, since she was only thirty-one years old in 1905. Fortunately, Edwin and she did not ignore it and sought the advice of their friend, physician and perhaps by now, housemate, Wyllis A. Silliman. Sadly, the doctor cited angina pectoris, commonly known just as angina, as the cause of her distress.

Angina is a life-threatening symptom of coronary artery disease caused by a lack of blood flowing to the heart. Today, it is a treatable disease with medicine and lifestyle changes, or if more severe, with the implanting of a stent or tiny tube to prop open the arteries. The severity, duration and type of angina can vary. Perhaps Beth's angina was one of the most common called "stable angina," which can be triggered by physical activity or stress. The pain usually lasts a few minutes and disappears when the patient rests. New or different symptoms may signal a more dangerous form of angina, called "unstable angina," and may lead to a heart attack. In the early twentieth century angina was known to be a signal of an impending early death.[284]

Angina rarely occurs in premenopausal women such as Beth. The average age for women to develop the malady is sixty-five years old, and for men fifty-five years old. A more plausible diagnosis is that Beth suffered from a cardiomyopathy, probably of a viral nature. Cardiomyopathy is a deterioration of the heart wall tissues causing valves to malfunction, and resulting in chest pain and shortness of breath upon exertion. After an initial examination, and knowing Beth's history as a farmer's wife, Dr. Silliman may have offered the

best advice he could: slow down and take rest breaks if physical activity triggers shortness of breath; avoid large meals and rich foods and do not become upset or emotionally stressed.[285] Although well-intended, many people would have trouble following these recommendations today, let alone as a 1900s farmer's wife.

Since Silliman diagnosed Beth with angina he may have prescribed nitroglycerin to alleviate her chest pain and to reduce blood pressure. Nitrates were a relatively recently adopted treatment for angina. Beginning with an Italian chemist in 1847, experiments with nitrates were conducted and its use advocated for treatment of a number of diseases. By 1878 British physician Dr. William Murrell experimented with its use to specifically alleviate angina. Nitroglycerin enjoyed widespread use after he published his results in the respected British medical journal, *The Lancet* in 1879.[286]

Nitrates work by dilating both arteries and veins, thereby reducing the amount of oxygen the heart requires. To dispel the fears of patients who knew that nitroglycerin was extremely explosive, doctors often used the names "glyceryl trinitrate" or "trinitrin."[287] Surely Silliman and Edwin, worked hard to keep Beth's illness under control. The nitrates helped but also presented a problem the longer Beth took them. Chronic use of nitrates often resulted in the phenomenon of drug tolerance. With nitrate tolerance, chronic exposure to nitrates causes a diminished effect so that effective dilation of blood vessels no longer takes place, and the anti-angina effect of the drug diminishes and eventually disappears.[288]

Having started their relationship as friends and business partners, Beth had become Silliman's patient and eventually, possibly from living on the farm together, very close and dear friend. We may never know the full extent of their association. Was it simply platonic, or was there more to it? There is documentation of their friendship as witnessed by Beth signing an affirmation on Silliman's passport application in 1909, when she certified that she had known him for six years and could verify his citizenship.[289] Such an affirmation is not given lightly by an acquaintance, but by someone close to the person, as Beth appeared to be.

When Wyllis told Beth he planned to leave Seattle in 1909 to study in New York and perhaps travel to Europe, she was probably frantic with distress and deeply worried. She had a serious heart disease and he was her treating doctor, someone she trusted and believed. On some level, she may have felt betrayed. Why was he leaving her, even after reassuring her that she was not in any immediate danger? It would have been upsetting. They were treating her angina and as long as she followed his advice and rested often, she would be fine. Perhaps he would learn of newer treatments in New York and Europe to bring back to her. As it happened, he was gone less than two months traveling first to New York where he attended postgraduate courses at one of the city's medical schools and then journeying on to England. He returned to New York in August 1909 and thence to Seattle.[290] Sadly, there were no new treatments for angina, only supportive care and controlled use of nitroglycerin.

In 1910, according to the Department of Commerce and Labor Mortality Statistics, heart disease ranked fourth in the cause of death superseded only by pneumonia, tuberculosis and gastro-intestinal infections. (People died of infections first; if someone lived long enough they contracted heart disease.) "During the past decade," the 1910 report stated, "there has been a large increase in the number of death and death rates from diseases of the circulatory system in general."[291] Today, heart disease ranks first as a cause of death, followed by cancer. The death rate for diseases of the heart, as might be suspected, is highest in the sixty to sixty-nine year age group. It was highly unusual for a thirty-nine-year-old woman to suffer from it. But, sadly, my cousin may have had a bad case of coronary heart disease.

By the end of 1915 and continuing into the beginning of 1916 Beth's illness grew worse. She traveled to Seattle and rented rooms at the Ethelton Hotel, located at 1317 Third Avenue, just one block from Wyllis' office at Second Avenue between Union and University Streets. Surely Edwin was deeply distressed. In all probability he spent time siting by his wife's side. Wyllis must have been equally frustrated, knowing that his years of medical training

could not afford Beth relief. Beth was only forty-one years old in 1916, a loving wife, a tremendous partner and friend to Edwin and to Wyllis. Through hard work and long hours she and Edwin had built and developed the farm into a successful enterprise. Now, as they reached middle age they should have been enjoying the fruits of their labor. Instead, Edwin now sat in a hotel room grieving for his wife who was slowly passing away before him. Wyllis also stayed by her side becoming more and more frustrated at his inability to personally help Beth as well as disenchanted that the medical profession could not save her life. It must have been an odd scene with Beth's husband and best friend sitting on either side of her bed, loving her and yet helpless to assist as she lay dying.

On February 14 Wyllis found Beth in severe distress at the Ethelton Hotel. She refused to go to the hospital, preferring instead the comfort and privacy of the hotel. With her doctor friend by her side, she passed away quietly at 10 p.m. that evening. Per her wishes, her body was cremated. Wyllis not only signed her death certificate, but also filled out all the pertinent personal information, a task usually left to the next of kin.[292] Was he trying to spare Edwin the sad task of doing so, did he feel as if he had the right to do so, or was it just convenient at the time? Perhaps Edwin had returned to the farm knowing there was little for him to do at the hotel. The funeral service was simple, perhaps with a few friends in attendance. There was no one in her family nearby to attend. Her elderly mother was frail, living in Long Beach, California, more than a thousand miles away. It would have been too long and sad a trip for her to make alone.

The Auburn Globe Republican published Beth's obituary on February 16, 1916. The headline read, "Mrs. E. C. Griswold Passes. Wife of Prominent Green River Valley Rancher Dies in Seattle." The announcement read,

> Mrs. Beth G. Griswold, wife of Edwin C. Griswold, died
> in Seattle on Tuesday and was buried in Mount Pleasant
> Cemetery Thursday. The Griswolds are long time
> residents of Green River valley and own a ranch near

the Diamond Mineral Springs. No particulars of Mrs. Griswold's death are at hand, though it is said she had been in poor health some time prior to her demise.[293]

Edwin served as his wife's executor. As stated in a subsequent inventory, Beth left a personal estate of $500 in household furniture and, as decreed by a community property state, one-half of the farm, which was appraised at $7750, a significant increase from when the couple purchased it. The total value of her share of the estate was $8,250, which Edwin inherited as her husband and named beneficiary.[294]

Five months after Beth's death, Wyllis packed his bags and left his ex-wife and children and his Seattle medical practice, and traveled to Europe.[295] He would not return permanently to America until 1935, living first in Paris for two years and then in Italy. When he returned to America for a short visit in 1922, he did not go to Seattle, but instead to Connecticut for a two month sojourn before he embarked on another European trip to France, Germany and Italy. Perhaps America and Seattle, in particular, held too many unhappy memories.

Chapter 15

THE OTHER MAN

"Music I heard with you was more than music,
And bread I broke with you was more than bread
Now that I am without you, all is desolate;
All that was once so beautiful is dead."
– *Bread and Music* Conrad Aiken (1889-1973)

When Beth Hamilton Griswold, Alex and Lizzie's daughter, died in 1916, her passing created a void for the two men who loved and knew her best. Her premature death at age forty-one left Edwin totally alone, since there were no children or relatives nearby to cushion his grief. Edwin did not last long after Beth's death, dying six years later in 1922 at the age of sixty-three.[296] Although he had a brother, Edwin chose to leave the farm to his friend George Krouse[297]

Wyllis was the "other" man to love Beth, and he was devastated by her death. Coincidentally, Beth died on February 14, Valentine's Day, which certainly intensified the sadness and melancholy of her passing for both Edwin and Wyllis.[298] Within six months, Wyllis was in Europe, according to his passport application, "to study and do literary work." World War I had begun in Europe in July 1914 making it a difficult and dangerous time to travel. Although America did not enter the war until April 1917, German U-boats prowled the north Atlantic looking for prey.[299]

In May 1915 a German submarine sank the British ship RMS *Lusitania* with 128 Americans among the 1,193 dead. Although Germany appeared to agree to President Woodrow Wilson's demands to limit submarine warfare after the sinking, in the spring

of 1916, just four months before Wyllis' departure, a German U-boat attacked the French passenger steamer *Sussex,* killing fifty people. The attack led to the so-called Sussex Pledge, signed on May 6, that limited indiscriminate sinking of non-military ships. It was a short-lived truce. By February 1917 unrestricted submarine warfare was again a routine strategy for Germany.[300] Fortunately Wyllis crossed the Atlantic in August 1916 during a period of truce.

Wyllis settled first in Paris at the Hotel Viejerja at 35 Rue des Ecoles in the heart of the Latin Quarter, near La Sorbonne, one of the most prestigious universities in France.[301] Perhaps it was near there that he encountered the wounded and maimed Allied soldiers coming from the German front, which in the spring of 1918 was within 75 miles of Paris. Wyllis certainly heard the fighting: the Germans had built the world's largest artillery gun, the Paris Gun, also known as William's Gun and manufactured by Krupp. It was moved to the front line and used to shell the city. Since the shells were fired in a parabolic arch the distance the shell traveled was much further. It took slightly less than three minutes for a shell to travel that arch and reach the city, a distant 120 kilometers from the front line. The guns fired dozens of shells at Paris, causing thousands of residents to flee.[302] Thankfully, by mid-July the Germans had retreated across the Marne, and were out of range. The war in Europe was in full engagement, and although few knew it at the time, the overly stressed and exhausted German Army and the infusion of enthusiastic American soldiers would bring the war to an end a few months later.

At home in Washington, Wyllis' twenty-two year old son W. Benjamin Silliman enlisted in the army in July 1917. He joined the Quartermaster Corps and served in France as a private in Company B, 18th Engineers. He was honorably discharged in May 1919.[303] There is no evidence that Wyllis and his son ever saw each other in Europe during the war. Putting his own pursuits aside as America entered the war, Wyllis joined the American Expeditionary Forces of the Young Men's Christian Association in France as one of 35,000 unpaid volunteers and 26,000 paid staff serving to assist the 4.8 million troops. The YMCA operated leave centers called "huts"

or "clubs," and provided humanitarian service to more than five million prisoners of war on both sides during hostilities.[304]

In March 1918 Wyllis reapplied for a passport to travel to France and Italy for "Y.M.C.A. work" and he pledged on his application that he would return to the U.S. within "one month after the war."[305] Due to concerns about secrecy with "Y" personnel moving freely among military personnel, thorough investigations of passport applications were conducted into every social welfare worker entering the War Zone. Character references were most important. Wyllis' references were above reproach.

One of his recommendations was Professor William H. Taft of New Haven, Connecticut. The former United States President was the Chancellor Kent Professor of Law and Legal History at Yale Law School. Wyllis and Taft were friends and college classmates at Yale when they both started college in 1874. Taft went on to graduate from Yale in 1878 while Wyllis transferred to Harvard, later returning to Yale for medical school. Wyllis also provided the name of Superior Court Judge Arthur Griffin of Seattle a notable member of the judiciary who also served as an attorney for the Puget Sound tribes and authored a book on native Americans.[306]

Along with his application, Wyllis included a February 1918 letter from the chief secretary of the American YMCA, which "ordered (him) to proceed to Italy where he was to report to Bologna for work in that area."[307] According to *A Summary of World War Work of the American YMCA* published by the International Committee of YMCA Associations in 1920, the Y was not represented in Italy until an Italian army captain petitioned the American International Committee. After successful negotiations between the Italian army and government, an agreement was reached in early 1918 for the Y to provide aid in Italy. The city of Bologna was chosen as Y headquarters.[308]

By April 1918 the first American presence at the Italian front was in full operation at Meolo in the province of Venice, about 95 miles north of Bologna. During hostilities in Italy there were about 150 of these huts, some remotely situated in cold mountain regions.[309]

The person Wyllis reported to in Bologna was Dr. John S. Nollen, who served as general secretary in Italy representing the International Committee.[310] Wyllis' importance to the establishment of the Y's presence in Italy cannot be overestimated. He spoke the language, he was a physician, and he was held in high esteem, since he was one of the first to be sent to Bologna after the Italian "Y" agreement was signed.[311]

According to his obituary many years later, Wyllis worked on the medical staff for the YMCA. Of the thousands of "Y" volunteers overseas, there were only seventy-four doctors and eighteen nurses (along with forty-five dentists and six opticians; sadly, there were also more than 250 undertakers).[312] Medical training was at a premium in the war zone and highly valued. "There was also," according to the Summary report, "city service at hospitals and convalescent homes," for which Wyllis also was well equipped to assist.[313] As one of the few doctors, Wyllis treated both Allied soldiers and prisoners of war, exhausting work for someone who was sixty-one years old.

In March 1922, after four years in Italy, Wyllis returned to the United States, sailing on the SS *Crete* from Naples to Boston.[314] Just a year later he returned to Europe to "write and study in France, Germany and Italy." He listed his home address as Rosemary Hall in Greenwich, Connecticut. At the time Rosemary Hall was an independent girls school which in later years merged with Choate to be called Choate Rosemary Hall, and eventually moved to Wallingford, Connecticut. According to Choate Rosemary Hall archivist Judy Donald, there is no record of Wyllis employed as a faculty member or serving as a doctor at the school for the time period in question.[315] He may have listed the school as an address because he had a friend who was a faculty member but there is no connection that could be found to the school at this time.

Wyllis stayed in Italy for twelve years, according to information provided by his daughter Laura Shears. He left Naples in December 1935 on the SS *President Garfield* and landed in New York City.[316] Wyllis then moved west to California within a few months, where his daughter Laura lived in Alameda, near Oakland, with her husband Herbert and son David. According to the 1938 and

1939 Alameda City Directories, Wyllis was listed as living with the family.[317] Although we do not know of his relationship with his children after the divorce, time may have healed any wounds (Laura was married at the time of the divorce; Benjamin was a young boy and there is no information available as to a reconciliation with him). Weary from travel and work, Wyllis was almost eighty years old, and he wanted to spend his remaining years enjoying his family. Although retired from medical practice, he also was listed in the California Occupational Licenses, Register and Directory, 1876–1879 as a licensed medical doctor.[318]

As the new European war erupted in 1939 Wyllis grew despondent when he read of the situation in Europe and Italy's part in it, according to his daughter. Italy's Fascist Prime Minister Benito Mussolini had formed an alliance with Germany in 1936 and became part of the "Tripartite Pact" signed in September 1940 with Germany and Imperial Japan. Speaking with a reporter from the *Oakland Tribune* newpaper, Laura said that having lived for more than twenty years in Italy, Wyllis had become extremely fond of the Italian people. According to his daughter, he was also in ill health by 1939.[319]

Laura also recounted that in the days before his death, her father suffered during a disastrous heat wave that spiked temperatures in Southern California to above 100 degrees—sometimes reaching 106— for more than a week.[320] Schools were closed and people flocked to the beach both day and night to cool off. In the days before air conditioning, such a heat wave could prove deadly and it was—killing some 140 people before a tropical storm dissipated the heat surge.[321]

On September 23, 1939 Wyllis walked out of his daughter and son-in-law's home. When he did not return, Laura called the local police. Three days later they found Wyllis' body—weighed down with cement—in the Oakland Estuary.[322] His death was reported in the September 25 issues of the *San Francisco Chronicle*, *Oakland Tribune* and *Bakersfield Californian*. His obituaries gave precedence to his medical background and work during World War I for the YMCA.

Wyllis was eighty-one when he died. He had never remarried after his divorce in 1907, and after Beth's death in 1915 he seemingly exiled himself to Europe. His desire to pursue literature was cut short by World War I, but he made great use of his skills as a doctor helping countless hundreds and perhaps thousands of soldiers and prisoners of war in Italy. His son, W. Benjamin died just two years after Wyllis and is buried in Veterans Memorial Cemetery in Seattle. Wyllis' former wife Minnie who moved to Bellevue, Washington died in 1943.

UPWARD MOBILITY

"The old American dream was...to accumulate
modest fortunes a little at a time, year by year by
year." - H. W. Brands in *The Age of Gold: The California
Gold Rush and the New American Dream* (2003)

While Alex and Lizzie's daughters Jennie, Beth and Alice married before the turn of the new century, their brother Alex Jr. had been finding his own way during the previous years. Perhaps Alex, a young man who wanted a better life for himself, was dazzled by the classic American dream of acquiring wealth by working hard, saving and investing wisely. Classic rags–to–riches stories abounded. Author Horatio Alger Jr. focused on them in his *Ragged Dick* series of books, works that followed the rise of a poor boot black, i.e, shoe shiner, to middle class respectability in New York City. These formulaic juvenile novels, first published in 1868 and followed by others in subsequent years, are remembered for their themes of hard work, frugality and honesty rewarded by riches.[323] This ethic of self–help and hard work, solidified by the long-standing Protestant work ethic, was replete with examples from real life successes.

Andrew Carnegie, founder of the Carnegie Steel Company, who became a billionaire and avid philanthropist, was a poor Scottish immigrant when he arrived in America in 1848 at the age of thirteen hoping for a better life. Working as a telegrapher, he invested his wages in railroads, railroad sleeping cars, bridges and oil derricks. His willingness to work hard and persevere brought

him numerous opportunities, which he parlayed into lucrative investments.[324]

Quitting school at age eleven, Cornelius Vanderbilt worked on his father's ferry transporting passengers and freight between Staten Island and Manhattan. By the age of sixteen he had started his own ferry service, eventually expanding it to include the transportation of food and merchandise. He also established a line of regional steamboats and eventually graduated to ocean-going ships. In later years he became a railroad baron, and at the time of his death it was said he was one of the richest men in America. He left an estate valued at more than $480 million, which today would be worth more than $300 billion dollars.[325]

John D. Rockefeller started work as an assistant bookkeeper for fifty cents a day, eventually going into the produce commission business. With his brother and a partner, he purchased an oil refinery in Cleveland that grew to become Standard Oil.[326] John Jacob Astor, a butcher's son who immigrated to America from Germany, built an extensive fur trade and later dealt in real estate and opium, eventually becoming another billionaire.[327] In the rough and tumble days of the era with little government regulation or oversight, these men and others engaged in ruthless business tactics if not downright exploitation. To their credit, many of them eventually gave much of their fortunes away in the form of schools, parks, hospitals, libraries and more—an expected practice of the ultra rich. This ideal of hard work progressed from an early mystique of frontier life in the eighteenth century to what we call the "American Dream," a set of ideals that include the opportunity for prosperity, success and upward social mobility achieved through hard work. The prospect of "bettering oneself" and of "improving one's lot" is part of the heart and soul of the American Dream for the working class and middle class.

Alex Jr. wanted a piece of that dream. After accompanying his parents to Seattle from Detroit when he was thirteen years old in 1889, he started work as a "cashier boy" for Lowman and Hanford Stationery and Printing Company by the time he was fifteen years old years old in 1891.[328] Located in one of the tallest buildings in

Seattle, the ten-story Lowman Building, the stationery firm was housed on several floors. In a large retail store, a cash boy was a messenger who carried the money received by the salesman from the customer to a cashier and then returned with the proper change. It was a responsible job that demanded agility and alacrity, since Alex had to go up and down stairs and across large expansive floors. Young Alex, who probably inherited the Hamilton trait of height and coltish long legs, may have been one of the fastest cash boys at the stationary firm. After two years Alex Jr. improved his position by working as a collector for Aust Brothers, a collections and insurance company, located in the National Bank Building at 404 Seattle.[329] Alex worked there for six years, trying his hand as a clerk for at least one of those years. During this time he boarded with his parents, simultaneously helping the family and saving some of his earnings.

It was during his time working as a collector that Alex would have witnessed an amazing change in Seattle—a seismic shift spurred on by the August 16, 1896 discovery of gold in the Canadian Yukon. The prior discovery of gold in the west in 1849 at Sutter's Mill in California had changed the America dream. As a result one hundred thousand men had come seeking their fortune, although few actually found it. H. W. Brands in *The Age of Gold: The California Gold Rush and the New American Dream,* wrote of the "old" and "new" American dreams, two philosophies that differed dramatically: "The old American dream ... was the dream of the Puritans, of Benjamin Franklin's '*Poor Richard*' ... of men and women content to accumulate their modest fortunes a little at a time, year by year by year. The new dream was the dream of instant wealth, won in a twinkling by audacity and good luck. (This) golden dream ... became a prominent part of the American psyche only after Sutter's Mill."[330] Despite the lure of the instant riches of gold, in the end most people who went to California made their money by farming, lumbering, mercantile and other more traditional pursuits.

In 1896 an estimated 100,000 prospectors seeking their dream made the trip to the Klondike region of the Yukon in northwestern Canada to try their luck, although less than half actually succeeded in making it to the goldfields. Fostered by a worldwide publicity

campaign engineered by Erastus Brainerd, a Seattle newspaperman, Seattle was established as the premier supply center and departure point for the northern gold fields. It was a bonanza for Seattle. Clothing, equipment, food, medicines and transportation were sold as 'Klondike' goods and provided a sudden influx of funds to the city storeowners. Soon Seattle had outcompeted San Francisco to win the larger share of the gold rush trade, in the process reaping a huge fortune.[331]

While there is no evidence that Alex actually traveled there, an important clue is that his occupation was listed as a miner on the 1900 US Census.[332] No one, least likely a twenty year old such as Alex Jr., was spared the lure of gold. The newspaper headlines were replete with stories of men who struck it rich. Alex had only to walk through downtown Seattle to see the frenzy each gold strike wrought and the excitement of the prospectors as they were outfitted for their trek into the wild. Even his brother-in-law, Platt Elderkin, had hit it rich in Snohomish, Washington (apparently with a mineral strike) a few years earlier, and although Platt and Alex's sister were now divorced, the couple had lived the high life in San Francisco—at least for a time.

As historian Pierre Breton wrote, the Klondike was "just far enough away to be romantic and just close enough to be accessible."[333] The prospectors came from around the world, although 60 to 80 percent were Americans or recent immigrants to America. Most had no prior experience in mining; they were clerks, like Alex, or farmers or small businessmen, factory workers or simple men down on their luck. Some were famous. One of the first to join the gold rush was William D. Wood, the mayor of Seattle, who formed a company to transport prospectors to the Klondike. The former governor of Washington, John McGraw, joined him. Rich man or poor, the lure of gold was too much temptation to ignore.[334]

The prospectors undertook an epic journey, including a difficult sea voyage north along the Pacific Coast, from cities like Seattle, Portland, San Francisco and Victoria, Canada. After disembarking at Alaskan ports, the argonauts then encountered mountains and trails clogged with ice and snow, ferocious storms and thousands of fellow

prospectors, as well as the ton of supplies each man was required to carry over the Chilkoot Trail. (The Northwest Mounted Police, a Canadian force established in 1873 and predecessor to the Royal Northwest Mounted Police, required each prospector to bring a ton of supplies to last a year to avoid starvation). A man who could carry one hundred pounds over a steep icy trail had to do it some twenty times—a backbreaking task for even the hale and hearty.[335]

Unfortunately, by the time most of the potential prospectors arrived in the Klondike, it was too late in the season to leave for the gold fields, since summers in the Yukon were brief. As a result, the prospectors had to build shelters for the winter and endure seven months of cold, darkness, disease and monotony. Some of the very few who found the elusive shiny mineral lived extravagantly, but for the vast majority who did not find gold life was about survival. Also, most prospectors did not arrive until late 1897 or 1898, by which time the best claims were taken and the gold areas played out.

The Klondike rush was virtually over almost as soon as it began, but excitement started again with the Nome Gold Rush in 1899. What separated Nome from the Klondike was both the ease in which the gold was obtained and the ease of accessibility to the site: the Canadian Yukon was difficult terrain to travel with no roads, rugged, high mountain passes vulnerable to avalanches and deep snow. The Nome area of Alaska, on the other hand, was easily accessible by boat from Seattle. Although Nome had a deepwater harbor for ships, there was no wharf, so vessels had to anchor off shore and their passengers were shuttled ashore by local boats.[336]

Indeed, in Nome much of the gold was lying within the beach sand contiguous to the landing places and could be recovered without any need for a formal claim. Many of the remaining Klondike prospectors rushed to Nome where gold could seemingly be found in the beach sands for dozens of miles along the coast. The season was relatively short since the beaches could only be worked from June to October. Thousands more people came during the spring of 1900 aboard steamships from Seattle and San Francisco. Between 1900 and 1909 Nome's population had reached as high as 20,000 but by late 1909 the population had dropped to 2,600.[337]

The big rush was over, although gold mining still continues in the area to the present day.

Indeed, one star-struck adventurer might have been Lizzie and Alex's now twenty-four-year-old son who in the 1900 United States Census cited his occupation as a miner. Mining was not for the faint of heart. Whether it was gold, copper or iron, it was a rough and tumble business accompanied by some unscrupulous people. Many mining towns and camps were lawless places where fires and fights were common and disease rampant. One can only imagine Alex's parents' reaction to his determination to become a miner. He was a young adult who could make his own choices, but as parents they would not have been thrilled with his decision. They undoubtedly cautioned him as to the many dangers involved and urged him to be careful and act prudently.

There is no record in any ship passenger manifests of Alex having traveled to Alaska and there is no documentation other than the census that identified him as a miner. Due to the ease of travel—a voyage as opposed to a long and perilous climb as in the Yukon—Alex would have traveled to Alaska and the Nome area via ship. His bade his parents farewell, most likely in the spring of 1900, and for the first time in his life set out by himself on an adventure that was both dangerous and fraught with possibilities. Alaskan mining had a fifty year history before the sensational Klondike discovery of gold. Besides gold there were many other minerals and most were just as lucrative. Other precious materials such as copper and iron were mined for years in Alaska. Russian explorers discovered copper on the Kasaan Peninsula and Prince of Wales Island in northwestern Alaska in 1865 with mining starting about 1895 and continuing through World War I.[338] The early twentieth century gold and silver rushes stimulated mining for bare metals and minerals such as copper, lead, iron and coal. Later, Alaska would become a predominate supplier of copper—a mineral in increasing demand for electrical and household goods as the spread of "electrification" in the late 1800s and early 1900s intensified.

Despite a search with the Alaskan Department of State no documentation of Alex living in Alaska could be located. Alaska and

western Canada, of course, were predominately wilderness areas with a scattering of small towns like Dawson and Skagway and unless a man died there, there were few records available citing his existence. By 1904 when Lizzie and Alex Sr. were leaving Seattle for California, it would seem probable that Alex returned to Seattle, if only to bid his parents farewell. Again, no record could be found of his doing so.

Although several men named Alexander Hamilton were listed in the Seattle City Directory after 1904, none of their birth dates or birth locations, according to the census, correlated with young Alex. Yet, in 1910, according to the United States Census Alex's mother Lizzie was noted as having three living children.[339] Although his whereabouts cannot be confirmed, it is possible that Alex continued to work as a miner either in Alaska, or perhaps in a western state, trying his luck and fortune to move ever upward. Somewhere we have to believe there is a record of his life after 1900. It hasn't been located yet, but the hope is that someday his story will be told.

Chapter 17

A HOME AWAY FROM HOME

"Veterans bought homes where they could 'live
out' and enjoy family life while continuing to
avail themselves of the Pacific Branch."
- Cheryl L. Wilkinson in "The Soldiers' City,"
Southern California Quarterly, Summer 2013

While Beth moved with her husband to their farm in rural Washington State in 1904, her parents Lizzie and Alex were relocating to California. Their destination was the "Pacific Branch of the National Home for Disabled Volunteer Soldiers" in Sawtelle, a community adjoining Los Angeles. The National Homes were created by Federal legislation in March 1865 near the conclusion of the Civil War. This particular facility was founded in 1887 on three hundred acres of land donated by Senator John P. Jones and Robert S. Baker and his wife, Arcadia Bandini de Stearns Baker. (Jones and Baker were land investors developing the Santa Monica area, and they believed that the home would contribute to the growth of the region.)[340]

The following year the home grew to more than six hundred acres after additional donations of 330 acres from the owners of the Wolfskill Ranch, one of the most noteworthy of California ranches, located east of Sepulveda Boulevard near the Disabled Home.[341] As described by its Board of Managers, "The Home is neither an [sic] hospital nor alms-house, but a home, where subsistence, quarters, clothing, religious instruction, employment when possible, and amusements are provided by the government of the United

States. The provision is not a charity, but is a reward to the brave and deserving." Beginning with three branches within the first year (located in Togus, Maine; Milwaukee, Wisconsin and Dayton, Ohio), the federal system grew to eleven National Home branches by 1929.[342]

Each National Home branch was comprised of barracks, a dining hall, hospital, cemetery and recreational facilities. The recreational facilities ran the gamut of beer halls, parks, lakes, zoos, theaters and libraries. The men could also work during the day to make additional money. Work was considered a form of occupational therapy that helped patients "… replace morbid ideas with healthy normal ones to incite interest and ambition and … restore a lost or weakened function either mental or physical."[343] Many of the branches had farms that not only employed the members, but also provided food to supplement the men's diet. At all the branches men helped to construct buildings, care for grounds, repair buildings and even care for the ill.[344] Alex's skills as a carpenter would have been in demand at such a large facility. Wages ranged from $5 a month to $25 a month.

Frederick Law Olmstead, the father of American landscape architecture and designer of New York's Central Park, and Andrew Jackson Downing, an equally famous landscape designer, had major influence in the designs of the National Home branches. (Olmstead served for two years as general secretary of the U.S. Sanitary Commission and was influential in espousing nationalized care for disabled veterans). The "grand campus" design of the Pacific Branch where Alex was admitted, for example, was an echo of the "common green" and "picturesque" concepts Olmstead had employed in Central Park. Olmstead's philosophy envisioned parks as places of harmony where people would congregate to escape life and stress. He foresaw "pastoral" parks with graceful greens, wide paths and trees promoting a sense of tranquility. [345]

At the National Home, world-renowned architect Stanford White designed the shingle style frame barracks and architect J. Lee Burton designed the streetcar depot and shingle-style chapel which served both Catholics and Protestants. Many of the National Homes

employed popular architectural trends of the era. The simplicity of the shingle style of architecture was in direct contrast to the highly ornamental Queen Anne style that had been in vogue in the latter part of the nineteenth century and was used in other National Homes.[346] The magnificent setting of the Pacific branch was framed by the plantings of pine and palm trees and eucalyptus groves. The Old Soldiers Home, as it was called, also was an attraction for both tourists and local land speculators, and numerous restaurants and hotels popped up just outside its Pacific Branch gates.

By 1905 residential lots and larger tracts that adjoined the Home were for sale and a new community sprang up which could house other veterans and their families. There was also a boom in the cottage housing industry as widows from various parts of the country relocated to be closer to potential "new" husbands who were receiving government stipends.[347] Over time, as Los Angeles and the surrounding areas expanded, the site of the home was absorbed into the city limits of Los Angeles. As the Veterans Programs Enhancement Act Master Plan stated in 1998, the home, "due to the high visibility valuation of the surrounding property and its location, is one of the most valuable parcels of real estate in the western United States."[348]

Lizzie and Alex certainly would have been impressed by the grandeur of the Home when they arrived in 1904. The warm California sun—a striking contrast to the often rainy, damp climate of Seattle—was also a welcome relief. Sun, fresh air and a dry climate were considered ideal conditions for those who suffered from lung ailments, like Alex. Thousands of people with TB—rich and poor—flocked to the warmer and drier climate of Arizona, but there were no veteran hospitals in the Territory of Arizona at that time (which did not become a state until 1912).

There was an added treat awaiting the Hamiltons in Los Angeles. Alex and Lizzie's nephew, George J. Asay, son of Alex's sister Alice Hamilton Boudinot Asay, had moved to Los Angeles in 1901 from New Jersey. Remarkably, and recalling his Uncle Alex who trekked west to Indiana in 1859 when he was just seventeen, young George—also seventeen—made the trip west by himself from Long

Branch, New Jersey, a distance of some 2,700 miles. Compared to his Uncle Alex's backbreaking trip, George had the ease and improvement of rail travel, which made the journey comfortable and relaxed.

George's mother, Alice—Alex's sister—had died years ago in New Jersey as had his father, Walter Asay. George worked as a lineman for the Los Angeles Railway Corporation and Alex and Lizzie had never met him since he was born in 1884 after his mother had moved from Detroit, where she had been living, back to New Jersey. Neither Alex nor Lizzie had seen any relative outside of their immediate family since they left Detroit in 1889, although in an era of flourishing letter writing, the families on each coast no doubt exchanged frequent family news via letters. Meeting George was a wonderful opportunity to renew family ties—to hear firsthand about Alex's brother John and his family in New Jersey, as well as about the death of Alex's beloved sister, Alice. It was surely a heartfelt if somewhat bittersweet reunion, with many hours spent catching up on family news.

Alex entered the Home voluntarily in December 1904, and was quickly introduced to a structured environment reminiscent of his youth as an Army recruit. He received—as all residents did—"a medical examination, a bath (mandatory for all new members) and clean cloths," according to Patrick J. Kelly, who wrote *Creating a National Home: Building the Veterans' Welfare State 1860-1900*. The veterans living at the National branches were subject, in fact, to the United States Articles of War that dictated how soldiers conduct themselves in war.[349]

Residents were organized into companies of approximately one hundred men, commanded by a sergeant who was chosen from among the residents and paid for his work. One captain, designated as the "Officer of the Day," inspected the buildings and grounds each morning to ensure that all regulations were observed. A branch governor, usually a Civil War veteran, managed each National Home. There was also a deputy governor, secretary and treasurer; later, more positions were introduced such as quartermaster, surgeon and chaplain.[350]

Alex, like all residents, was required to wear the distinctive blue army uniform, as was each veteran, until the Veterans Administration assumed management of the homes in 1930. The men slept in dormitories and each had a bed, a chest for his clothes and a chair. The day was closely structured. It began with reveille at 5:00 a.m., followed by breakfast at 5:45 a.m., dinner at noon; supper at 5:30 p.m. and bugle taps at 9:30 p.m.. The men ate together in large dining halls and weekly prayer meetings were held in addition to morning and evening services on Sundays.[351]

For those residents who did not follow the rules, there was a daily court to deal with their infractions. Examples of rule breaking included bringing liquor onto campus or disorderly conduct. Although punishments were applied sparingly, they ranged from detention in the guardhouse to a fine, or being deprived of pay for labor to the extreme measure of expulsion from the Home.[352] Such structured communal living was not to everyone's taste and residents or their families could opt out by simply requesting a voluntary discharge. Many did. Some of these veterans moved outside the gates to a community of their own, "a soldier's city," as Sawtelle was described in Cheryl L. Wilkinson's 2013 essay *The Soldier's City: Sawtelle, California, 1897-1922*.[353]

In a prescient move, the Pacific Land Company (PLC), a group of real estate investors, had purchased land outside the Soldier's Home and begun to offer small lots at low prices, targeting Union pensioners and Pacific Branch members who tired of the regimentation of the Home. To sweeten the deal, PLC even negotiated an agreement with the Home that "allowed resident veterans to sleep outside the Pacific branch while still retaining their full membership benefits." This option proved especially attractive to married men who could keep their families intact and spend time with them while eating one or more meals at the Home. By doing so this allowed them to stretch their limited pension funds even further. A small lot could be purchased for as low as $60, up to $150 for an acre of farmland. There was even an installment plan that coincided with pension check payments.[354]

Other residents, bored with the regimentation of the Home

and not able or willing to purchase outside living quarters, sought "passes" to go into the city, visit family or friends, or just get drunk. "A visit to a nearby city on business, or for a short break from the Home, required a pass," wrote Patrick J. Kelly in his book, "and residents wishing to leave the Home for a period of time received furloughs."[355] While her husband was still living at the Home, Lizzie and the wives of other residents and their families often came to visit to be with their loved ones. In addition to the residents' families, the local community was also invited to use the recreational opportunities offered. The attractive campus design and settings of the Home enticed visitors who were seeking a peaceful contrast to the growing pains of Los Angeles.

Many of the branches became tourist attractions. Visitors came for weekend picnics in the grand gardens. Others came to see— hopefully with awe and respect—the disabled veterans parading about in their blue uniforms. "Visitors," according to Eastern Branch member Wes Weitman, "go into every building, look into every room and examine every nook and corner." He felt such scrutiny was beneficial and kept the Home accountable. If there were problems, he reasoned, the public would report them soon enough.[356] Fortunately, transportation was not a problem for visitors and families, since the Los Angeles Pacific Railroad streetcars operated throughout Los Angeles, Sawtelle and the Santa Monica area.

Unfortunately, Alex's records at the Home are incomplete. His admission papers state his Army service and honorable discharge, which were two necessary criteria for admission, but do not provide a medical history. Alex would have been initially examined and diagnosed by the doctors at the Barry Hospital on the grounds of the Home. Although we know he suffered from tuberculosis there are no medical records which diagnose the progression of his illness.

TB, one of the oldest human diseases, was a leading cause of death in the United States at the time, as it was in many European countries in the early twentieth century. TB attacks the respiratory system and other organs (it can affect the kidneys, spine or brain as well as lungs) by destroying body tissue. It can be latent or asymptomatic

and not contagious or, in its active stage, very contagious. Active TB presents itself as coughing, chest pains, night sweats, fever and weight loss. It is spread through the air by coughing, sneezing or even talking. It had such a significant impact and high mortality rate that organizations to prevent the disease were founded, one of which was the American Lung Association, organized in 1904. Before antibiotics were discovered as an effective treatment for TB in the 1940s, patients were often treated in sanatoria where therapy included fresh air, sleep, wholesome food and exercise. Once they entered the hospital, patients were isolated from their families (in some TB sanatoriums, children of patients stayed in a special area so as not to be separated completely from their parents; there were even schools on some sanatorium grounds).[357]

Those veterans who needed continual medical care and observation lived at Barry Hospital under the supervision of a medical director and a staff of nurses. The hospital, which had been built in sections from 1891 to 1909, provided "Tuberculosis cottages"— places of comfort and segregated care for ailing veterans with TB. (A new hospital called Wadsworth Hospital was constructed in 1927 to accommodate the growing number of veterans.)[358]

It is impossible to state the exact nature of the treatment that Alex received. Did he remain in the hospital? Did he experience remissions where he was able to live in the dormitories with others? Or was he a complete invalid? Despite repeated searches for his medical records, the Veterans Administration was unable to provide any insight into his history. While Alex stayed at the Home, Lizzie found rental lodging in Los Angeles at 412 7th Avenue, a short streetcar ride away.[359]

If Alex was feeling well and his TB was latent, perhaps he was able to get a weekend pass to visit nearby family. One can imagine that on those weekends when Lizzie visited her husband— if his condition allowed—the two walked arm in arm along the landscaped pathways of the Home. Perhaps on cool days they visited the library or even the Home theatre for some entertainment. It had to be a difficult separation for the couple—Alex at the Home and Lizzie living at a boarding house. By 1904 the couple had been

married for thirty-six years and had never lived apart from one another. They were both sixty-two years old and had weathered many challenges, including the deaths of two of their children. Did they reminisce about their courtship in New Jersey? Did they talk about their grief in losing six-year-old Annie or perhaps cry over the loss of twenty-three-year-old Jennie when she died just six months after her wedding.

They also had many fond memories—perhaps they recalled their trek from New Jersey to Detroit and then on to Seattle while it was still a territory and of course, the joys of raising a young family. Lizzie knew that her time with her husband was growing shorter each day. Undoubtedly she made the most of the situation and tried to cheer him at each visit. Meanwhile, she was left to deal with the emotional and physical loneliness of their separation when they parted and he returned to the Home and she to her boarding house.

THE LAST CIVIL WAR WIDOW
OF THE FAMILY

"The exclusion of family members from NJDVS
(National Home for Disabled Volunteer Soldiers) benefits
and the lower pension rates for dependents resulted in a
steadily growing population of indigent widows."
- Cheryl L. Wilkinson in "The Soldiers' City,"
Southern California Quarterly, Summer 2013

The wives and families of the men at the Home had a dual challenge: they had to survive on what was usually a tight budget and they had to maintain personal relationships with their loved ones, while dealing with the loneliness of living apart from them.

Shortly after the laws creating the National Homes were passed, the Board of Managers for the homes, in their first annual report, urged Congress to adopt legislation allowing "wives and children of the soldiers to be with him (the member) on the lands of the asylum." They suggested that veterans and their families be housed "in detached cabins supported by a small amount of outdoor relief."[360] Congress, however, never even considered changing the network's charter, and after 1866 the subject of allowing the family members of residents to be admitted to the homes was never seriously taken up again.[361] "Despite its domestic representation (as a home)," Patrick J. Kelly wrote in his book "the National Home assisted a population exclusively of male veterans and denied entry

to their dependent family members."[362] This structure produced serious, long-ranging consequences, both physical and emotional, for those men and their families.

According to Cheryl Wilkinson in her essay "The Soldiers' City," the dilemma of wives of pensioners was especially pronounced. Becoming ill or debilitated to any degree, for example, would seriously impede their economic survival. "The prolonged illness or death of one spouse," she wrote, "would threaten disaster to the economic well-being of Pacific Branch couples. Though the Pacific Branch hospital and medical facilities were available to veterans, the entitlement did not extend to their wives." This double standard had long reaching effects on the wives, especially when their husbands died. Even if they received the $12 per month widows' pension, as mandated by federal law, many wives faced destitution once they lost their partner.[363]

Although the legislation creating the Homes allowed the Board of Managers to confiscate the pensions of the residents without surviving dependents, the board chose not to exercise this power. Prior to 1899 Home residents had their pensions paid to the treasurer of their branch home to be "disbursed for the benefit of the pensioner, the balance remaining to be paid upon the pensioner's discharge to him and on his death the balance to be paid to his widow or children or legal heirs." Many residents, according to Patrick Kelly, voluntarily sent a portion of their pension to their dependents. Recognizing that some residents, however, retained all of their federal payments for their own use, in 1899 Congress required Home residents receiving pensions to apportion one-half of their payments to surviving wives or dependent children.[364]

Alex received a $12 per month federal pension stipend. Veterans with specific war-related injuries, such as the loss of an arm or leg, received disability pensions for their specific disability ranging from $15 to $100 (as amended in the July 4, 1864 pension law). Most likely Alex gave most of the money he received to Lizzie to defray her lodging, food and transportation expenses, keeping perhaps a small amount to pay for various extra services at the home. The average annual wage in 1905 was between $200 and $400 per year

or $16 to $33 per month.[365] In all probability, Alex and Lizzie had some money tucked away which Lizzie could use to augment the meager monthly stipend, but presumably neither she nor Alex wanted to access their limited savings. Besides the necessities, Lizzie would have needed shoes repaired or a dress mended and various miscellaneous unexpected expenses. There was also the cost of the streetcar when she visited Alex. Despite her frugality in an age when the cost of living was lower, how did she survive?

There are no records that document whether Lizzie worked while she lived in California. She had last worked more than thirty-six years earlier in a rubber factory in New Brunswick, New Jersey before her marriage, so had few marketable skills to offer. She was sixty-two years old and factories were not hiring "old women." "Most of the women [wives of pensioners], wrote Wilkerson, "were already in the fifties and sixties, far older than the single young women whom employers sought to employ as office workers and clerks."[366]

There were, of course, other possibilities. She might have taken in laundry or done fine ironing. However, those functions necessitated a home in which to wash and a clothesline on which to hang the clothes, neither of which she had. Perhaps she watched or cared for some of the neighborhood children while their mothers and fathers worked. The truth is we don't know how Lizzie managed while Alex was in the home, but somehow she did.

In 1907 Alex voluntarily left the Pacific Branch.[367] Perhaps the rules and regulations of the place became too onerous, or perhaps his TB was advancing to a stage where he realized he did not have much time left and wanted to spend every minute with Lizzie. Whatever the reason or reasons, Alex signed himself out of the home on July 27, 1907 after two and a half years at the Pacific Branch. He and Lizzie then moved to a rental at 1780 Pacific Avenue in Long Beach, some 22 miles from Sawtelle.[368] There he and Lizzie returned to a normal married life living together as they had previously. It was a bittersweet time for the couple, both knowing that Alex's illness was at the end stage. Their nearest relative was their young nephew George Asay, who lived in Los Angeles. George was perhaps a

frequent visitor to his aunt and uncle's home, and may have helped Lizzie with Alex, whose medical needs must surely have accelerated in the months since he left the soldier's home.

In addition to fatigue, weight loss, fever, headache, coughing and irritability which Alex would have experienced during the active stage of his TB, by now the disease would have advanced to persistent coughing, breathlessness, and fever. A bone-rattling cough would have been debilitating to Alex and a constantly frightening reminder to Lizzie, who was helpless to do anything for him. Perhaps a friendly doctor suggested cocaine or morphine (both readily available in those days at any pharmacy without a prescription) to silence his cough for a few hours. Lizzie surely tried to obtain whatever might help him, but in the end it was a long, losing, bitter battle.

Alex lost his fight to TB on March 31, 1908 when he died at home one day before his sixty-sixth birthday.[369] Lizzie likely was at his side, holding his hand, perhaps quietly speaking to him of happier times in the past, of their courtship days, or of their children, their travels and family. Alex may have passed peaceably in a quiet stupor of morphine or cocaine. Or he may have had a hard death from suffocation because he did not have enough lung tissue left to oxygenate his blood sufficiently. Afterwards, George probably came from Los Angeles and helped Lizzie with the simple funeral arrangements.

One of the benefits of honorably discharged veterans such as Alex was their eligibility for a free burial. Each of the eleven National Homes had a National Cemetery on their grounds or nearby. By law, each of them was enclosed "with a good and substantial stone or iron fence" and each grave was marked with a small headstone or block. By 1873 Congress had authorized money to pay for the headstones with rather exacting specifications; they were to be white marble or granite four inches thick, ten inches wide, and twelve inches long.[370] Interestingly, the Sawtelle cemetery, established in 1889, did not adhere to the headstone specifications; they provided a larger granite headstone for departed veterans. Alex was laid to rest at the cemetery on

April 4 with honor and dignity, as befitting a Civil War veteran.

According to a spokesperson at the National Cemetery, the army utilized a standard operating procedure for veteran burials with military honors. As told by home resident Henry Spalding to author Patrick J. Kelly in *Creating a National Home*, "After the Home's chaplain performed a brief ceremony in the branch church, a funeral procession consisting of the Home band, the hearse carrying the body, and the remainder of the funeral party formed and with 'a slow and mournful cadence' marched to the cemetery. As their comrade was lowered into his grave, the band plays a dirge, the firing party presents arms and the detail salute, three volleys are fired over the grave, and t'is done."[371] One can easily imagine Lizzie in her grief seated with bowed head before the grave as two army veterans carefully folded the American flag and presented it to her. The flag was undoubtedly wet with her tears.

Alex's death, although expected, must still have come as a shock to Lizzie. She had spent the last year nursing and caring for him, and now, with the exception of her nephew George, she had no family in California. Undoubtedly she felt bereft and at a loss, like a top spinning and then suddenly coming to a stop and teetering over. Her loss intensified when five months after Alex's death, George decided to return to Long Branch, New Jersey, possibly because his brother John was ill (John died in 1910).[372] He also may have wanted to be closer to what remained of immediate family, namely his half-sister Cecelia, who was living in Bordentown, New Jersey, and his half-brother William, living in New Brunswick.

What was to happen to Lizzie? She was the last Civil War widow in the family. Was her future to mimic that of her mother-in-law Mary Ann who, after fighting for months to obtain a pension, only received a pittance for her efforts? Two weeks after Alex's death, on April 13, 1908, Lizzie made a declaration for a widow's pension.[373] Necessity likely fueled her efficiency in preparing the documents quickly. She appointed Milo B. Stevens and Company, pension attorneys headquartered in Washington, D.C., as her representatives to process the claim.[374] The Stevens firm had branches in Cleveland, Ohio; Detroit, Michigan; and Chicago, Illinois and the firm

advertised prolifically in city directories throughout the country. They had expertise in handling pension claims and it may have been one of their ads that caught Lizzie's attention. Lizzie filed Alex's death certificate and proof of the marriage, as well as proof of his military service, in the claim application. She was awarded a pension of $12 per month on August 13, 1908, an amount which would increase to $20 per month by 1916 and another $5 per month to $25 in 1917. If she was a prudent spender, she might have been able to make ends meet.

In 1910, just two years after Alex's death, the United States Census reported she was living on her "own" income—most probably her pension money and any small savings she had managed to accumulate—with a lodger, sixty-four year old Teresa C. McAilen. Mrs. McAilen was a widow for nine years and a mother to three although all had pre-deceased her. She did not have any income, according to the census statistics, yet she was residing with Lizzie at 310 Pacific Avenue in Long Beach.[375] There is no information as to whether she was a friend (she does not seem to have been a veterans' widow) or a poor unfortunate that Lizzie took pity on, but she remained living with Lizzie until 1916. At the very least Lizzie had some companionship in her latter years and since the two women were of the same generation, they no doubt had much to talk about.

While perhaps not unique for the times, it seems that tragic occurrences abounded in the Hamilton family. One of the saddest after her husband's passing was the news that Lizzie's daughter Beth, married and living in rural Washington State, was ill with heart disease. Beth may have kept the news from her mother until her condition deteriorated to such a point where remission was not likely. The news of her passing on February 14, 1916 came by telegram or letter from Beth's husband. The news was overwhelming and it created still another deep layer of pain and grief. With no family close by to comfort her, Mrs. McAilen, who by this time had probably become Lizzie's closest friend, must have been the only person to provide here with consolation.

By this time Lizzie's health had begun to fail. She was seventy-one years old and suffering from arteriosclerosis or hardening of

the arteries. She also was treated for chronic nephritis or kidney disease.[376] Both of these diseases would have been caused by hypertension or diabetes or both. Her daughter's death certainly did not help her frame of mind. Although the average life expectancy for women in 1919 was 58.4 years, according to the California Department of Health, women who had reached the age of sixty-five were expected to live another 13.4 years to 78.4 years old (today the average life expectancy for women who reach sixty-five is 85.5).[377] Sadly, Lizzie didn't make it.

Since 1916 Lizzie had been living at the Yale Hotel, located at First and Pacific Avenues in Long Beach. From the information available, it appears Lizzie lived there alone (she no longer roomed with Mrs. McAilen perhaps because of growing medical expenses or perhaps for other reasons, although the two remained close). Lizzie's doctor, A. W. Buell, had an office at 204 Pine Street, just up the street from the hotel near the corner of First and Pine.[378] It may have been a matter of convenience for Lizzie to live at the hotel. Her health may have deteriorated to the point where her physician wanted her close to his office so he could monitor her.

On April 23, 1919 at 7:30 a.m. at the age of seventy-four years and ten months, Lizzie suffered a stroke or "apoplexy," according to her death certificate, and died. Employing modern medicine hindsight it is most likely that she suffered an ischemic/embolic stroke, when a clot breaks off in a blood vessel and travels to the brain. Lizzie's friend Teresa McAilen provided the information for Lizzie's death certificate, since there were no next-of-kin living nearby.

Lizzie was the last Hamilton Civil War widow, since her sister-in-law Lida, my great-grandfather John Hamilton's wife, had died in 1909 in Long Branch, New Jersey. Lizzie's difficulties in her last years—a small veteran's pension which covered only the basic necessities, a distancing or actual loss of adult children (her daughters Beth and Jennie had died earlier, and Alice and Alex's whereabouts were unknown-perhaps not to Lizzie, although they were not nearby), and a tragic downturn in her own health, mirrored many other Civil War widows experiences. At the end it was only

her friend and former roommate Mrs. McAilen, another widow, who grieved her passing. As news of her death reached New Jersey there were no doubt mourning nieces and nephews; however, they would have been unlikely or unable to have made the journey west. Lizzie, probably according to her wishes, was cremated. Certainly, if she had little money, cremation was the less expensive alternative.

By today's standards, Lizzie's circumstances seem sad and pathetic. In reality she and her Northern sisters fared better than Confederate widows, who received smaller pensions and had to deal with the additional burden of a shattered economy, the destruction of their way of life and the loss of an entire generation of men. Still, there is a sadness that permeates the thought of Lizzie's passing. With her death the Civil War became a distant remembrance for Alex's and John's children—fading memories of losing a grandfather wounded in battle, an uncle killed on the battlefield and two brothers forever changed by the experience of war, as well as the two women who loved them, bore their children and stood by them through good times and bad.

A RESPECTABLE BUT POOR
TRADE FOR WOMEN

"The past 75 years brought momentous changes
in family life patterns of America as we adapted
to dynamic economic, social, and demographic
developments." - James R. Wetzel in "American
Families: 75 Years of Change," *Monthly Labor
Review* (March 1990)

When Alex Hamilton's widow Lizzie Gilliland Hamilton died
in 1919, the Civil War was fifty-four years in the past and
long eroded from the memory of many of the Hamilton family
children and grandchildren. There may have been stories Lizzie's
and Lida's adult children shared with each other about some of
their fathers' more colorful exploits and experiences in the war, but
for the most part the conflict was a distant memory far removed
from the children's and grandchildren's experiences.

Indeed, the twentieth century brought so many changes
and improvements to lives and families that the past was often a
distant memory. As James R. Wetzel wrote in his essay "American
Families: 75 Years of Change," " ... life changed dramatically in the
20th century as women bore fewer children (due to medical and
hygiene innovations children had a better survival rate than their
predecessors in the 19th century); fewer people lived in traditional
nuclear families and finally the economic roles within the family
shifted as women were more likely to work outside the home."[379]

While these changes affected many throughout the century, the early years bore the difficult transition from a traditional family life to a more modern one—although not necessarily a happy shift for the Hamiltons.

In June 1915 John and Lida's oldest son, John Jr., just forty-two years old, died of an apparent case of pneumonia in Long Branch, New Jersey, just three years before his father passed. A building contractor, he had been active in the Long Branch community as a member of Lodge No. 78 of the Free and Accepted Masons, and had held several offices in the lodge.

Every Decoration Day (the original name for Memorial Day) his lodge marched in the annual parade and May 30, 1915— although a cold rain fell—was no exception. (Decoration Day was designated as a day to decorate the graves of war dead; though there are numerous claims to its origin, the first recognized service took place May 30, 1868.) Unfortunately, John caught a cold, which developed into an infection and he died from what his obituary called "intermittent fever." He left a young widow, Edna Haines Hamilton, and two small children, J. Herbert, age twelve (1903-1991) and E. Mildred, age five (1910-2009), but did not leave a will. At the time of his death, according to records at the Monmouth County Surrogate's Office, his estate did not exceed $150; he did, however, leave debts that his wife was unable to pay. The only asset the widow owned, although it was heavily mortgaged, was their home at 63 Jackson Street.[380]

Edna had "purchased" the Jackson Street property on June 5, 1907 from Ella Emmons and her husband, Cornelius. It was an odd transfer. The purchase price for the Jackson Street property was $350 and Edna purchased it alone, not jointly with her husband. Additionally, while Ella's husband's name is on the deed, it is clear from reading the deed that Ella was not the first owner of the property (the property was conveyed to her in 1886 through an inheritance, perhaps by a relative).[381]

Property rights for women were controlled and administered by individual states. New Jersey, although often viewed as a progressive state, was the last of the northern states to pass a comprehensive and

progressive married women's property law. Under English common law, "a married women, known as a 'femme cover' or a woman 'covered' by her husband's status, forfeited all personal property and surrendered control of real property to her husband"[382] upon their marriage. Widows and single women were permitted to own property.

Eventually New Jersey passed a limited version of the Women's Property Act in 1852. A more comprehensive form was enacted in 1874 which gave married women the right to own property in their own name. By 1895 married women had gained the right to contract, to sue and be sued for property and in 1896 they were granted the legal right to their earnings and wages as separate property. Most important, perhaps for the Hamiltons, was that the law declared that a married woman's separate property "… shall not be subject to the disposal of her husband nor liable for his debts."[383] (These acts, which were legislated to give married women more property rights, recently were repealed in New Jersey since anti-discrimination laws guarantee equal protection under the law to men and women.)

The Hamilton-Emmons deed generates a great deal of speculation. Why would Ella Emmons, a retired sixty-year-old milliner, "sell" property to Edna Hamilton? Coincidentally, Ella's husband, Cornelius was, like John Hamilton Jr., a carpenter by trade who worked for a lumber mill. The two men certainly knew each other in a small town like Long Branch. Was the property transfer something John and Cornelius arranged between their wives? Was the deed transfer a result of a legal case? Or was Ella somehow related to Edna? A search of the Monmouth County legal system did not find any filings related to the two parties and there is no evidence that Ella and Edna were related or that they knew each other well.

Based on the selling price of $350 for the property, it becomes apparent that the land was vacant. Further evidence appeared in the *Red Bank Register* of June 12, 1907, where a short article stated, "John P. Hamilton of Long Branch, who recently sold his residence at that place, is building a small bungalow which he will occupy

when completed."[384] The "small bungalow" was to be situated at 63 Jackson Street. Perhaps we will never know why the property was deeded to Edna, but the fact remains that Edna, a married women, now owned land.

In November 1907, the same year that John built their house, the couple took a mortgage for $1,500 with Alonzo Sherman, a principal in H. B. Sherman & Sons, a local feed company. Although the mortgage was recorded jointly in the couple's name, it reads in part, "… the consideration moneys for which this bond and mortgage are given are loaned and advanced to her (Edna) for her (Edna's) own us and benefit …"[385]

Edna was cited in the mortgage as being loaned the money because she was the sole owner of the property. It is somewhat unusual, however, that the property Edna purchased as a married woman remained in her name alone, although there are plausible reasons why this was done. The law, as previously stated, provided a suitable answer in that property owned by a wife could not be used to pay the debts of a husband. Perhaps John, a contractor and businessman, was concerned that if he was ever sued, his personal property could be subject to a claim and he wished to preserve their home for his wife and children. Or perhaps John's credit standing was not what it should had been and by keeping the property in Edna's name he was again preserving it from creditors.

Whatever the motive for the first mortgage, the Hamiltons took a second mortgage in 1908 with the New Jersey Mortgage and Trust Company for $2,000 over one year at 5% semi-annual interest.[386] It seems plausible that John used at least part of the first mortgage for building supplies for his house; perhaps the remaining amount was used for his contracting business. We know that John Jr. lived well. According to my mother Mildred, her father had one of the first automobiles in Long Branch (in 1913 a car cost about $490, equal to one-third of an average annual salary for a worker).

When John died in 1915, his father, my great-grandfather John Sr., likely helped his daughter-in-law and grandchildren with their finances, although he was living on a small Civil War Pension at the Disabled Soldiers Home in northern New Jersey and had limited

means. His assistance, if any, was short-lived, since he died in 1918. Clara M. Haines, Edna's mother, who lived with the family, may also have offered support and perhaps some small monetary contribution to the household. But she also had passed away the year before John in 1914. Sadly, though there were immediate family members in Long Branch, for reasons unknown they did not come to Edna's aid. For Edna and the children, life became even more difficult. Local charities took pity on the family and on holidays a basket of food was left on their Jackson Street stoop. Daily life was still a bitter struggle for the young family; they often ate oatmeal each day since it was cheap and nutritious.

In 1918, according to the Monmouth County Clerk records, Edna paid off the $2,000 loan she and John had taken out with N.J. Mortgage and Trust Company in 1908. She had help doing so. Sarah S. Clark of East Orange, New Jersey loaned Edna $3,000 in the form of a mortgage that same month.[387] We do not know Clark's exact relationship to Edna although it's likely the families of each were well acquainted. They lived within four blocks of each other in Newark in 1880 and both Edna's mother Clara and Susan worked in the garment industry—Clara as a seamstress and Susan as a "vest maker."[388] The following year Edna took another loan from Sarah for $600 payable in one year at 6 percent interest.[389] Interestingly, these two loans were not cancelled until 1946 presumably on the death of Clark's daughter Addie Clark Plumley, whose estate forgave the loans since there was no hope of them ever being repaid. Edna was not without some resources. She was a skilled seamstress, having been taught by her mother Clara who was employed as a seamstress in Newark where she lived before moving to Monmouth County. We do not know if Clara did sewing at home by order, if she worked on garments in the shop of a contractor, or worked in custom sewing, but she was listed in the 1880 Federal Census and the Newark City Directory as a seamstress.

Alice Kessler-Davis, in her book *Women Have Always Worked: A Historical Overview*, points out that sewing was the major industry in large cities like Philadelphia, Boston, New York and Chicago, and was considered "an honorable but poor tradition."[390] Not

to be outdone by its neighbor New York, in 1880 Newark, New Jersey had twenty-two clothing manufacturers and eight shirt manufacturers. There also were at least seventeen businesses that repaired clothing in the city.[391] After the invention of the sewing machine in 1850, the garment industry became highly structured, with merchants sending bundles of cloth to contractors who hired seamstresses to make clothing. Once completed, the contractor returned the garment to the merchant. These contractors had "shops" or "rooms" where seamstresses worked frequently under dire conditions (146 garment workers died in the infamous 1911 Triangle Shirtwaist Factory Fire in New York City many because the exit and stairwell doors were locked to prevent workers from taking unauthorized breaks).[392] Clara also may have worked as an operator of a sewing machine in the garment industry.

At home, Clara and Edna would have made their own clothes and those of their families. My mother Mildred often related a story about her brother Herb and a white linen summer suit their mother made for him. Edna sent her son to Sunday school at a nearby church and admonished him not to get his suit dirty. When he sheepishly returned home it looked like he fell into a muddy hole, according to my mother, and my grandmother "boxed his ears good."

Edna also designed outfits and the float itself when Herb and Mildred took part in the Children's Parade on the Long Branch boardwalk. For several years in a row, her unique floats and designs won first and second place silver loving cups. (The trophies were called loving cups because they had two handles and were often used in marriage toasts as well as awards). Another testament to Edna's skill as a seamstress is an intricate nightdress with a train that she designed and sewed for herself.

Edna's brother, Dewitt Clinton Haines, worked as a buyer for Bamburgers Department Store at 109 Market Street in Newark. Founded in 1892 by Louis Bamburger, the store by the mid-1920s employed 2,800 people and ranked as one of the top five department stores in the country in terms of sales volume. It was a progressive and modern place to work, boasting a library, health and

social services and a music club. Louis Bamburger also established a branch of Rutgers University in the store to allow his employees to further their education.[393]

Dewitt may have reached out to help his sister in her poor economic state. While there is no proof, he may have assisted in securing her a position as a seamstress with the store. Bamburgers employed a multitude of seamstresses and tailors to customize and fit the clothing their clientele purchased. Unfortunately, by 1922 Edna had became ill. We do not know if she had a breakdown or was suffering from depression or another mental ailment. She entered Trenton State Hospital, a psychiatric facility, in April (the same hospital where her husbands' Aunt, Susan had been admitted in 1870). At the time Edna was at the hospital, Henry Andrews Cotton, a psychiatrist, was its medical director. A physician who believed that mental illness was the result of untreated infections in the body, Cotton, who was director from 1907 to 1930, along with his staff practiced experimental "surgical bacteriology" on patients, including the routine removal of teeth, tonsils, spleens, colons, ovaries and other organs.[394]

Constructed on the theory of infection-based psychological disorders, Cotton surgically removed suspected "infected" organs and teeth as his method to cure mental illness. As radical as Cotton methods were one hundred years ago, today, surprisingly, ongoing research suggests that some mental disorders may indeed be triggered or caused by infections. One example is the sudden onset of acute Obsessive Compulsive Disorder (OCD) after a strep infection in children. Cotton's procedures, however, were not based on scientific evidence at the time; his exaggerated cure rates were built on faulty methodology used in compiling data. Based on publicity of his successful "cure" rates, however, patients and/or their families—many of them members of the "Social Register" (a directory of the social elite)—pleaded to be treated at Trenton.[395]

Edna, who apparently was not suffering from any physical ailments, underwent an intestinal operation at the asylum. Sadly, in an era before antibiotics, surgery often resulted in a very high rate of postoperative morbidity and mortality—usually from

infection. Following the operation, Edna developed peritonitis and bronchial pneumonia. Two weeks later she died at the age of forty-two, leaving behind her two children.[396] Creditors petitioned the Surrogates Court for the payment of outstanding bills left by her estate, including the undertaker's funeral bill in the amount of $94.53, a plumbing bill of $17.77, medical services and others. The estate was not closed out for more than four years, and only then when the Hamilton home was seized and sold at auction leaving Edna's children with the paltry sum of $362.14.[397]

J. Herbert, who was a young man of eighteen at the time, was able to care for himself, but his twelve-year-old sister Mildred, who had been living with her uncle Clinton in Irvington, New Jersey, was sent to live with distant relatives in Quebec, Canada. It is a family mystery of who these "relatives" were. It was not something my mother spoke about because her four years in Canada were not happy ones. She neither understood nor spoke French and was treated as an outsider according to her remembrances. She said that she was little more than a maid in the home where she stayed. To her relief, she returned to New Jersey at age sixteen.

It seems odd that neither her uncle Clinton (on her mother's side) nor her aunts—Jennie, Minnie or Laura (on her fathers' side)—took her in. Perhaps they were at the edge with their own families and she might have been a financial burden, or perhaps there was a family argument regarding who would take her in. Clinton did, in fact, petition the court after his sister's death for a claim of $332.29, which he received—probably as payment for feeding and sheltering his niece.[398] Both Herbert and Mildred married and lived in New Jersey until their deaths at eighty-eight in 1991 and ninety-nine in 2009, respectively. Herbert and his wife, Ann Heinzman, had a daughter, Gail, and Mildred and her husband, Raleigh Rajoppi, had two daughters, my sister Carol and myself.

Dire financial straits followed by an early death were not unusual for many poor widows. Although life and accident insurance were available, John evidently did not purchase these. Social Security was not yet initiated (the program began in 1935) and pensions and death benefits for the self-employed, like her husband, a freelance

contractor, were also unknown. Despite the ownership of her home, she could not cope, since the house was over-mortgaged, and Edna was unable to free herself of that burden. Unfortunately, her ability to earn her living through sewing, if she did in fact work as a seamstress, provided too little to feed and shelter her family. The stress of everyday living must have been a tremendous burden for her so it is more than understandable that at some point she broke. It was a fate many poor women or those without a close supportive family experienced.

Chapter 20

A PATRIOTIC LEGACY

"In a house which becomes a home, one hands down
and another takes up the heritage of mind and heart,
laughter and tears, musings and deeds."
–*Generation to Generation* by Antoine de Saint-Exupery

As he did, many of my great-grandfather John Hamilton's siblings, nieces and nephews stayed or returned to New Jersey, living predominantly in Long Branch, New Brunswick and Bordentown. Following in the footsteps of their great-grandfather, many family members served their country in the military, in government or as public service volunteers.

Family patriarch Alexander Hamilton and his wife Mary Ann's oldest daughter Mary Jane Fourcett died at the young age of twenty-seven in 1865 leaving a daughter, Mary Ida Fourcett (1861-1945). Mary Ida's father James later remarried and took the young child to live in Connecticut, but father and daughter returned to New Brunswick, New Jersey in the 1880s where they both found jobs in the local rubber factory.[399] Mary Ida married Henry "Harry" G. Dalyrumple (1860-1910) in Manhattan in 1883 and the couple lived with her father James until his death in 1886. The couple had three children, Clifford Vancleve (1883 -?), Royal Ellsworth (1884-1970) and Florence M. (1886-1963).

Their sons both registered for the military in World War I and later for World War II, although they were not called up in either conflict to serve. Royal worked as an accountant for the U.S. Steel

Corporation for most of his adult life, while Clifford, who was also an accountant, worked for the Works Progress Administration (WPA) in the "Mathematical Tables Project," then one of the largest computing programs in the world.[400] Mathematicians and physicists computed tables of math, including exponential functions, logarithms and trigonometric functions, all of which filled thirty-seven volumes. The project participants also did computations and calculations for World War II projects, including tables for the LORAN navigation systems, microwave radar, bombing and short wave. The project continued to operate until 1948.[401]

Mary Ida's third child, Florence, married Bernard Moos in 1907 and lived in Rockland County, New York on a farm. She and her husband, a bookkeeper, had three children: Hope (1908 - ?), Bernard Jr. (1912-1998) and Gilbert E. (1916-1989). Both Bernard Jr. and Gilbert enlisted in the military in 1941, just prior to the start of World War II. Both men served in the army. Other members of the family also served their country. My great-grandfather had two sons: granduncle Walter and my grandfather, John Jr. Walter married Lydia Rockhill in 1904 and was a resident of Red Bank for thirty-seven years. He was employed at Fort Monmouth, New Jersey for many years working for the WPA, and he retired in 1955.

During World War I, at the age of thirty-six, Walter registered for military service. He registered again in 1941 at the age of sixty, though he was not called up. The Selective Service Act, which required mandatory registration, was passed during World War I and about 24 million men completed draft registration cards between 1917 and 1918. There were three registration cycles during the war. The first included all men between the ages of twenty-one and thirty-one and was held on June 5, 1917. The second registration was for those who reached twenty-one after June 5, 1917. The last registration, held on September 12, 1918, was for men eighteen through forty-five and Walter was included in this last group. When the armistice ending the war was signed on November 11, 1918, the Selective Service process was abruptly halted and by the following year local, district and medical Selective Service advisory boards were closed.[402] But Walter was able to serve his community and

country in other ways. He was a member of Union Hose Company of Red Bank and a member of Onward Council, Junior Order, United American Mechanics. The couple did not have children and Walter died in 1956, and his wife followed in 1969. They are buried in West Long Branch's Glenwood Cemetery.

The Hamilton's oldest daughter, Minnie, married Douglas Riddle, in 1888. When Minnie's parents moved to Detroit in 1877, Minnie stayed in Long Branch with her Aunt Maggie and Uncle Walter Asay and their one-year-old son Walter Jr. until her parents returned. After marriage Minnie and her husband lived in Oceanport in Monmouth County. There Douglas operated the Riddle Boat Works with his brother Perley and their father, Thomas. During World War I the boat yard closed and Doug and his brother worked at the Aeromarine Plane and Motor Company in Keyport, New Jersey building military seaplanes and flying boats.[403] Doug served as an Oceanport Borough Councilman from 1921 to 1930. The couple had two children, Elsie (1888-1972) and D. Glenn (1896-1916).

The Riddles son-in-law and grandchildren carried on the tradition of service to country. Their daughter Elsie married Edward M. Berry, a veteran of the Spanish-American War, who registered for World War I at the age of thirty-nine in 1918 and again at the age of sixty-two in 1942 for World War II. Similar to Walter Hamilton, he was not called up, but served as an Oceanport Councilman from 1925 to 1933, chief of the Oceanport Fire Department and as president of the Hook and Ladder Company of Oceanport. The couple had four children, all of whom served in the military: Douglas G. (1913-1989) served in World War II; Edward M. Jr. (1915-1979) served as a Technical Sargent in World War II (he served in New Guinea and Southern Philippines and received the Air Medal with bronze oak leaf cluster; Asiatic Pacific Service Medal, the Distinguished Flying Cross and a Good Conduct Medal); Robert G. (1921-1989) joined the US Marine Corps in 1942 and was stationed in San Diego, California and Elizabeth "Betty" A. (1925-2011) served as a Lieutenant Colonel in the US Army; Douglas G. also was elected to serve as an Oceanport councilman in 1942, but resigned at the start of the war.

Like her brothers John and Walter, Minnie, who died in 1924, is buried in Glenwood Cemetery in West Long Branch. Her husband Douglas, who died in 1938, is in the same cemetery, along and two of their children, Edward and Elizabeth. Their son Douglas is buried at Monmouth Memorial Park in Tinton Falls and Robert is at Woodbine Cemetery in Oceanport. Elsie and Edward Berry are buried in Glenwood Cemetery in West Long Branch. John and Lida's next oldest daughter, Laura P., married Harry G. Woolley of Long Branch in 1887. Harry was an insurance agent who maintained his own agency and owned a home at 44 Norwood Avenue in Long Branch. He served as secretary of the Long Branch Fireman's Relief Association for twenty-seven years. The couple had two children, Albert (1891-1941) (who suffered from an "unknown ailment," according to my mother's recollections), and Ida (1898-1969). Harry died in 1939 and Laura followed him in 1940. Both are buried at Glenwood Cemetery.

Edna Hamilton, the next oldest daughter, married Edward M. Haviland in 1891. Edward's father was a well-known boat captain in the Red Bank area. Edward worked as a fish and oyster dealer in Brooklyn, where the young couple lived. They had a daughter Mildred who died in infancy, but in 1909, when Edna's mother Lida died, Edna's youngest sister, twenty-year-old Jennie, came to live with the Havilands, and also worked as a bookkeeper. Edward died in 1923 and the following year found Edna living in Orange, New Jersey (possibly with a Haviland relative). To date, I have not located Edna after 1924. She may have remarried since she is not buried with her husband in Red Bank.

Jennie met her husband Harry Bolshaw in Brooklyn while working as a bookkeeper in her brother-in-law's fish store and the couple married in 1910. In 1917, at the age of twenty-seven Harry registered with Selective Service but wasn't called up. He registered again in 1942 at the age of fifty-three but again was not called. The couple first moved to Philadelphia and then settled in Hasbrouck Heights in Bergen County, New Jersey. Harry worked in the telegraph industry, eventually becoming a credit manager for Western Union. He was also active in the community serving

as a Hasbrouck Heights councilman from November 1928 to December 1934. The couple had two daughters, Eleanor (1911–1983) and Marion (1914–1996).

Jennie was the record keeper of the family. As her granddaughter, Jean Taormina (Marion's daughter), recalled, Jennie was extremely organized. She kept lists and saved everything, even leaving instructions on how she wanted her spectacles placed on her face when she was "laid to rest."[404] She saved her father's letters from the Civil War and made copies to distribute to key family members. She also made notations of other family events including newspaper clippings of weddings and deaths and handwritten notes. Without her notes, other members of the family would have been lost to posterity—especially her Uncle Alex and his children, living first in Detroit and then moving to Seattle and California.

Jennie's daughter Marion, her son–in–law Lester Puth, and the couple's daughter Jean lived with Jennie and her husband in Hasbrouck Heights for many years. As her granddaughter Jean recalled, Jennie was an excellent seamstress, making most of the family's clothing, and was fastidious in her own dress and always appeared "prim and proper." She inherited the Hamilton trait for height, measuring about 5 feet 7 inches, which for the time period was tall for a woman. Jennie died in 1972. Her husband Harry predeceased her in 1947, and the couple is buried in Paterson's Cedar Lawn Cemetery.[405]

The other surviving Hamilton family members living in New Jersey were William and Cecelia Boudinot, children of Alice Hamilton and her first husband, Miller Boudinot. A sibling to Edna, Jennie, Laura, Walter and John, Alice married Miller Boudinot in New Brunswick, New Jersey in 1870 and the family moved to Detroit, Michigan. When Miller died suddenly in 1882, Alice returned to New Jersey with her two children, William, (1872–1940) and Cecelia (1877–1979). Four other children died.

After a short time in New Jersey, Alice married her uncle by marriage Walter Asay who had a son, Walter, Jr. from his marriage to Maggie Howland Asay. Walter and Alice had two more children, George Jackson (1885–1958) and John Henry (1887–1910). Cecelia

was a senior at Long Branch High School when her mother died in 1894. Her stepfather Walter Asay died the following year, and tragically Walter Asay Jr., Cecelia's twenty year old stepbrother, died the year after from a brain abscess. Cecelia assumed a great deal of responsibility for her stepbrothers George, ten, and John, five, after the deaths of her mother and stepfather.

Within a few years, John, at age thirteen in 1900, was living with his father's relatives, Theodore Young and his family in Ocean, near Long Branch and was apprenticed as an electrician (both Theodore Young Sr. and his son, Ted Jr. were also electricians). Cecelia's other stepbrother George left New Jersey for Los Angeles, California in 1901 at the age of nineteen, meeting his Uncle Alex a few years later at the Disabled Veterans Home near Los Angeles. George returned to New Jersey after his Uncle Alex's death in 1908 and worked as a janitor in the Long Branch Public Schools. He married Ada Bacon and they had two children, Kenneth C. (1916-1967) and Lois B. (1921-1984). In the mid-1920s John returned to California with this family and settled in Beverly Hills where he worked as a school custodian. He died there in 1958 and his wife passed seven years later in 1965.[406] George's son, Kenneth, was the first in the family to graduate college in 1938.[407] Cecelia's other stepbrother John Asay stayed in touch with her until his death in 1910. Cecelia had a close relationship with him as he often visited her in Bordentown while living in Morrisville, Pennsylvania. She in turn would sew shirts and do other domestic chores for him.

Cecelia's brother William M. Boudinot was twenty-two when his mother died. He went to live with his uncle, William B. Boudinot in New Brunswick. He lived in the city along the Raritan River for the remainder of his life. In 1909 he married a widowed French immigrant, Louise Marchall, who was from Beaucourt, France, five years his senior. William worked various jobs as a salesman, in a grocery store, for a contractor, as a laborer in a government camp and lastly as a clerk. At the age of forty-four he registered for the World War I draft, but, like other family members, wasn't called. A member of the First Reformed Church of New Brunswick, he died in 1940 and his wife followed him

in 1941. They are both buried in Van Liew Cemetery in New Brunswick.

The longest living member of the family, Cecelia Boudinot, left Long Branch for Bordentown in south Jersey in 1899 to work at the Eagle Shirt Factory. After years of caring for her family, Cecelia was at last independent, receiving a separate listing in the Bordentown City Directory as "Boudinot, Cecelia, shirt operator." Located at Spring and Ann Streets, the factory opened in 1822 and changed ownership several times over the years before succumbing to changing times and being abandoned to disrepair. The factory was renovated and rehabilitated in 2015 for senior citizen housing.[408]

In 1900 Cecelia married Joseph Quigley (1876-1941), a wire maker like her stepfather, who worked as mill gauger in a steel factory. The couple lived with Joseph's parents at the bottom of Federal Street close to the winding Black's Creek which runs into the Delaware River on the south side of historic Bordentown. Later that year Mabel (1900-1965) was born and then the twins Sarah (1903-1929) and Robert T. (1903-c. 1955). Cecelia's husband Joseph registered for military service at the age of forty-two in September 1918. Joseph was included in the third wave of registrations for Selective Service for men age eighteen through forty-five but again the war ended sooner than anyone expected and the Selective Service system was curtailed.

In an interview with *The Register-News* conducted on her 100th birthday in 1976, Cecelia admitted to working hard in her job as a shirt operator before her marriage, but after her marriage, she claimed "I worked harder yet." Cecelia remained at the Federal Street home, which had been built years earlier by her husband's family, for many years. She eventually moved around the corner to 336 Oliver Street and continued to care for herself and her home until she was 96. She deeded her Oliver Street home to her daughter, Mabel B. Hill, in 1965 and went to live with her grandson and his wife, Robert and Glenda Hill.[409] When she was featured in the newspaper on her 100th birthday, she had survived her husband and her children and had a godson, three grandchildren, four great-grandchildren and two great-great grandchildren. Cecelia died in

January 1979 at the age of 102. She was the last of her grandfather John Hamilton's nieces and with her death the last of an era. Cecelia's life—as well as any other Hamilton woman—showcased the strength and perseverance of dealing with the trials of a family recovering from the affects of the Civil War. Illness—both physical and mental—alcoholism, unemployment, economic depressions, poverty and early death did not deter these women's commitments to push on, to nurture their families, to learn new skills and to go where women were not expected or often, not welcomed.

The Hamilton women were not unique to the North. Tens of thousands of women had to face similar consequences in the aftermath of the Civil War when they were challenged with economic destitution on the death of a husband or the illness, psychological and physiological trauma and/or addiction of the men who returned. The legacy of these brave and steadfast women lives on in the stories they shared with their children, who passed the legacy forward to their children, grandchildren, and great-grandchildren. For all these stories I was able to glean, there are so many more untold stories, and yet even this glimpse into the Hamilton women's' lives offers a window into the American experience.

CHAPTER NOTES

CHAPTER ONE (pages 1-11)

1 Pension Application, Mary Ann Hamilton, WC 60.031, 1863. U.S. National Archives. Washington, DC.

2 Rajoppi, Joanne Hamilton, *New Brunswick and the Civil War: The Brunswick Boys and the Great Rebellion* (Charleston, SC: The History Press, 2013).

3 National Archives and Records Administration (NARA); Washington, D. C.; Crew Lists of Vessels arriving at Boston, Massachusetts, 1917-1943; Publication Number: T938; Roll: 6 (accessed 7/10/2014).

4 Police Court Docket. Alexander S. Hamilton, Lynn, MA., October 27, 1850.

5 Year: 1850; Census Place: Newburyport, Essex, Massachusetts; Roll: M432_313; Page: 251A; Image: 17 (accessed 6/15/2014).

6 Massachusetts, 1855-1865 Massachusetts State Census (microfilm). New England Historic Genealogical Society, Boston, Massachusetts (accessed 6/24/2014).

7 McGrew, Jane Lang, "History of Alcohol Prohibition," National Commission on Marihuana and Drug Abuse, Washington, DC: http://www.druglibrary.org/schaffer/library/studies/nc/nc2.htm (accessed 3/1/2016)

8 Ibid.

9 Ibid.

10 Year: 1860; Census Place: Eel, Cass, Indiana; Roll: M653_247; Page: 540; Image: 26; Family History Library Film: 80347 (accessed 8/18/2014).

11 Marriage record. Mary Jane Hamilton and James W. Fourcett, Vol. V, p. 92, January 1, 1861. New Jersey State Archives.

12 Pension Application, Mary Ann Hamilton.

13 Ibid.

14 Letter of John Hamilton to Mary Ann Hamilton, January 14, 1862.

15 Civil War Payment Vouchers, 1863, M:1441. New Jersey State Archives.

16 Pension Application, Mary Ann Hamilton.

17 Ibid.

18 Davidson, Amy. "The 'Soldier's Disease,'" *The New Yorker.* November 11, 2010: http://www.newyorker.com/news/amy-davidson/the-soldiers-disease (accessed 3/1/2016).

19 Lowry, Thomas P., M.D. *The Story the Soldiers Wouldn't Tell: Sex in the Civil War.* (Mechanicsville, PA: Stackpole Books, 2012), 108.

20 Letter of John Hamilton to Mary Ann Hamilton, January 29, 1864

21 Administration Bond. Estate of Alexander S. Hamilton, Vol. A, 120. Middlesex County Surrogate, New Brunswick, NJ.

22 Elder, Angela Esco. "Civil War Widows." Essential Civil War Curriculum. August 2012: http://www.essentialcivilwarcurriculum.com/civil-war-widows.html (accessed 3/1/2016).

23 Ibid.

24 Ibid.

CHAPTER TWO (pages 12-18)

25 Holmes, Amy E. "'Such is the Price We Pay:' American Widows and the Civil War Pension System" in *Toward a Social History of the American Civil War: Exploratory Essays.* Maris A. Vinovskis, ed. (New York, NY: Cambridge University Press, 1990): 171-196.

26 Elder, "Civil War Widows."

27 Gugliotta, Guy, "New Estimate Raises Civil War Death Toll," *The New York Times,* April 2, 2012: http://opinionator.blogs.nytimes.com/2014/04/15/the-civil-war-death-toll-reconsidered (accessed 9/21/2014).

28 Hacker, David J., Libra Hilde and James Holland Jones. "The Effect of the Civil War on Southern Marriage Patterns." *Journal of Southern History,* Vol. 76, No. 1 (February 2010): 39-70.

29 An Act to Grant Pensions, U.S. Statutes, Thirty-Seventh Congress, Sess. II, 1862. Ch. 165, 166.

30 Ibid. (Non-commissioned officers, musicians and privates received a pension of $8 per month while a sliding scale of pension payments was put into effect for officers; the same process of a sliding pension pay scale was followed in the navy).

31 Prechtel-Kluskens, Claire, "A Reasonable Degree of Promptitude:

Civil War Pension Application Processing, 1861-1885." *Prologue Magazine* 42, no. 1 (Spring 2010).

32 Pension Application, Mary Ann Hamilton.

33 Ibid.

34 Military Service File, Alexander S. Hamilton. U.S. National Archives, Washington, DC.

35 Pension Application, Mary Ann Hamilton.

36 Ibid.

37 Ibid.

38 Ibid.

CHAPTER THREE (pages 19-26)

39 Military Service File, John P. Hamilton. U.S. National Archives, Washington, DC.

40 Death Certificate. Mary Jane Hamilton Fourcett. New Jersey State Archives.

41 Year: 1880; Census Place: New Haven, New Haven, Connecticut; Roll: 106; Family History Film: 1254106; Page: 195B; Enumeration District: 88; Image: 0346 (assessed 9/21/2014).

42 The Conference on Research in Income and Wealth, ed. *Trends in the American Economy in the Nineteenth Century,* "Wage Trends, 1800-1900." (Princeton, NJ: Princeton University Press: 1960): http://www.nber.org/chapters/c2471.pdf (accessed 10/2/2014).

43 Marriage Record. John Hamilton and Eliza A. Howland, Vol. BG, August 27, 1867, p. 515. New Jersey State Archives.

44 Year: 1870; Census Place: New Brunswick, Middlesex, New Jersey; Roll: M593_873; Page: 284A; Image: 106910; Family History Library Film: 552372 (accessed 4/10/2010).

45 Marriage Record. Alex Hamilton and Lizzie Gilliland, Vol. BG, January 18, 1868, p. 482. New Jersey State Archives.

46 Year: 1860; Census Place: New Brunswick, Middlesex, New Jersey; Roll: M653_700; Page: 303; Image: 304; Family History Library Film: 803700 (accessed 2/29/2010).

47 1870 Census, New Brunswick, New Jersey.

48 History.com Staff. "Dorothea Lynde Dix": http://www.history.com/topics/womens-history/dorothea-lynde-dix (accessed 7/30/2014).

49 WordPress.com. "1880 Forms of Insanity 2010 DSM": https://inmates of Willard.files.wordpress.com/2011/10/document-2010-dsm_hipaa.pdf (accessed 4/10/2010).

By the 1840 Census mental disorders were classified under a single category, "idiocy/insanity." In the 1880 Census seven categories were used for mental illness including mania, melancholia, paresis (general paralysis), epilepsy, dipsomania, dementia and puerperal mania.

50 Burrows, George Man, *An Inquiry into Certain Errors Relative to Insanity and Their Consequences: Physical, Moral and Civil.* (London, England: Thomas and George Underwood, 1820).

51 Trenton Psychiatric Hospital. Susan Hamilton. Case Books, Book E, Vol. 10, 1 July 1869-30 October 1871, 127. New Jersey State Archives.

52 Dix, Dorothea, "Memorial to the Legislature of Massachusetts." (Boston, MA: Munroe & Francis, 1843).

53 Pouha, Katherine and Ashley Tinen, "Lunacy in the 19th Century: Women's Admission to Asylums in United States of America," *Oshkosh Scholar,* Vol. 1 (April 2006): 95-103.

CHAPTER FOUR (pages 27-37)

54 Letter to Alice Hamilton from Miller Voorhees Boudinot, circa December 1869.

55 Marriage Record. Miller Boudinot and Alice Hamilton, Vol. BI, January 4, 1870, p. 520. New Jersey State Archives.

56 1870 Census, New Brunswick, New Jersey.

57 Letter of Administration. Estate of Mary Ann Hamilton, New Brunswick, NJ. Vol. D, p. 44, Middlesex County Surrogate, NJ.

58 Ibid.

59 Letter to Mary Ann Hamilton from John Hamilton. April 1864.

60 Ibid.

61 Whitfield-Spinner, Linda, Dissertation, "A History of Medicine and the Establishment of Medical Institutions in Middlesex County, New Jersey that Transformed Patient and Doctor Relationships during the Early Twentieth Century," (Dissertation, Drew University, May 2011), 31.

62 Ibid., 30-38.

63 1870 Census, New Brunswick, New Jersey.

64 Bernstein, Samuel. "American Labor in the Long Depression, 1873-1878." *Science & Society* 20 (1), (Winter 1956): 60, 74-77.

65 Hansan, John E. "Charity Organization Societies (1877-1893)": http://www.socialwelfarehistory.com/eras/civil-war-reconstruction/charity-organization-societies-1877-1893 (accessed 11/10/2011).

66 Ancestry.com. U.S. City Directories, 1822-1995 (database). Provo, UT, USA: Ancestry.com Operations, Inc., 2011 (accessed 5/1/2010).

67 Trenton Psychiatric Hospital. Susan Hamilton. Case Books 1848-1910. New Jersey State Archives.

68 Detroit History. "Statistically Speaking...1797-Present": http://www.historydetroit.com (assessed 6/5/2014).

69 Boudinot Family Bible. "Deaths." James Boudinot, July 8, 1874.

70 Ancestry.com. U.S. City Directories, 1822-1995 (database online) (accessed 6/1/2014).

71 DeYoung, Jacqueline, Comp. "The History of the Detroit Police Department Precincts 1865-1970." (Detroit, MI: Detroit Police Department, 1971): 1-14.

72 Michigan Historical Society, "The Growth of Manufacturing: Furniture Cities": http://www.hal.state.mi.us/museum/explore/museums/hismus/prehist/manufac/furniture_cities.html_(accessed 6/5/2014).

73 Ancestry.com. U.S. City Directories, 1822-1995 (database online) (accessed 6/1/2014).

74 Boudinot Family Bible. "Births and Deaths." Frank Boudinot, b. August 29, 1878; d. October 5, 1878.

75 Detroit: The History and Future of the Motor City. "Recreation Park": http://www.detroit1701.org/Recreation%20Park.html (accessed 6/5/2014).

76 Austin, Dan. "Water Works Park Tower" http://www.historicdetroit.org (accessed 6/5/2014).

77 Trenton Psychiatric Hospital. Susan Hamilton, Registration Book, 1876. New Jersey State Archives.

78 The New York Times, "New Jersey Epileptics: The State Village to Receive Them will be Opened Next Month," 12 October 1898.

79 Ancestry.com. U.S. City Directories, 1822-1995 (database online) (accessed 5/1/2010).

80 Boudinot Family Bible. "Deaths." Mary A. Boudinot, 12 May 1881.

81 Blakeslee, Jean, "Happy Birthday Cecelia Rachael Quigley, 100 Times," The Register-News, Bordentown, New Jersey, 26 August 1976, p. 3.

82 Burstyn, Joan N., ed. Past and Promise: Lives of New Jersey Women. (Metuchen, NJ: The Scarecrow Press, 1990), p. 97.

CHAPTER FIVE **(pages 38-46)**

83 *Entertaining A Nation: The Career of Long Branch.* (Long Branch, NJ: Work Project Administration, 1940), 72-98.

84 Hazard, Sharon. *Long Branch in the Golden Age: Tales of Fascinating and Famous People.* (Charleston, SC: The History Press, 2007), 80-83.

85 Ibid., p. 86.

86 Ibid.

87 Moss, George H. Jr. and Karen L. Schnitzspahn. *Victorian Summers at the Grand Hotels of Long Branch, New Jersey.* (Sea Bright, NJ: Ploughshare Press, 2000), 21-24.

88 Boudinot Family Bible, "Deaths."

89 Death Certificate. Sylvester Hamilton. H-32. 6 November 1882. New Jersey State Archives.

90 French, J. M., M.D., "Infant Mortality and the Environment." *Popular Science Monthly* 34 (December 1888): 221-29.

91 Long Branch Board of Education. "Annual Report of the Long Branch Board of Education and the Principal of the Public Schools for the Academic Years 1881-1882." (Long Branch, NJ: Stults & Son, 1882).

92 French, 228-229.

93 Death Certificate. Ida Hamilton. H-33. 14 December 1882. New Jersey State Archives.

94 Long Branch Board of Education. "Annual Report of the Long Branch Board of Education and the Principal of the Public Schools for the Academic Years 1891-1892." (Long Branch, NJ: Press of the Long Branch Record, 1893).

95 Long Branch Board of Education. "Annual Report of the Long Branch Board of Education and the Principal of the Public Schools for the Academic Years 1878-1879." (Long Branch, NJ: Press of the Long Branch Times, 1879).

96 Long Branch Board of Education. "Annual Report of the Long Branch Board of Education and the Principal of the Public School for the Academic Years 1893-1894."

97 Whaples, Robert. "Child Labor in the United States." EH Net Encyclopedia, ed. By Robert Whaples, October 7, 2005: http://eh.net/encyclopedia/child-labor-in-the-united-states/ (accessed 5/4/2015).

98 *Red Bank Register.* "Wanted." March 18, 1885, 4.

99 Long Branch Board of Education. "Annual Report of the Long Branch Board of Education and the Principal of the Public Schools

for the Academic Years 1882–1883."

100 Ibid.

101 Tyack, David and Elisabeth Hansot. *A History of Coeducation in American Public Schools: Learning Together* (New York, NY: Yale University Press and Russell Sage Foundation, 1990), 114–115.

102 Long Branch Board of Education *Annual Report*, 1890–1891.

103 Burstyn, *Past and Promise,* 96.

104 Ibid.

CHAPTER SIX (pages 47–53

105 Marriage Return. Alice Hamilton Boudinot and Walter Asay, A-12. New Jersey State Archives.

106 Ancestry.com. New Jersey, Births and Christening Index, 1660–1931(database online). Provo, UT, USA: Ancestry.com Operations, Inc., 2011 (accessed 10/1/2013).

107 Conner Prairie Organization. "Women's Roles in the Late 19th Century": http://www.connerprairie.org/learn-and-do/indiana-history/america-1860-1900/lives-of-women.aspx (accessed 11/10/2014).

108 Ibid.

109 Juster, Norman, ed. *So Sweet to Labor: Rural Women in America.* (New York, NY: Viking Books, 1979).

110 *Entertaining a Nation: The Career of Long Branch,* 64.

111 Ibid., 64–65.

112 *The New York Times.* "Improvements at Long Branch: The Projected Secession of the South End of the Village." April 3, 1886.

113 Conner Prairie Organization, "Women's Roles in the Late 19th Century."

114 Peters, Amy Condra, "Godey's Lady's Book and Sarah Josepha Hale: Making Female Education Fashionable" http://www.loyno.edu/-history/journal/1992-3/peters.htm (accessed 11/10/2014).

115 Harrington, Henry. F., "Female Education," *Ladies' Companion,* Vol. 9, 1838, 293.

116 *Past and Promise,* 96–97.

117 Long Branch Board of Education Annual Reports, 1880–1889.

118 Marriage Return. Laura Hamilton and Harry Woolley. W-43, New Jersey State Archives.

119 *The Red Bank Register.* "Orange Blossoms." 11 January 1888, 1.

120 Death Certificate. Alice (Allie) Hamilton. H-35, New Jersey State Archives.

121 Hamilton, Jennie. *Notebook*. Newspaper Clipping. May 1888.

CHAPTER SEVEN (pages 54-62)

122 Census Reports, Vol. IV, Twelfth Census, "Vital Statistics, Part II Statistics of Death," United States Census Office (Washington, DC, 1902), Table 8, 227-657.

123 Ibid.

124 Haines, Michael. "Fertility and Mortality in the United States": http://www.eh.net/encyclopedia/fertility-and-mortaility-in-the-united-states/ (accessed 11/5/2014).

125 James B. Morris Post #46, Long Branch, New Jersey: http://www.lyoncamp.org/morris46.htm (accessed 8/10/2011).

126 Sons of Union Veterans of the Civil War: Grand Army of the Republic History": http://www.suvcw.org (accessed 7/14/2011).

127 The National Woman's Relief Corps. "Our Mission": http://suvcw.org/wrc (accessed 12/1/2015).

128 Dalton, Kristen. "Gravestone Ensures Civil War Nurse Won't Be Forgotten: Grave of Mary Dunbar in WLB Cemetery in Need of New Headstone." *Atlanticville,* 19 January 2012, 1: http://atl.gmnews.com/news/2012-01-http://alt.gmnews.com/news/2012-01-19/Front_Page/Gravesone_ensures_Civil_War_nurse_wont_be_forgott.html (accessed 3/14/2016).

129 "Superintendent's Report." Home for Disabled Soldiers, Kearny, NJ, 1915.

130 Moss and Schnitzspahn, *Victorian Summers at the Grand Hotels of Long Branch, N.J.,* 59.

131 Ibid., 92, 94, 102.

132 Ibid. 49.

133 *The New York Times*, "Exposition at Long Branch." December 20, 1895.

134 *The New York Times*, "Doll Carnival To-Day." August 26, 1911.

135 Member List. 1886 Long Branch Atlantic Fire Engine and Hook #2. Monmouth County, New Jersey Archives.

136 *Entertaining a Nation: The Career of Long Branch, 147-148.*

137 Ibid.

138 Member List. 1892 Long Branch Atlantic Fire Engine and Truck Co. #2. Monmouth County, New Jersey State Archives.

139 Probate File. Estate of Walter Asay. No. 922. Monmouth County Surrogate, NJ.

140 Marriage Return. Edna Hamilton and Edward M. Haviland. H-19, New Jersey State Archives.

CHAPTER EIGHT (pages 63–72)

141 History.com. "Great Blizzard of '88 Hits East Coast: http://www.history.com/this-day-in-history/great-blizzard-of-88-hits-east-coast (accessed 4/25/2016).
142 Interview. Gene Tunney. 23 April 2016, Bordentown, NJ.
143 Boudinot Family Bible. "Births." Alice had six children with Miller Boudinot including Mary A., William M., James R., Cecelia B., Frank K. and Miller V. Only William and Cecelia reached adulthood; with her second husband Walter Asay, she had two children, George and John and was stepmother to Walter Jr. Although Walter Jr. died in early adulthood, George and John survived.
144 Boudinot Family Bible. "Deaths." Alice Asay. 7 October 1893.
145 *The Red Bank Register.* "Obituary." October 18, 1893, 5.
146 *"Annual Report of the Long Branch Board of Education and the Principal of the Public Schools for the Academic Year 1893-1894."*
147 Ibid.
148 *Entertaining a Nation: The Career of Long Branch*, 171–172.
149 *Long Branch Board of Education Annual Report 1893-1894.*
150 *The Red Bank Register.* "School Days are Over: Commencement Exercised in the Opera House." 20 June 1894, 1.
151 *"Annual Report of the Long Branch Board of Education Annual Report 1893-1894."*
152 Ibid.
153 Blakeslee, "Happy Birthday Cecelia Rachael Quigley, 100 Times."
154 Lunacy Commitment. Walter Asay. Monmouth County, NJ Archives.
155 Charland, Louis. C. "Esquirol, Jean-Etienne (1772—1840)." *Encyclopedia of Clinical Psychology*, Robin L. Cautin and Scott O. Lilienfeld, ed., (New York, NY: John Wiley & Sons, Inc., 2015), 1-4.
156 Death Record. Walter Asay. A-8, New Jersey State Archives.
157 Petition for Guardianship. Cecelia Boudinot, George and John Asay. No. 1737, Monmouth County Surrogate, NJ.
158 Death Record. Walter Asay Jr. A-2, New Jersey State Archives.
159 Final Guardian Account. Cecelia Boudinot, George and John Asay, No. 1737. Monmouth County Surrogate, NJ.
160 Year: 1900; Census Place: Ocean, Monmouth, New Jesey; Roll: 986; Page: 13A; Enumeration District: 0124; FHL microfilm: 1240986 (accessed 4/8/2011).

161 Blakeslee, "Happy Birthday Cecelia Rachael Quigley, 100 Times."

162 Interview with Gene Tunney. April 23, 1016. Bordentown, NJ.

163 Letter to Cecelia Quigley from John Asay. 6 October 1910.

164 Interview, George Tunney.

165 Hamilton, *Notebook*.

CHAPTER NINE (pages 73-81)

166 Year: 1860; Census Place: Eel, Cass, Indiana; Roll: M653 247; Page:540; Image: 26; Family History Library Film: 803247 (accessed 6/1/2010).

167 Letter of Administration. Estate of Mary A. Hamilton. Middlesex County Surrogate, New Brunswick, NJ.

168 Wikipedia. "Panic of 1873": https://en.wikipedia.org/wiki/Panic_of_1873 (accessed 6/5/2014).

169 Mott, Edward H., ed. "The Erie Route: A Guide to the New York, Lake Erie and Western Railway and its Branches with Sketches of the Cities, Villages, Scenery and Objects of Interest Along the Route, and Railroad, Steamboat and Stage Connections." (New York, NY: Taintor Brothers, 1882), 8-12.

170 Detroit Historical Society. "Industrial Detroit (1860-1900) http://detroithistorical.org/learn/timeline-detroit/industrial-detroit-1860-1900 (accessed 1/23/2015).

171 Detroit Public Library Digital Collection, "Guide Map of the City of Detroit." S. Farmer & Co., Detroit: 1872 http://www.digitalcollections.detroitpubliclibray.org (accessed 1/23/2015).

172 Detroit Superintendent of Schools, *One Hundred Years: The Story of the Detroit Public Schools 1842-1942*. Detroit Board of Education, 1942.

173 Ibid.

174 Ibid.

175 Detroit Historical Society, "Industrial Detroit (1860-1900).

176 Michigan Department of Natural Resources, "The Growth of Manufacturing: Furniture Cities."

177 Ibid.

178 Schroeder, Joseph J., Jr. ed. *Sears Roebuck & Co. 1908 Catalogue No. 117 The Great Price Maker*. (Chicago, IL: The Gun Digest Company, 1969), 408-415.

179 Michigan Historical Museum, "The Growth of Manufacturing: Furniture Cities."

180 "Census of Manufacturers 1880." United State Census Office, Washington, DC.

181 Ancestry.com. *U.S. City Directories, 1822-1995* (database online) (accessed 2/2/2015).

182 Death Indexing System. Annie Hamilton. No. 59, 231, Michigan Department of Community Health.

CHAPTER TEN (pages 82-90)

183 Seattle Municipal Archives, "Brief History of Seattle": http://www. seattle.gov/cityarchives (accessed 1/20/2015).

184 Northern Pacific Railroad Company. "The Pacific Northwest: A Guide for Settlers and Travelers." (New York, NY: E.W. Sackett & Rankin, 1882), 65.

185 *One Hundred Years: The Story of the Detroit Public Schools 1842-1942.*

186 Ibid.

187 Tyack and Hansot, 190-191.

188 Ibid.

189 Detroit Board of Education. "Thirty-Eighth Annual Report of the Board of Education of the City of Detroit for the Year 1880." Detroit, MI: Free Press Book and Job Printing House, 1881).

190 Tyack and Hansot, 212.

191 Ancestry.com. *U.S. City Directories, 1822-1995* (database on line) (accessed 6/1/2014).

192 Ibid.

193 Carter, Susan B. and Mark Prus, "The Labor Market and the American School Girl, 1890-1928." *Journal of Economic History*, 42 (1982): 163-171.

194 De Vault, Ileen A., *Sons and Daughters of Labor: Class and Clerical Work in Turn of the Century Pittsburgh.* (Ithaca, NY: Cornell University Press, 1995), 56.

195 Ibid.

196 Kessler-Harris, Alice. *Women Have Always Worked: A Historical Overview.* (New York, NY: The Feminist Press, 1981), 95-96. Despite the fact that New England mill owners advertised that female mill workers would live in "supervised" boarding houses with good wages, few women ever lived in boardinghouses and in fact, by the 1820's and 1830's mill owners cut salaries and increased hours to such an extent that women workers organized, petitioned legislatures for shorter hours and, when denied, struck. In response, mill workers slowly eliminated these workers by hiring

young immigrant women. "By the 1850's, factory work was done by immigrant women and was considered off-limits for native-born."

197 Ibid, 56-72.

198 Smithsonian Education. "Carbons to Computers. A Short History of the Birth and Growth of the American Office": http://www.smithsonianeducation.org/educators/lesson plans/carbons/start.html (accessed 7/16/2014).

199 Ibid.

200 Kessler-Harris, 96.

201 Rotella, Elyce J., "Women's Labor Force Participation and the Growth of Clerical Employment in the United States." *The Journal of Economic History* 39, no. 1 (March 1979): 331-333.

202 *The New York Times,* Letter to the Editor, April 8, 1896

203 The Suffragettes. "Anti-Suffrage": http://www.thesuffragettes.org/history/anti-suffrage/(accessed 1/28/2015).

CHAPTER ELEVEN (pages 91-100)

204 Northern Pacific Railroad Company, "The Pacific North-West: A Guide for Settlers and Travelers: Oregon and Washington Territory." (New York, NY: Land Department Northern Pacific Railroad Co., 1882), 73.

205 Ibid.

206 Ibid.

207 Ibid, 74.

208 Ibid, 73-75.

209 Early Office Museum. "Early Clerical Workers: Gender and the Office": http://www.officemuseum.com/office_gender.htm (accessed 7/16/2014).

210 Muhich, Peri. "Mercer Girls": http://www.historylink.org/index.cfm?DisplayPage=output.cfm&file_id-1125 (accessed 1/20/2015).

211 History.com staff. "Geronimo": http://www.history.com/topics/native-american-history/Geronimo (accessed 3/15/2014).

212 Seattle Municipal Archives, "Brief History of Seattle."

213 Ibid.

214 Ancestry.com. *U.S. City Directories, 1822-1995* (database). Provo, T, USA: Ancestry.com Operations, Inc, 2011. (accessed 8/15/2014).

215 Ibid.

216 Marriage Records. Platt B. Elderkin and Alice B. Hamilton. No. 210, 1897. Washington State Archives.

217 Birth Register. Baby Girl Elderkin. King County Auditor. Washington State Archives.

218 Ancestry.com. *U.S. City Directories, 1822-1995* (database online). (accessed 8/16/2014).

219 Blake, Werner. "Snohomish –Thumbnail History": http://www. HistoryLink.org/index.cfm?FDisplayPage=putput.cfm&file_ id=8508 (accessed 4/8/2015).

220 *Los Angeles Herald.* "Wily William Wallace." October 15, 1895, 4.

221 *San Francisco Chronicle.* "Hotel Arrivals-Palace Hotel." July 5, 1895, 11.

222 Cooper, Bruce C. "A Brief Illustrated History of the Palace Hotel of San Francisco": http://the palacehotel.org (accessed 4/8/2015).

223 *Los Angeles Herald,* "Wily William Wallace."

224 *San Francisco Call.* "Real Estate Transactions." June 12, 1896, 14.

225 Ancestry.com. *U.S. City Directories, 1822-1995* (database online) (accessed 4/8/2015).

226 *San Francisco Call.* "Divorce Suits Filed." February 12, 1899, 72.

227 Ibid., "In the Divorce Court." August 11, 1899, 71.

228 Western States Marriage Index. Platt Elderkin and Marie A. Bidewell: http://www.abish.byui.edu (accessed 6/10/2014).

229 Ancestry.com. California, Death Index, 1905-1939 (database online). Provo, UT, USA: Ancestry.com Operations, Inc., 2013. (accessed 6/10/2014).

230 Marriage Records. Jean Hamilton and David Millar. Washington State Archives.

231 Fish, Diane. "Farming History: Farming Bears Fruit." Kitsap Sun Puget Sound blogs. May 13, 2011.

232 Hamilton, *Notebook.* (Although the newspaper clipping is included in Jennie Hamilton's *Notebook,* there is no citation given for it as with other newspaper clippings she collected).

CHAPTER TWELVE (pages 101-109)

233 Swan, Coco. "History of the Honeymoon": http://www. weddingnight.com (accessed 2/23/2015).

234 List of Puget Sound Steamboats. "Puget Sound Mosquito Fleet": https://en.wikipedia.org/wiki/Puget_Sound_Mosquito_Fleet (accessed 2/23/2015).

235 *Seattle Post-Intelligencer.* "Steamers: City of Kingston." August 17, 1895, p. 7.

236 Joshua Green Foundation. "Puget Sound's Mosquito Fleet": http://www.history link.org/index.cfm?DisplayPage=output. cfm&file_id=869(accessed 2/23/2015).

237 Ibid.

238 British Columbia Board of Trade. "Boosterism and Early Tourism Promotion in British Columbia, 1890-1930": http://www. ubcpress. ca/books.pdf/chapters/sellingbc/selllingbcpf (accessed 2/25/2015).

239 Ibid, 17.

240 Ibid, 14.

241 Ibid, 18.

242 Tourism Victoria. "Victoria BC Landmarks" http://www. tourismvictoria.com (accessed 2/25/2015).

243 Shapleigh, John Blasdel. "In Memory of Dr. Washington E. Fischel": http://www.worldcat.org/title/in-memory-of-dr-washington-e-fischel-oclc/15189957 (accessed 2/1/2015).

244 Ibid, 3-7.

245 Ibid.

246 Ibid, 5.

247 Ibid, 2.

248 Ibid, 7.

249 Crossen, Harry Sturgeon. "The Menace of 'Silent' Ovarian Cancer." JAMA, 1942, 119: 1485-9; 1486-7.

250 Shapleigh, "In Memory of Washington E. Fischel," 14.

251 Ancestry.com. Missouri, Death Records,1834-1910 (database online). Provo, UT, USA: Ancestry.com Operations, Inc., 2008 (accessed 3/15/2015).

252 University of Missouri. "Ellis Fischel Cancer Center History": www.muhealth.org/locations/ellisfischelcancercenter (accessed 4/8/2015).

253 Hamilton, *Notebook*. (Clipping from *The Home News*, New Brunswick, New Jersey, January 1892).

CHAPTER THIRTEEN (pages 110-118)

254 Ancestry.com. *U.S. City Directories, 1822-1995* (database online) (accessed 11/5/2011).

255 Ibid.

256 Rochester, Junius. "Arthur Armstrong Denny": http://www. historylink.org/index.cfm?DisplayPage=output.cfm&file_id=921

(accessed 2/22/2015).

257 Marriage Return. Edwin C. Griswold and Beth G. Hamilton. No. 2780, Washington State Archives.

258 Ancestry.com. *U.S. City Directories, 1822-1995* (database online) (accessed 11/5/2011).

259 Wikipedia. "SS *Columbia* (1880)": https://en.wikipedia.org/wiki/SS_Columbia1880 (accessed 6/12/2016).

260 Ancestry.com. U.S. National Homes for Disabled Volunteer Soldiers, 1866-1938 (database online). Provo, UT, USA: Ancestry.com Operations, Inc. (accessed 4/6/2012).

261 Discover Los Angeles. "Historical Timeline of Los Angeles" http://www.discoverlosangeles.com (accessed 4/10/2012).

262 U.S. Department of the Interior. "The Homestead Act, 1862-2012": http://www.blm.gov/wo/st/en/res/Education_in_BLM/homestead_act/origins.html (accessed 5/15/2014).

263 Ibid.

264 City of Auburn, Washington. "History": http://www.auburnwa/gov/about/history.htm (accessed 3/20/2015).

265 Growing a Nation: The Story of American Agriculture: http://www.agclassroom.org/gan/timeline/farmers_land.htm (accessed 3/26/2015).

266 Washington State Dairy Federation. "Washington State Dairy Federation History": www.wastatedairy.com (accessed 3/26/2015).

267 Deed. Book 394, p.50.. Eleazer P. Whitney and Mary E. Whitney to Wyllis A. Silliman and Edward C. Griswold. Washington State Archives.

268 Year: 1860; Census Place: Clarkson, Monroe, New York; Roll: M653_785; Page: 350; Image: 43; Family History Library Film: 803785 (accessed 8/24/2015).

269 Wikipedia. "United States Land Surveying": http://www.en.wikipedia.org/wiki/Section_(United_States_and_surveying (accessed 9/23/2014).

270 Stein, Alan J. "Green River Flood Devastates Valley Around Kent Beginning on November 24. 1959": http://www.HistoryLink.org/index.cfm?DisplayPage=output.cfm&file_id=3575 (accessed 3/26/2015).

271 Crowley, Walt. "Interurban Rail Transit in King County and the Puget Sound Region": http://www.historylink.org/index.cfm?DisplayPage.output.cfm&file_id=2667 (accessed 3/26/2015).

272 Greater Kent Historical Society. "History of Kent": http://www.gkhs.org (accessed 3/26/2015).

273 Stein, Alan J. "Carnation/Tolt": http://www.HistoryLink.org/index.cfm?DisplayPage=output.cgm&file_id=391 (accessed 3/26/2015).

274 Deed. Book 528, Page 216. Wyllis A. Silliman and Minnie Silliman to Edwin Griswold. Washington State Archives.

CHAPTER FOURTEEN (pages 119–127)

275 Osterud, Grey. *Putting the Barn Before the House: Women and Family Farming in Early Twentieth-Century New York.* (Ithaca, NY: Cornell University Press, 2012), p. 59.

276 Ibid., 119-121.

277 Ibid., 110.

278 Ibid., 132-136.

279 Ibid.

280 Year: 1910; Census Place: Green River, King, Washington; Roll: T624_1657; page: 5A; Enumeration District: 0033; FHL microfilm: 1375670 (accessed 3/27/2015).

281 Estate. Edwin C. Griswold. No. 31942, King County, Washington.

282 Divorce Complaint. Silliman, A. Wyllis vs. Minnie D. Silliman. Case 55950, Washington State Archives.

283 Ibid.

284 Mayo Clinic. "Angina": http://www.mayoclinic.org/diseases-conditions/angine/basic/symptoms/com-20031194 (accessed 4/2/2015).

285 Ibid.

286 Ibid.

287 Ibid.

288 Ibid.

289 National Archives and Records Administration (NARA); Washington, D.C.: NARA Series: *Passport Applications, January 2, 1906-March 31, 1925*; Roll: #87; Volume #: Roll 0087–Certificates: 7014-7913, 28 May 1909-07 June 1909 (accessed 6/18/2015).

290 Ibid.

291 Department of Commerce and Labor Bureau of the Census. "Mortality Statistics: 1910," Bulletin 109. (Washington, DC: Washington Printing Office. 1912), p. 33.

292 Certificate of Death. Beth G. Griswold. No. 358.14, Department of Health, State of Washington.

293 *Auburn Globe Republican.* "Mrs. E. C. Griswold Passes." 16 February 1916.

294 Estate. Beth G. Griswold. No. 19737. Washington State Archives.
295 Passport Application, Wyllis A. Silliman, 1909.

CHAPTER FIFTEEN (pages 128–133)

296 Death certificate
297 Estate. Edwin C. Griswold, October 11, 1922. Washington State Archives.
298 Certificate of Death. Beth G. Griswold.
299 About Education. "The Sussex Pledge (1916): http://www. european history.about.com/od/worldwar1/p/prsussexpledge. htm(accessed 5/2/2015).
300 Ibid.
301 NARA Series: Passport Applications, January 2, 1906– March 31, 1925; Roll: #488; Volume #: Roll 0488-Certificates: 10000–10249, 21 Mar 1918-22 Mar 1918 (accessed 6/18/2015).
302 History.com Staff. "Paris Hit by Shells from New German Gun": http://www.history.com/this-day-in-history/paris-hit-by-shells-from-new-german-gun (accessed 5/2/2015).
303 Registration State: Washington; Registration County: King; Roll: 1991651; Draft Board: 02 (accessed 8/25/2015).
304 International Committee of YMCA Associations. *Summary of World War Work of the American YMCA. 1920*, 119–120.
305 Passport Applications, Wyllis A. Silliman, 1918.
306 Ibid.
307 Ibid.
308 International Committee of YMCA Associations. Summary of World War Work of the American YMCA, 63.
309 Ibid.
310 Ibid., 64.
311 Ibid.
312 Ibid., 65.
313 Ibid.
314 Year: 1935; Arrival: New York, New York; Microfilm Serial: T715, 1897–1957; Microfilm Roll: 5743; Line: 1; Page Number: 3 (accessed 4/20/2015).
315 Telephone Interview. Judy Donald, Andrew Mellon Library, Choate Rosemary Hall, September 1, 2015.
316 Year: 1935; Arrival: New York, New York; Microfilm Serial: T715, 1897–1957 (accessed 4/20/2015)
317 Ancestry.com. *U.S. City Directories, 1822-1995* (database online)

(accessed 4/15/2015).

318 California State Archives; Sacramento, California, 1940 (accessed 4/25/2015).

319 *San Francisco Chronicle.* "Obituary Wyllis A. Silliman." September 29,1939, p. 15.

320 Ibid.

321 *Oakland Tribune.* "Heavy Death Toll Feared in S. California Hurricane; L.A., Neighboring Cities Flooded by Torrential Rains." September 25, 1939, p. 7.

322 *Bakersfield Californian.* "Victim of Drowning Found to be Doctor." September 28, 1939. p. 18.

CHAPTER SIXTEEN (pages 134-140)

323 Alger's Ragged Dick. "Alger's Dick" http://twain.lib.virginia.edu/tomsawye/alger.html (accessed 3/1/2015).

324 Biography.com Editors. "Captains of Industry" http://www.biography.com/people/andrewcarnegie–9238756 (accessed 3/1/2015).

325 Ibid.

326 Ibid.

327 Biography.com Editors. "John Jacob Astor": http://www.biography.com/people/john–jacob–astor–9191158 (accessed 3/1/2015).

328 1891 Seattle City Directory.

329 Ibid.

330 Brands, H.W. *The Age of Gold: The California Gold Rush and the New American Dream.* (New York, NY: Anchor Books, 2002).

331 University of Washington Libraries. "The Klondike Gold Rush": https://content.lib.washington.edu (accessed 3/5/2015).

332 Year: 1900; Census Place: Seattle Ward 8, King, Washington; Roll: 1745; Page 12B; Enumeation District: 0114; FHL microfilm: 1241745 (accessed 3/12/2015).

333 Breton, Pierre. *Klondike: The Last Great Gold Rush, 1896-1899.* (Anchor Books, Canada, 2001).

334 Lange, Greg. "Klondike Gold Rush": http://www.historylink.org/index.cfm?DisplayPage=output.cfm&file_id=687(accessed 3/15/2015)

335 Ibid.

336 U.S. Department of the Interior. "Minerals in Alaska": http://www.alaskacenters.gov (accessed 3/20/2015).

337 Ibid.

338 Warner, L.A., E. N. Goddard et al. "Iron and Copper Deposits of Kasaan Penisula, Prince of Whales Island, Southeastern Alaska." Geological Survey Bulletin 1090. (Washington, DC: U.S. Government Printing Office, 1961), 133 pp.

339 Year: 1910; Census Place: Long Beach Ward 4, Los Angeles, California; Roll: T624-85; Page: 188; Enumeration District:0042; Image: 828; FHL Microfilm: 1374098 (accessed 7/27/2012).

CHAPTER SEVENTEEN (pages 141-148)

340 U.S. Department of the Interior. "Veteran Affairs National Home for Disabled Volunteer Soldiers: Pacific Branch": http://www.nps.gov/nr/travel/veterans_affairs/Pacific_Branch.html (accessed 4/16/2015)

341 Ibid.

342 Kelly, Patrick J. *Creating a National Home: Building the Veterans' Welfare State, 1860-1900.* (Cambridge, MA: Harvard University Press, 1997), pp. 93-93.

343 Ibid, 160.

344 Ibid.

354 U.S. Department of the Interior. "History of the National Home for Disabled Volunteer Soldiers": http://www.nps.gov/nr/travel/veterans_affairs/History.html (accessed 4/16/2015)

346 U.S. Department of the Interior. "Veteran Affairs National Home for Disabled Veteran Soldiers: Pacific Branch."

347 Wilkinson, Cheryl L., "The Soliders' City: Sawtelle, California 1897-1922." *Southern California Quarterly* 95, no. 2 (Summer 2013):188-226.

348 Department of Veterans Affairs. "Veterans Programs Enhancement Act of 1998 (VPEA) Master Plan." Los Angeles, CA., 2011, 7-8.

349 Kelly, *Creating a National Home*, 140-142.

350 Plante, Trevor K. "Genealogy Notes: The National Home for Disabled Volunteer Soldiers." *Prologue*, 36, 1, (Spring 2004):1-6.

351 U.S. Department of the Interior. "Daily Life at the National Home for Disabled Volunteer Soldiers": http://www.nps.gov/nr/travel/veterans_affairs/Daily_Life.html (accessed 4/16/2015).

352 Kelly, *Creating a National Home*, 142-144.

353 Wilkinson, "The Soldiers' City," 217.

354 Ibid, 202.

355 Kelly, *Creating a National Home,* 154-157.

356 Ibid, 187-188.

357 U.S. National Library of Medicine. "Infectious Disease: Tuberculosis" http://www.nlm.gov/medlineplus/tuberculosis.html (accessed 4/15/2015)

358 Sherins, Robert S., M.D. "Wadsworth Veterans Hospital, A Consequence of History, Origin of the Wadsworth VA Hospital, formerly Pacific Branch of the National Home for Disabled Volunteer Soldiers, aka Sawtelle Veterans Old Soldiers Home," (Pacific Palisades, CA: Self-published, 2011).

359 Ancestry.com. U.S. National Homes for Disabled Volunteer Soldiers, 1866-1938 (database online). Provo, UT, USA: Ancestry.com Operations, Inc., 2007 (accessed 8/2/2011).

CHAPTER EIGHTEEN (pages 149-156)

360 Kelly, *Creating a National Home*, p. 99-100.
361 Ibid, 99-100.
362 Ibid, 98.
363 Wilkinson, "The Soldiers' City," 217.
364 Kelly, *Creating a National Home*, 101.
365 Department of Commerce and Labor, Bureau of the Census. *Census of Manufactures: 1905 Earnings of Wage-Earners Bulletin 93.* (Washington, DC: Government Printing Office, 1908), 179 pp.
366 Wilkinson, "The Soldiers' City," 218.
367 Ancestry.com. U.S. National Homes for Disabled Volunteer Soldiers, 1866-1938 (database) (accessed 6/2/2014).
368 Ancestry.com *U.S. City Directories, 1822-1995* (accessed 6/2/2014).
369 Death Certificate. Alexander Hamilton. March 29, 1908. California State Board of Health.
370 U.S. Department of the Interior. "History of the National Home for Disabled Volunteer Soldiers: Pacific Branch" (accessed 4/16/2015).
371 Kelly, *Creating a National Home*, p. 148-149.
372 Hamilton, *Notebook*.
373 Pension Application. Lizzie M. Hamilton, Certificate 655.161. U.S. National Archives, Washington, DC.
374 Ibid.
375 Year: 1910; Census Place: Long Beach WARD 4, Los Angeles, California; Roll T624_85; Page: 188; Enumeration District; 0042; Image: 828; FHL microfilm: 1374098 (accessed 7/27/2012).
376 Death Certificate. Mrs. Elizabeth Hamilton, 280, California State Death Certificates.

377 California Department of Health Services Center for Health Statistics. "Abridged Life Tables for California, 2004." Table I, 4: http://www.cdph.ca.gov/pubsforms/Pubs?OHRLifetables2004.pdf (accessed 8/4/2012).

378 Ancestry.com. *U.S. Directories, 1822-1995* (database online) (accessed 5/2/2015).

CHAPTER NINETEEN (pages 157-165)

379 Wetzel, James R. "American Families: 75 Years of Change." *Monthly Labor Review,* 113, 2, (March 1990): 4-13.

380 Letters of Administration. John P. Hamilton Jr., No. 10815, Monmouth County Surrogate, NJ.

381 Deed. Ella J. Emmons and Cornelius J. Emmons to Edna S. Hamilton, Book 803, Page 469, Monmouth County Clerk, NJ.

382 Burstyn, Past and Promise, 3.

383 Ibid, 101.

384 Red Bank Register, "Building a Bungalow," June 12, 1907, p. 8.

385 Mortgage, Edna S. Hamilton and John P. Hamilton Jr. to Alonzo Sherman, Book 347, Page 466, Monmouth County Clerk, NJ.

386 Mortgage, Edna S. Hamilton and John P. Hamilton Jr. to N.J. Mortgage and Trust Co., Book, 357, Page 414, Monmouth County Clerk, NJ.

387 Mortgage, Edna S. Hamilton to Sarah S. Clark, Book 547, Page 364. Monmouth County Clerk, N.J.

388 Ancestry.com. *U.S. City Directories, 1822-1995* (database online) (accessed 12/1/2015).

389 Mortgage, Edna S. Hamilton to Sarah S. Clark, Book 108, Page 363. Monmouth County Clerk, NJ.

390 Kessler-Harris, *Women Have Always Worked,* 84.

391 1880 Newark City Directory.

392 Kessler-Harris, 85-86.

393 Bodian, Nat. "The Legendary Philanthropies of Newark's Louis Bamburger": http://www.oldnewark.com/memories/bios/bodianbamburger.htm (accessed 12/10/2015).

394 Wikipedia. "Henry Cotton": http://www.en.wikipedia.org/Henry_Cotton_doctor (accessed 2/3/2016).

395 Ibid.

396 Death Record, Edna S. Hamilton. New Jersey State Archives.

397 Order. "Decree for Sale," Orphan's Court, Monmouth County Surrogate, N.J.

398 Order, "Order Confirming Sale of Lands," Orphan's Court, Monmouth County Surrogate, N.J.

CHAPTER TWENTY (pages 166–173)

399 Ancestry.com. *U.S. City Directories, 1822-1995* (database online) (accessed 4/20/2015).

400 Year: 1940; Census Place: New York, Bronx , New York; Roll: T627_2488; Page: 8A; Enumeration District: 3-1129 (accessed 10/14/2016).

401 Abramowitz, Milton and Irene Stegun, eds. *Handbook of Mathematical Functions with Formulas, Graphs, and Mathematical Tables.* (Washington, DC: Government Printing Office, 1964).

402 "Selective Service Act of 1917." *Major Acts of Congress. Encyclopedia. com. 7 Nov. 2016* http://www.encyclopedia.com (accessed 11/2/2016).

403 Berry, Douglas. "Riddle Boats Works." *Oceanport in Retrospect* (Oceanport, NJ: Oceanport Historical Society, 1970), 58-60.

404 Interview. Jean Taormina, Dewey Beach, DE., August 27, 2015.

405 Ibid.

406 Year: 1930; Census Place: Los Angeles, Los Angeles, California; Roll: 137; Page: 8A; Enumeration District: 0120; Image: 283.0; FHL microfilm: 2339872 (accessed 4/21/15).

407 Year: 1940; Census Place: Los Angeles, Los Angeles, California; Roll: T627_222; Page: 62A; Enumeration District: 19-56 (accessed 4/21/15).

408 "Union Eagle Apartments," Mission First Housing Group: http://www.missionfirsthousing.org (accessed 9/10/2014).

409 Blakeslee, "Happy Birthday Cecelia Rachael Quigley, 100 Times."

APPENDIX

FAMILY

CHARTS

APPENDIX

CHART 1

FAMILY of ALEXANDER SEWALL HAMILTON and MARY ANN RYAN

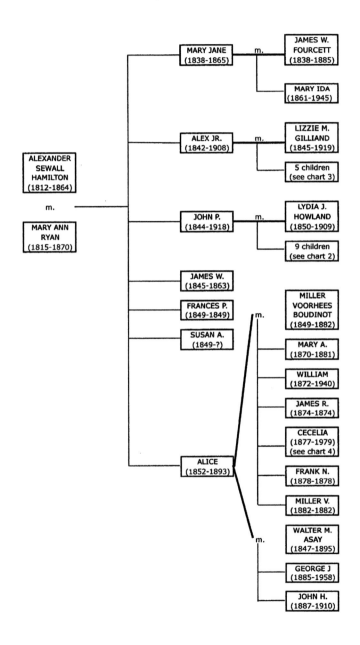

CHART 2
FAMILY of JOHN P. HAMILTON AND LYDIA JANE HOWLAND

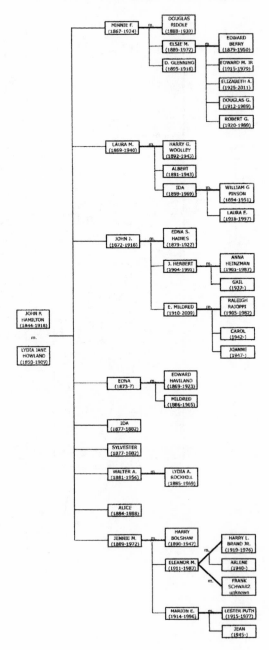

CHART 3
FAMILY of ALEX HAMILTON and LIZZIE M. GILLIAND

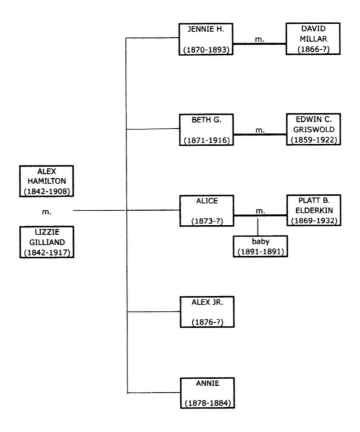

CHART 4
FAMILY of CECELIA BOUDINOT QUIQLEY AND JOSEPH H. QUIGLEY

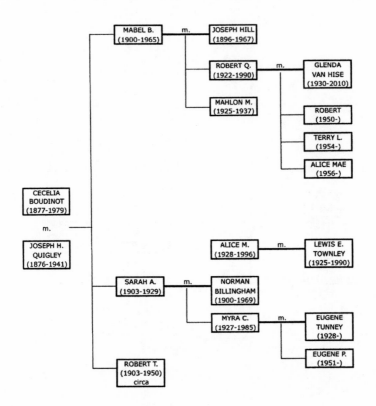

INDEX

ABOUT THE AUTHOR

JOANNE HAMILTON RAJOPPI, a former journalist, is a lifelong resident of New Jersey. A history aficionado, she chronicled the military service of her great-grandfather during the Civil War in her book *New Brunswick and the Civil War: The Brunswick Boys in the Great Rebellion* based on the letters he wrote to his family.

A contributor to *Meet Your Revolutionary Neighbors: Crossroads of the American Revolution,* she also has authored several pamphlets and calendars detailing the history of the region. She is also a trustee and officer of the Union County Historical Society. During the Civil War Sesquicentennial she established and chaired a four-year revolving exhibit in the historic Union County Courthouse. She serves the Union County Clerk and is a former mayor of her hometown.

CPSIA information can be obtained
at www.ICGtesting.com
Printed in the USA
FFOW05n1755030217

9 781939 995186